YOSEMITE IN TIME

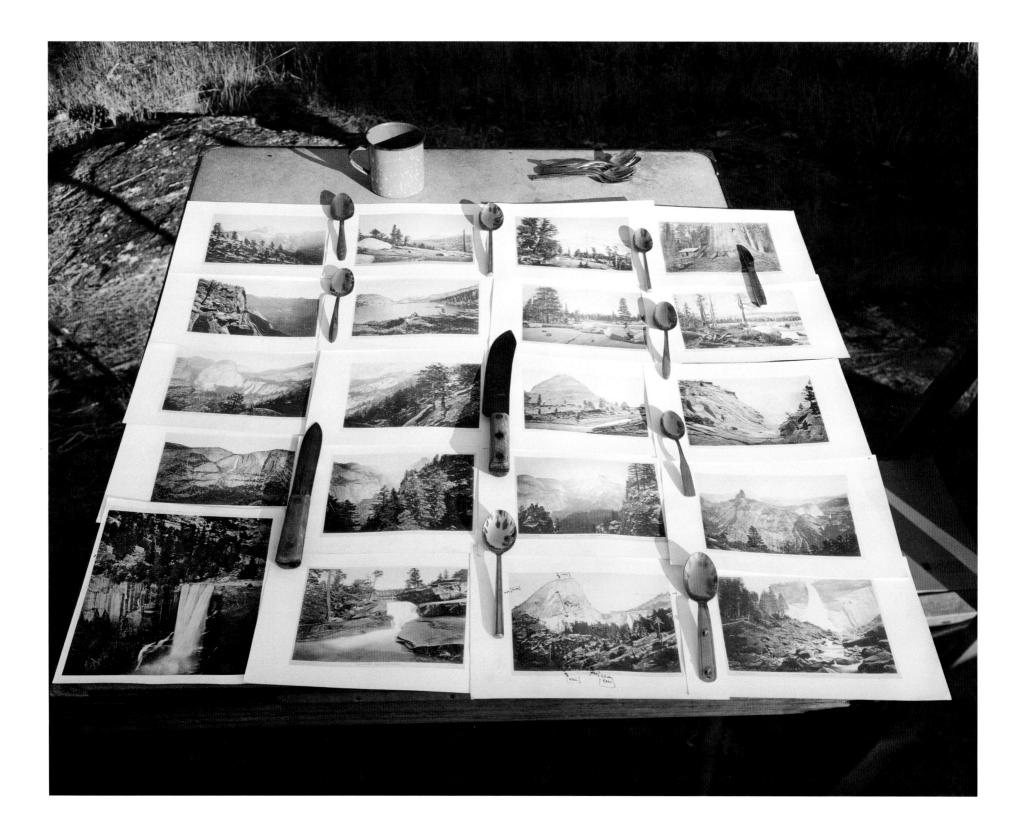

YOSEMITE IN TIME

ICE AGES TREE CLOCKS GHOST RIVERS

MARK KLETT REBECCA SOLNIT BYRON WOLFE

TRINITY UNIVERSITY PRESS
SAN ANTONIO, TEXAS

 Published by Trinity University Press
San Antonio, Texas 78212
www.trinity.edu/tupress

Second printing

The type for this volume was set in Bembo, modeled on typefaces cut by Francesco Griffo in 1495 in Venice, Italy. Stanley Morison surpervised its design for the Monotype Corporation in 1929. All photography was scanned and digitally prepared for the printer by Mark Klett and Byron Wolfe. Printing and binding were done by Tien Wah Press, Singapore. The paper is Galerie Art Silk, 150 gsm text weight.

Project Director: Barbara Ras
Project Editor: Sarah Nawrocki
Designed and typeset by David Skolkin

Frontispiece: Mark Klett. Muybridge's Yosemite on our breakfast table, Foresta Camp, 2001.

Library of Congress Cataloging in Publication Data

Klett, Mark, 1952–
Yosemite in time : ice ages, tree clocks, ghost rivers / Mark Klett, Rebecca Solnit, and Byron Wolfe.
 p. cm.
Includes bibliographical references.
ISBN-13: 978-1-59534-016-0 (hardcover : alk. paper)
ISBN-10: 1-59534-016-5 (hardcover : alk. paper)
1. Yosemite National Park (Calif.)—History. 2. Yosemite National Park (Calif.)—Description and travel. 3. Yosemite National Park (Calif.)—Pictorial works. 4. Yosemite National Park (Calif.)—Environmental conditions. 5. Landscape—California—Yosemite National Park—History. 6. Landscape—California—Yosemite National Park—Pictorial works. 7. Natural history—California—Yosemite National Park. 8. Natural history—California—Yosemite National Park—Pictorial works. I. Solnit, Rebecca. II. Wolfe, Byron, 1967– III. Title.
F868.Y6K55 2005
979.4'47—dc22 2005010361

CONTENTS

ACKNOWLEDGMENTS

THIS WAS AN INTRICATE PROJECT, stretching over four or five years and involving exploration of the wildernesses of photographic archives and obscure photographic sites. Many helped us travel through both arenas. We would like to thank those who joined us at one point or another on the five expeditions and supplied everything from good ideas to heavy lifting: Ellen Manchester and Walker Dawson, Geoff Fricker, Catherine Page Harris, Michael Light, Michael Rauner, and Barbara Wolfe. Large thanks are due to Greg Adair, who let us camp in his yard in Foresta, a significant help early on; and to various park rangers, interpreters, and ecologists who proffered on-location advice. Also in Yosemite, we received assistance and advice from librarian Linda Eade and historian Jim Snyder in the Yosemite Research Library, as well as from park naturalist Sue Beatty, and benefited from the generous assistance of park interpreters and others.

Elsewhere, we relied on several archives and libraries, whose resources and staff were crucial to this project. We are grateful to the Bancroft Library, University of California, Berkeley, both for permission to use images from their extensive collections and for encouragement and assistance, particularly from James Eason, Susan Snyder, and Jack Von Euw; to Jeffrey Fraenkel of Fraenkel Gallery in San Francisco, who loaned us his copy prints of Watkins photographs; to Dianne Nilsen and Douglas Nickel at the Center for Creative Photography, Tucson, Arizona, another important source of images;

to the Ansel Adams Publishing Rights Trust for permission to use that artist's work; to the Denver Public Library; to Julian Cox, Weston Naef, and Jackie Burns at the J. Paul Getty Museum in Los Angeles; and to Aaron Schmidt at the Boston Public Library Print Collection. Robert Dupree helped with printing images for use in the field. Further research assistance was given by Jenny Watts at the Huntington Library in San Marino, California; and John Rohrbach at the Amon Carter Museum of American Art in Fort Worth, Texas. Special thanks are due to the extraordinary independent photohistorian Peter Palmquist, for his letters to Rebecca in answer to questions on clouds, Watkins, shadows, and other important things. His death in 2002 was a huge loss to photographic history and the California scholarly community.

Barbara Ras's unswerving interest in this project as it evolved and her commitment to publishing it were a huge boon, as was working with the brilliant book designer David Skolkin. The Headlands Center for the Arts generously made their facilities available to us at a crucial stage in the project.

Byron also thanks the Chico Museum, the Department of Communication Design at California State University, Chico; and Mark thanks the Katherine K. Herberger College of Fine Arts at Arizona State University. They both thank their families—Emily Matyas and Lena and Natalie Klett; Barbara, Ethan, and Ben Wolfe and Nelson and Jean Wolfe—for their unwavering support through long absences during fieldwork and the even longer hours spent in the studio and behind computer monitors completing the photography.

INTRODUCTION

YOSEMITE IS A PLACE that could be quantified as so many acres, so many pines, so many jays, so many waterfalls. But the experiences people seek and find there are wildly varied: tour groups pass through in half a day, backpackers wander the backcountry for weeks, painters set up easels in the meadows. People study the climate, the geology, the forests, and the tourists. Others hope for relaxation, adventure, or revelation; they sit in folding aluminum chairs, take the short walk to the base of Yosemite Falls, or climb huge rock walls and spires. Yosemite is a singular place onto which are mapped myriad expectations and desires.

What the early white visitors looked for in the 1870s, how they moved through the place, and how they talked about it differs in profound ways from how contemporary visitors interact, though a passion for the landscape prevailed then and now. And what we, the trio of *Yosemite in Time*, were looking for also differs: we sought traces of those long-gone visitors, particularly two who came with huge cameras, and for ways of gauging what had changed between their time and ours.

"Change is the measure of time" is an aphorism my collaborator Mark Klett learned as a geologist and found equally applicable for photography and exploration of place. The pictures Mark and Byron Wolfe made for this project measure the difference between photographic visions and also measure changes in the landscape. I was measuring the radical changes in ideas about the place.

Yosemite was from the early 1860s on one of the most intensively photographed places in the American West, an early site for the development of landscape photography, and a key site for modernist photography as well. It was, arguably, the first national park. (Yellowstone was the first wilderness park managed by the federal government, but there was no state government in Wyoming Territory in 1872. In contrast, when Yosemite Valley was set aside by an act of Congress during the Civil War, California had a strong state government and the national government had, to say the least, its hands full. Yosemite was enlarged and made a national park in 1890.) Yosemite was holy ground to the founders of the Sierra Club, which began in 1892 as a mountaineering club not so different from the Alpine Club or the Adirondacks Club, though few remember that the Spanish word Sierra in its name references the particular mountain range in which Yosemite is set (and that the club's full political identity only began to emerge fifteen years or so later, in the unsuccessful fight to keep Hetch-Hetchy Valley, just north of Yosemite Valley in the park, from becoming a reservoir supplying water and power to San Francisco). For all these reasons, Yosemite has been a key site in how we think about nature, landscape, and conservation. For my collaborators and for me, it was an ideal site in which to explore what those things mean today, as the place continues to change, in its ecology, its management, its demographics, and its meaning.

In the summer of 2000, Mark Klett, Byron Wolfe, and their collaborators were finishing up their Third View Project. I was doing research for my book on the San Francisco–based photographer Eadweard Muybridge (1830–1904), and I wanted to talk to Mark about Muybridge, panoramas, photography, and the representation of time. I had conceived a great affection for Mark's superlative camp kitchen setup, so I joined the Third View expedition as camp cook for a week. One result of that week of camping in the West is Mark's photograph of me cooking coq au vin under a spectacular sky on the north shore of the Great Salt Lake, the frontispiece to their *Third Views, Second Sights* book. Another is his influence on my interpretation of Muybridge's panoramas and of the subject of time in photography, in my book *River of Shadows: Eadweard Muybridge and the Technological Wild West.* A third is the book you are holding, *Yosemite in Time,* itself the result of our five expeditions into Yosemite over three years. We didn't expect this project to arise during those days at the Great Salt Lake and Yellowstone. It sneaked up on us.

For me, the first inklings came in the fall of 2000. I was at Eastman House in Rochester, New York, where the kind curators left me alone with a stack of Muybridge's 1872 mammoth plate photographs of Yosemite—contact prints made from glass negatives about twenty by twenty-four inches in size. Standing at a table slowly sifting through the fifteen or twenty prints, I got vertigo, something that never happens to me—not even when I visited the original sites of many of the photographs years later. There was something so precipitous, so destabilizing, so wild and unconventional about Muybridge's Yosemite mammoth plates that I wanted to understand what he had done with that place that so often looks so majestically serene in other artists' versions.

It was then that I began to wonder if Mark and Byron might rephotograph them—for rephotography is a marvelous and unique means of investigation not only of what a place once was but who the photographer was who made that photograph in some vanished time. By standing in the same place

at the same time of day and year (which is necessary to get the angle of the light right) you return to the site of the photographer's choices—how he went onto the very lip of a cliff, what he chose to crop out and what he chose to show of the landscape that could be represented so many other ways, what time of day and year he was there, and where and when his photographs are in relation to each other.

Rephotography began as a technique for geologists and other scientists to study changes in the landscape. You took an old photograph and attempted to return to the exact site to make another photograph. In 1977, when Ellen Manchester, Mark Klett, and JoAnn Verburg began the Second View Project, they also attempted to return at the same time of day and year, so that the light as well as the topography would match. They were interested not only in the photographs but in the photographers. For that project, the photographers were the prodigies of the U.S. Geological Survey, which in the 1860s and 1870s had explored, mapped, studied, and photographed the West, particularly the Rockies and the desert regions: Timothy O'Sullivan, William Henry Jackson, William Bell, and Andrew J. Russell, among others. Rephotography has since become a familiar mode of operating inside the art world and out, but most practitioners settle for a simple then-and-now format, something that Mark and Byron departed from by rephotographing again what had been rephotographed before in Third View and made utterly original in our Yosemite project, where times and visions layer and collide. (My collaborators also achieve a far greater degree of precision—in location and in light—than is common in rephotography.) "Adding the third view," Byron wrote me, "suggests the idea of a continuum so that rephotography can function more as a time-lapse animation" and gets beyond the then-and-now format that is the simplest picture of time. A third view implies the possibility of a fourth, a fifth, of understanding change as continuing beyond our own time.

We talked about a project desultorily in the winter and into the spring of 2001, and then came the clincher, the first in a series of fortuitous coincidences or strokes of luck for the project that became this book. On May 17 of that year, I e-mailed them: "In Yosemite Research Library Monday I found and transcribed the locations from which Muybridge made his 51 mammoth plate photographs of the Valley and the Sierra, as deduced by some 1950s researchers who sound like they know what they're talking about. I also think there may be another unknown Muybridge panorama lurking in there; certainly two of the photographs taken from Panorama Point overlap" (pp. 83–84). What I had found was tremendously exciting: a small bundle of index cards on which the locations had been written in wobbly blue ballpoint pen by Mary or William Hood, a couple who had explored and written about the place decades earlier. They made a Yosemite rephotographic project far more feasible than it would have been otherwise, since none of us then knew the place intimately. With their information, our scouting for sites could begin in the right vicinity, even though the given locations were sometimes vague or inaccurate in the details.

Looking back over the hundreds of e-mails this project produced, I can see that we wandered into the project without ever making any formal pacts or plans. It was a fishing trip, an expedition to find out what was there and what we could make of it. And it was a collaboration, which is of its very nature improvisational. That May or June, I produced more background information on when Muybridge was in the Yosemite region—which he entered on the summer sol-

stice of 1872 and stayed in for months—and marked the approximate locations of the photographs on a map. Byron downloaded and printed out rough copies of Muybridge's Yosemite mammoth plates from the online archive for U.C. Berkeley's Bancroft Library (a glorious institution without whose resources and librarians *Yosemite in Time* would not have been nearly as possible). Mark wrote me, "Photos made around the solstice are fairly easy to remake because the angle of the sun doesn't change much from day to day around that time. I'd say that we'd have almost a month on either side for midday shots when the lighting won't look much different. Side-light details are usually the best indicators." By late July, we were in the field with cameras, film, piles of prints, books, checklists, and maps. And coolers full of food and Mark's incomparable field kitchen. I cooked. They cleaned up. I wrote. They photographed.

But the creative work was always more complicated than that, because it was a real collaboration, in which the ongoing conversation contributed to what I wrote, I occasionally influenced how and what they photographed, the expeditions in pursuit of pictures also brought me to new ideas, and revisiting the photographic sites and watching them make pictures influenced me as well. In a true collaboration, you can trace actual handiwork—the act of making—but you can't sift out the generation of ideas, which arise from the ongoing conversation. At some point, Mark wrote, "I remember having a discussion about the nature of collaboration while driving through the park. It had to do with accepting uncertainty, with letting the process guide discovery. This is pretty standard stuff. But from an interpersonal perspective it was important because we had to establish the premise that we could accept personal vulnerabilities—the right to be wrong, to have ideas

that wouldn't work or weren't good, to speculate without the fear of feeling foolish. We had to agree to work in an environment of mutual support, of mutual success, and to share the responsibility for failure." We explored the landscape of Yosemite and ideas about photography and time together, forays in the one arena encouraging those in the other.

Mark and Byron had by that time become an extraordinarily aligned team: Mark operated the camera while Byron made calculations that compared the distance between objects in the scene to those in the original photograph. They'd discuss their results, then refine their location. The panoramas required extensive on-site problem-solving and invention, with further refinement taking place through e-mail correspondence as they worked back in their studios.

The first surprise for this Yosemite work was that two Muybridge photographs showing very different views of Yosemite Valley's south wall had been taken from two spots very close to each other. It was clear from the site—but not the photographs—that he had taken one and then picked up the camera and made the other, probably in the same few hours, and that the photograph of El Capitan was made earlier in the day than the image of Three Brothers. Or clear to Mark and Byron, who had trained themselves to read such signs in pictures and places together. This is the kind of discovery rephotography yields, and it prompted Byron and Mark to make a panorama exploring the distance between those two points and, in a less literal way, between Muybridge's time and ours. Mark had, ever since he rephotographed Muybridge's 1878 panorama, been fascinated by how such multiple-image artworks can represent time, and one of the serendipities of this project was that rephotography and panorama-making merged as methods of exploring time and place.

Mark recalls, "The 'ghost river panorama' was the first time we speculated that it might be possible to connect different points in space into one composite image. It was problematic—how could we link images of both near and far spaces while moving the camera in space? This seemed possible because the two vantage points were visible from one another and we could select objects common to bordering pictures. But the background wasn't ideal, so we had to create priorities. We knew it would not depict a normal representation of space. I remember being challenged to piece together space in a nonperspectival way, something David Hockney had worked on fifteen years earlier, but we had historic images as both guides and limits."

Byron added, in another e-mail, "I think the rephotography became a little more personal and inventive partly because of our understanding of Muybridge, but also because the timing was right for us. Before, the rephotography was a foil that allowed us to engage a place in a seemingly dispassionate way that would hopefully prompt a dialogue to then enter with our own pictures. This allowed us to handle the specific places, and our own experiences, in more complex and wide-ranging ways. I don't think the Yosemite work we did deals with personal experiences (nor do I think it should), but there was something gratifying about bouncing around inside the boundaries we've established with the relatively strict methodology of rephotography."

The second surprise on that first expedition was the realization that the other photographers who made Yosemite into an international icon—Carleton Watkins in the nineteenth century, Ansel Adams and Edward Weston in the twentieth—had in all the 1,200-square-mile vastness of Yosemite National Park often photographed very near each other over the decades. We first realized this overlap between disparate artists at the site of Muybridge's "Moonlight Rock" photograph, a wildly overgrown site a few hundred yards above that of Adams's famous "Clearing Winter Storm," both of which Byron and Mark rephotographed. (Adams, Byron's research unearthed, actually published five photographs from this site, including "Yosemite Valley: Thunderstorm," "Winter Morning," "Rain and Mist," and "Moonrise," as well as "Clearing Winter Storm.") So what began as a project about Muybridge grew into a project encompassing much of the history of American landscape photography.

You can see this overlap of different times and visions in the panorama exploring the few hundred feet between Weston's juniper and Muybridge's glacier traces on the glacial slope south of Lake Tenaya (p. 124) and most stunningly in the Lake Tenaya panorama (pp. 116–17), which documents a shoreline on which Weston in 1937 stood two feet from Muybridge in 1872, while Ansel Adams in 1942 stood twenty feet farther south. One reward of these overlaps was seeing how different visions and different photographic technologies could represent the same places so differently: the artists who came before us found what they were looking for—tangles, precipices, and dramas in Muybridge's case; stillness and sublimity in Watkins's; grandeur and supernatural clarity in Adams's. We too found what we were looking for: a landscape full of photographs, ghosts, shifts in vegetation, and other traces of passing time. Every representation of a landscape is also a representation of desire.

What isn't visible in these images, though it appears obliquely in the texts, is that Yosemite in Time truly comes out of expeditions that began with flurries of e-mails about film, equipment, food, geography, maps, books, and schedules,

and entailed car-camping for a week at a time (photography is too bulky to do it any other way, though we did backpack to Little Yosemite Canyon for some rephotography). The project required long hikes to remote locations, such as the top of Yosemite Falls, with a lot of photographic gear, as well as occasional bushwhacking expeditions through dense manzanita thickets to find locations that had become overgrown and obscure (though occasionally photographs of what looked like wilderness turned out to have been made from the roadside). There were campfires, mosquitoes, long conversations, lemonade on the porch of the Wawona hotel after inspection of the Mariposa Groves of sequoia trees, guests along at various stages, car trouble, and more.

Which is to say that it had some of the demands as well as all the pleasures that the term expedition calls to mind, of which I hope the principal one is truly visible: the pleasures of discovery that now belong to the reader. Not discovery of the untouched and truly unknown, but of traces of histories, conjunctions, overlaps, patterns, meanings in the steep, intricate, hallowed, scarred landscape of Yosemite.

—Rebecca Solnit

YOSEMITE IN TIME

2 Charles Leander Weed, *Yosemite Valley from Mariposa Trail,* c. 1865.

Mark Klett and Byron Wolfe, *Yosemite Valley off the old Mariposa Trail, now overgrown with dense manzanita brush,* 2003. 3

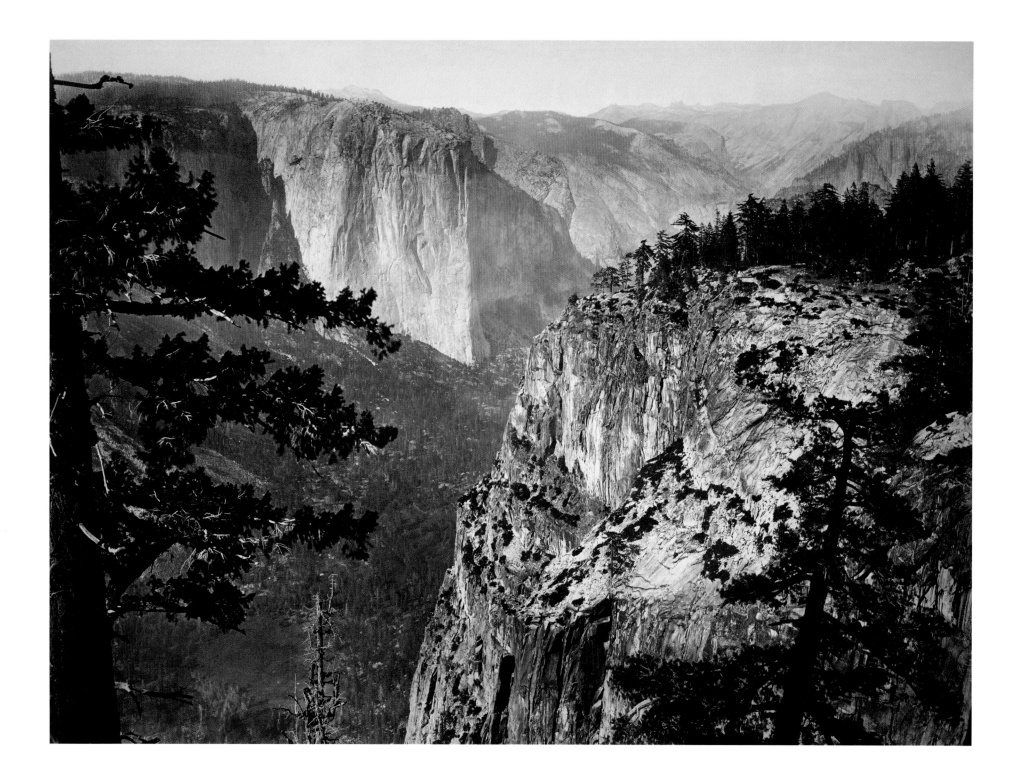

4 Carleton E. Watkins, *First View of the Yosemite Valley from the Mariposa Trail,* c. 1866.

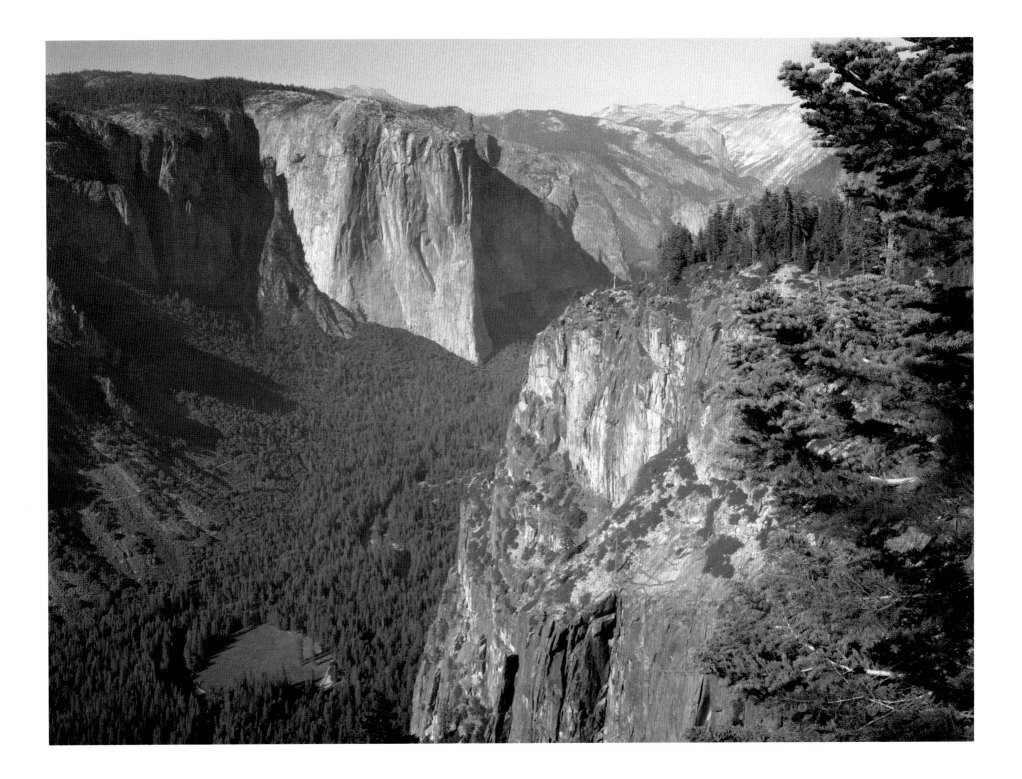

Mark Klett and Byron Wolfe, *View of the Yosemite Valley from the old Mariposa Trail,* 2003. 5

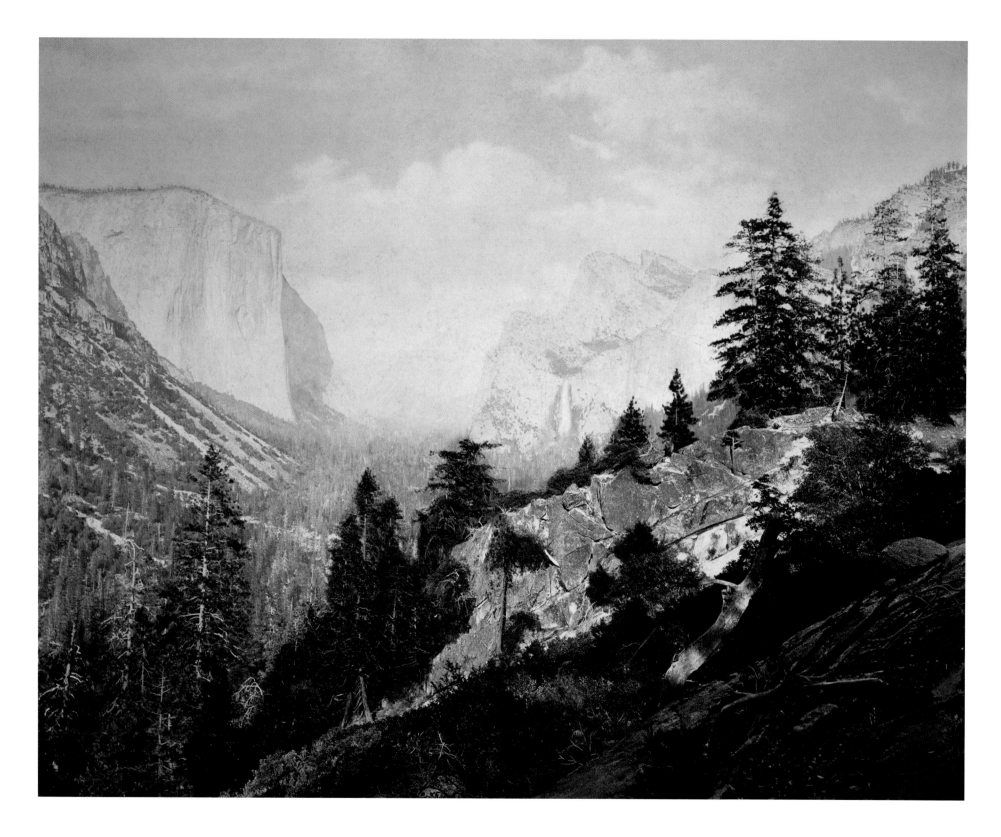

6 Eadweard Muybridge, *Valley of the Yosemite, from Moonlight Rock, No. 1*, 1872.

Mark Klett and Byron Wolfe, *Opening a view through the scrub oak at Moonlight Rock above the Wawona Tunnel parking lot,* 2001. 7

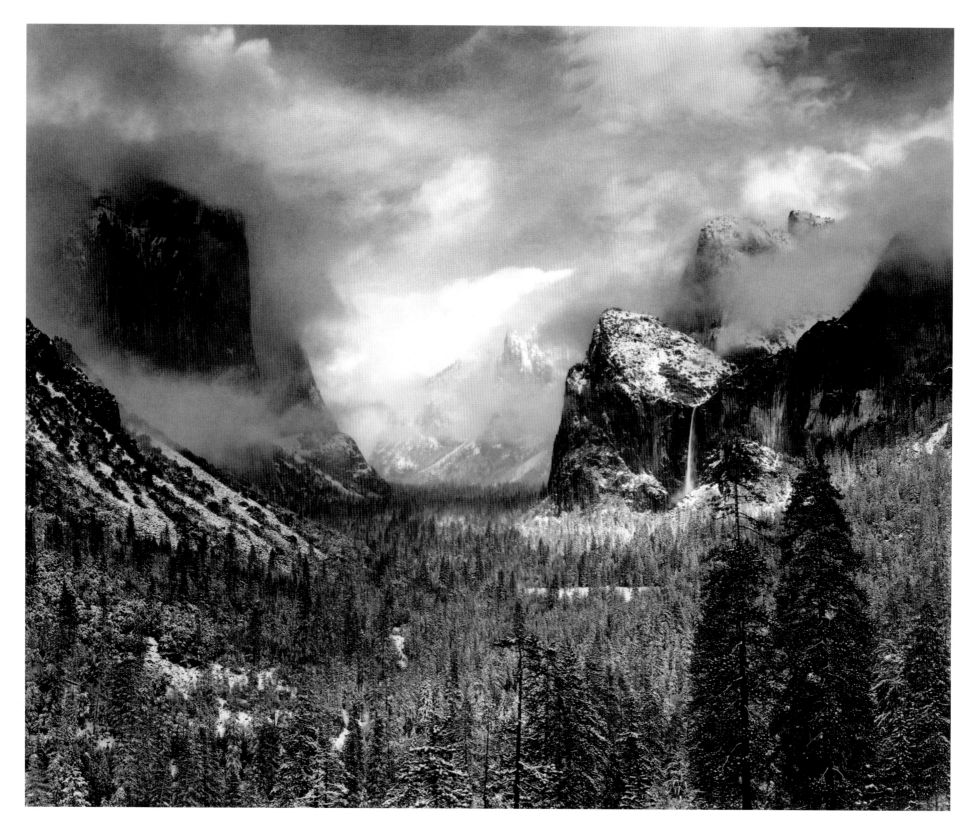

8 Ansel Adams, *Clearing Winter Storm, Yosemite National Park,* 1944.

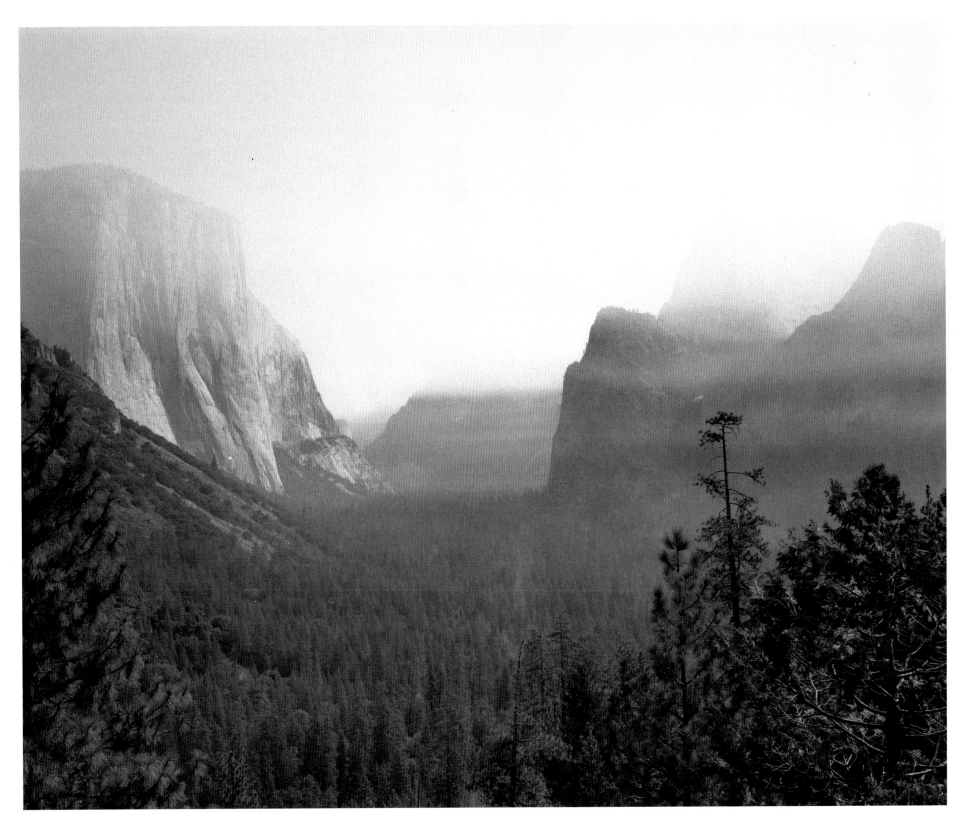

Mark Klett and Byron Wolfe, *Clearing autumn smoke, controlled burn,* 2002. 9

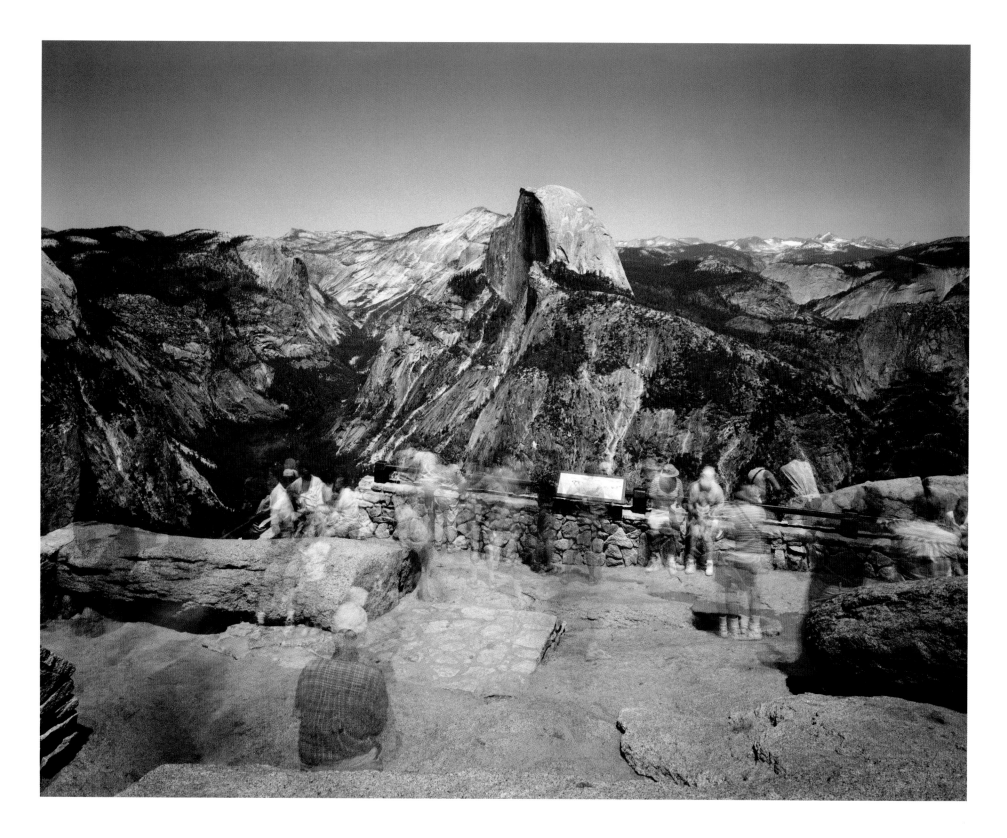

10 Mark Klett and Byron Wolfe, *Eight minutes at Glacier Point*, 2002.

GHOST RIVER

OR PHOTOGRAPHY IN YOSEMITE

*I once heard Martin Broken Leg, a Rosebud Sioux who is
an Episcopal priest, address an audience of Lutheran pastors
on the subject of bridging the Native American/white culture
gap. "Ghosts don't exist in some cultures," he said, adding
dismissively, "They think time exists." There was nervous
laughter; we knew he had us. Time is real to us in America,
time is money. Ghosts are nothing, and place is nothing.*

—Kathleen Norris, *Dakota: A Spiritual Geography*

LOOKING FOR 1872

Yosemite Valley is packed with superlative vertical spectacles—
tall cascades, immense granite walls, monoliths, and spires—but
quietly meandering all its seven-mile length, often shrouded in
trees, is the Merced River, not the widest or longest or most
anything, just the usual miracle of a river, transporting snow-
melt from high country streams through the valley and down
deep canyons to the San Joaquin River and eventually to the
sea. The river enchanted the photographer Eadweard Muy-
bridge, and water is the primary subject of more than half of
the fifty-one gargantuan prints in his 1872 series titled "The
Valley of the Yosemite, Sierra Nevada Mountains, and Mari-
posa Grove of Mammoth Trees." He photographed the great

granite behemoth of El Capitan, but made a second picture that showed not the 3,300-foot-tall wall of rock but its reflection in the still water of the Merced, where the shade from trees made the water dark and the reflection strong.

In August 2001, my collaborators Mark Klett and Byron Wolfe rephotographed the same site, but this time the reflection was in what had become a sunny stretch of river, and the result was a vague, washed-out, oddly composed picture (p. 66). They could have made something that looked much more like Muybridge's image by finding a different spot with a stronger reflection, but the point was to be in the same spot to see what had changed. The exacting art of rephotography

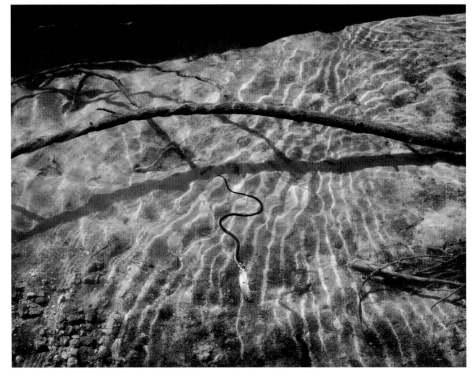

Byron Wolfe, *While looking for Muybridge: a snake devouring a fish at the edge of the Merced River,* 2001.

produces, among other things, random-looking photographs, since fidelity to place and fidelity to composition are different things: trees, light, water shift, and sometimes the former view is entirely obscured. To be in the same place and to be in the place where things look more or less the same are not the same thing.

Muybridge's picture of El Capitan's reflection is wonderful and terrifying. The absolute solidity of the granite formation has been supplanted by its own fluctuant, uncertain, fluid image. Muybridge would pursue chaos and instability all through Yosemite in 1872, which made him a complicated artist to rephotograph, even aside from the way he manipulated his images. Rephotography of documentary work has often been done, but how do you rephotograph something that's personal, emotionally invested, expressive, and even manipulated? And how do you photograph Yosemite? Muybridge was the door we entered by.

For most serious photographers for many decades, Ansel Adams seemed to have visually exhausted or visually sewn up the place. His pictures felt definitive, a visual last word on the subject. Artistically, time had stood still in Yosemite; nothing much had been achieved there since Adams. We would enter the future through the past, find out what was possible in Yosemite not by attempting to make it ours but to understand what it had been when our predecessors made it theirs. We would not approach Yosemite as wilderness, unmarked, without history, but let its marks and its history be our material. At this point, Yosemite is not a place one could enter to make a wholly original artwork in the conventional sense of originality: unprecedented, different, separate. There has often been a kind of cannibal ferocity in originality, a desire to erase one's parents or teachers, an attempt to shake off the past to reach

the future. Rephotography is instead a way to move forward through the past. Yosemite is so far from being a wilderness that its photographic history is now also its landscape, and this double terrain is what we would explore.

In the end, *Yosemite in Time* would not be about Muybridge alone, but he was our eccentric, adventuresome starting point. And a frustrated search for one of Muybridge's sites and its surprising conclusion was where our project began to find its purpose. One afternoon in early August 2001, Byron, Mark, and I were walking up and down a stretch of the Merced's south bank at the western end of the valley, looking for the spot from which, 129 years before, Muybridge had photographed the triple-peaked rock formation popularly known as Three Brothers (p. 70). In Muybridge's picture, a bend of the river fills the foreground, and reflected in that still water are trees on either bank and the base of the formations. Muybridge titled his photograph of those peaks the "Pompoms (Jumping Frogs)." He always preferred the names given by the valley's original inhabitants and used them whenever possible. Like many other photographs in his 1872 Yosemite series, this one was titled to suggest that its subject is the landmark in the background, not the river that actually dominates the picture.

On that first week of the three-year project, we marched downstream along the eroded bank with its snags, past a Japanese family—a man, two women, and a little girl in pink and pigtails, then some plump Americans, then a couple on a fallen tree who looked romantic from behind, though the many plastic packages of processed food lying at their feet dispelled some of that aura. Back and forth we charged. No point on the riverbank seemed to be the right one from which to rephotograph Muybridge's "Pompoms." His images

were made in the summer and fall of 1872, only twenty-one years after white people had first entered the valley, but the celebration and commercialization of its sublimities and spectacles were already well under way. Yosemite's tourist infrastructure then included a resident photographer, competing hotels, souvenir sellers, and guides.

In 1872, Muybridge was using a mammoth plate camera, a camera that made twenty-by-twenty-four-inch negatives on glass plates, though he also made stereo photographs, designed to be seen through the popular handheld device that gave the images the illusion of three dimensions. He traveled with a retinue of assistants and a mule train for his extensive gear. These assistants and men who may be mule-handlers often showed up in the mammoth plate prints as figures so tiny that they vanish in scaled-down reproductions. Other photographers had been at work in Yosemite. California cameramen Charles Leander Weed and Carleton Watkins had made mammoth plate photographs there years earlier, and Watkins would return later that year. J. J. Reilly, a stereophotographer with a passion for clouds, had also taken up seasonal residence in the valley. So Muybridge worked hard at doing what had not been done before, and in his compositions and his locations he was utterly original and often daring.

We were working hard at doing what he had done before by trying to rephotograph his images, though following is always done in a different spirit than leading. And this time, following him proved frustrating. Downstream an avalanche chute clearly in the picture vanished, and the other features were not in the right alignment. Upstream, where a group of women lounged on a sandy bank and two more were communing in water up to their chests, Mark took out his tripod, but we were still not in the right place. Mark and Byron

argued learnedly about how to relocate to make this feature in the rock wall rise, that feature fall, so that things would assume the positions they had in the original photograph.

I often laid the groundwork for finding a location, since I knew Yosemite's features and topography better and was fonder of research than they were, but I was not a fluent reader of this evidence in the actual landscape. I came along because our ideas arose out of the places as well as the photographs and the conversation along the way. Mark and Byron were able to find the locations where the various features of a landscape lined up precisely as they did in the photograph and to read from the shadows both what time of day and what time of year it had been made. Once they had the approximate location and we had waited until or returned for the right time of day, Mark would make a black-and-white Polaroid negative/positive photograph of the place. Byron would then visually compare and measure, with ruler and calculator, the Polaroid's proportions against the copy of the original photograph; they would keep relocating—usually a few feet or yards at a time—until they were there. Only then would the rephotograph be made.

The afternoon we were pursuing the "Pompoms," I sat down to wait while they worked, and after a while I turned around and saw an apparition: not only could we see the subject of the Muybridge photograph we'd sought when we faced southeast, but to the northwest was the subject of another, Cathedral Rocks (p. 76). It was as though some strange slippage between reality and representation had taken place. We were in one place in the present; we were in two photographs of two places in the past at once. The place in which we stood was turning into pictures, the pictures we had seen were leaping out as places.

Yosemite must be one of the most photographed landscapes on earth. Weed arrived in 1859, eight years after the U.S. Army barged in to attack the indigenous inhabitants, and Watkins came two years later and photographed the place extensively, repeatedly, obsessively, into the late 1870s. When he opened a gallery, it was called the Yosemite Gallery, and when he exhibited his work in European fairs, he showed images of Yosemite. Landscape photography had hardly begun when this place became its American apotheosis. Muybridge had been there in 1867, at the start of his photographic career, and his 1872 work would be his most ambitious series until five years later, when he launched his motion studies, the sequences of high-speed photographs that laid the foundation for motion pictures.

(His interest in motion appears in Yosemite as a fascination with moving water, and the slow exposures photographic technology then required turned the rushing water into a strange, filmy, opaque white substance. The ghostly water is an accurate recording not of water as such but of the accumulation of its movements over a period of time. In one wonderful image taken in the high country (p. 38), a cascade of water rushes into a pool, and the rushing water is white, while the pool is almost black.)

What is remarkable about this sort of image saturation in the 1860s and 1870s is that it makes Yosemite Valley into what postmodern theorist Jean Baudrillard would describe as "a precession of simulacra": a phenomenon known by its images and representations more than (or rather than) firsthand experience. Yosemite was and is celebrated as wilderness, but photographs of it were being sold in New York in the 1860s when only a few hundred visitors a year saw the place itself. On the one hand, the four thousand years or so of indigenous pres-

ence meant that Yosemite long ago ceased to be wilderness in the ways that white Americans would often envision it: the region was not virginal, untouched, or a place apart. On the other hand, the Euro-Americans who showed up saw it through their own culture's artifacts and aesthetics—and the place matched up to the landscape aesthetics imported from Europe superlatively. Millions would know Yosemite only as images, millions more would arrive in it looking for a reality that matched the images. It was a realm of aesthetic glories but even more of codifications. We ourselves learned much about the place through the photographs that were our destinations and often had the experience of using a photograph as a guide to find the pictured place, then turning that place into new pictures.

And of course Yosemite is most tied to a photographer born in 1902, not long before Muybridge and Watkins died—Ansel Adams, whose career is defined by his Yosemite pictures that in turn define the place for many people. Among the many commercial establishments in the valley is the Ansel Adams Gallery, selling books, prints, cards, and jewelry. Adams himself first arrived in Yosemite as an adolescent, after reading an illustrated book (by Yosemite pioneer James Hutchings) that whetted his appetite for the place. Upon his arrival, his parents gave him his first camera. Adams did something peculiar to Yosemite: he made pictures that did not resemble what viewers were likely to see—the topography might be there, but the drama of black skies (from using red filters), high contrast, perfectly sharp vision throughout, foregroundless revelation, and a total lack of human traces might not. Although Yosemite is often hazy, he liked to photograph after storms, when the air was preternaturally clear, the world washed clean. Rephotographing Adams, we found his images had

sometimes been taken surprisingly close to the road but facing away from the development, cropped to make the place look pristine. Adams's friend and California compatriot Edward Weston made a few photographically productive visits to the place around 1937, further demonstrating that this place that had so suited Victorian aesthetics was equally available to modernism's very different desires.

Ever since photography became readily available to amateurs, tourists have made their own pictures in Yosemite, and nowadays the standard ritual of seeing a place, including this place, involves an approach, a flourishing of the camera, a picture—usually with friends or family in the foreground—and, soon afterward, departure. Visitors seldom sit still in these places; it is as though the stillness entered not the viewer but the picture they had captured. We, however, would sit still a lot, or I would, while Mark and Byron worked. Rephotography is a slow, painstaking art. Even when you find the right location quickly, it can require hours of calculations and adjustments of location or returning another day or another season to be in the right place when the light matches that of the original photograph. The moment of the photograph—a fraction of a second nowadays, a few seconds or minutes in Muybridge's time—should be framed within the hours or days of looking around it took to arrive, the years of honing a vision and practice, so that the question of how long it takes to make a photograph has nothing to do with how long the film was exposed.

After all our fruitless pacing of the bank of the Merced, we arrived at Muybridge's location when a visitor on our project, the photographer Geoff Fricker, who has a passion for rivers, pointed out that riverbed change can be radical and that the banks of 1872 were not necessarily where those of 2001 were.

We backed up and backed up, strolling through swathes of grass growing up through sand, and finally found the banks of Muybridge's river, a hundred feet south of where the water now flowed (pp. 72–73). A breeze blew up the silver underside of the willows and alders. We were in the right spot, standing on the banks of the 1872 river a century and a third later, when it was a river no more. In the right spot and early for the rephotograph, we sat down for lunch and began to talk about time.

Swimming Upstream in the Rivers of Time

To say that time was the common interest that brought us to Yosemite is to say everything and nothing. Maybe the first thing to say about time is that it's a catch-all term for a wild variety of phenomena and ideas, including pace, duration, sequence, spirituality, causality, and celestial measurement, all of which might be sorted and understood differently in another culture. Linguist Benjamin Whorf wrote half a century ago of the conceptual differences embedded in different languages and cultures: "I find it gratuitous to assume that a Hopi who knows only the Hopi language and the cultural ideas of his own society has the same notions, often supposed to be intuitions, of time and space that we have, and that are generally assumed to be universal. In particular, he has no general notion or intuition of time as a smooth flowing continuum in which everything in the universe proceeds at an equal rate, out of future, through a present, into a past." In Hopi, time is not a river.

Euro-Americans, abetted by the industrial age's coordinated clocks, calendars, schedules, hourly wages, whistles, bells, and deadlines, usually believe time *is* a river in which everything moves forward at the same speed: time is the current carrying all things along with it. You can't step in the same river twice, the ancient Greek philosopher Heraclitus famously said, but that conundrum about a stable form with ever-changing contents could be elaborated. On the banks of a real river like the Merced, one finds that the metaphor becomes beautifully complicated. Mark likes to point out that the sides of a river don't move as swiftly as its center, and then there are eddies, backwaters, floods, snags, whirlpools, droughts, ice thick enough to walk on, frozen waterfalls that climbers ascend with crampons and an ice axe in either hand. How much like a river is time? Can you row upstream? Can rephotography? Can you be caught in an eddy like a repetition compulsion? Does time have backwaters, where things change most slowly, and rapids? Even the fact that we talk about time standing still or traveling backward in time pictures time as a phenomenon you ordinarily move forward through. Like a river.

Muybridge's river was not ours. In Yosemite that August afternoon of 2001, we were sitting on the banks of what was no longer a river. Heraclitus implies that the water's flow means the river is forever changing, but he says nothing about the riverbed shifting. Yosemite would give us metaphors for time over and over, then undermine them. A metaphor is always a partial description not to be taken literally, for the metaphorical is the opposite of the literal; this is like that in some significant way, but it is not the same as that. The natural world is where metaphors come from. But when you plunge into that world, rivers, trees, clouds, water are also immediate sensual experiences, not metaphors at all, but the vivid source from which arise the metaphors that enrich and aid the abstraction of language. Time is a river in Euro-American imagination, but a much simpler one than the river whose former banks we sat on that August day in 2001.

Byron and Mark were fond of theories in which time was not a flow, but a series of discrete moments, a version of time suitable for photographers. Mark particularly liked physicist Julian Barbour's suggestion that time was, as the philosophical writer Jorge Luis Borges before him had put it, a garden of forking paths: that out of every event emerge multiple paths or outcomes. In this sense, time was not a single river but something always branching into every possible outcome; time was a tree growing at infinite speed to produce infinite branches, so that there were many pasts and more presents and this very moment is begetting many futures. Borges spoke of "a growing, dizzying web of divergent, convergent, and parallel times. . . . In most of those times, we do not exist; in some, you exist but I do not; in others, I do and you do not; in others still, we both do." After all, my collaborators added, photography does not record continuums, but moments; it is not the camera but our imaginations that construct narratives out of these moments.

Rephotography is concerned with two moments in time, but their relationship is not always as simple as a single pairing of original and rephotograph might suggest. Rephotography was developed as a technique by scientists, particularly geologists, to study changes in a landscape. The past and present images of the same place reveal what has happened in the years between, and if the location is exact, the changes—erosion, accretion, a glacier moving or melting, a forest encroaching—can begin to be measured with some precision. In 1977, Mark, who trained and worked as a geologist before turning to photography, teamed up with Ellen Manchester and JoAnn Verburg to launch the Rephotographic Survey Project, which culminated in the 1984 book *Second View*. They used the techniques that had allowed scientists to study change in a landscape, though the images they rephotographed were not anonymous documents but the work of stylistically distinctive individuals: Timothy O'Sullivan, William Henry Jackson, and others of the great geological surveys of a century before, who had explored the deserts, canyons, and mountains of the arid American West.

The technique of rephotography also reveals a lot about the initial photographer's sensibility, interpretations, and decisions. When you return to the site of a photograph, you return to the site of creative decisions about what to include and exclude, you discover how far the artist went up a difficult slope, where a series of photographs were made in relation to each other, even what time of day and year they were made. You can compile this information to map the movements of someone a century and more ago. One famous *Second View* rephotograph revealed that O'Sullivan tilted his camera to make a geological formation look more dramatic. Rephotography is a significant research technique, unearthing information about the nature of place, the passage of time, and the decisions of artists available through no other means. It allows change to be revealed in its particulars, which often contradict the generalizations.

In rephotographing the work of these past figures, most particularly Timothy O'Sullivan, Mark made them into mentors who influenced his own work. Sometimes he spoke as though these nineteenth-century adventurers were contemporaries—colleagues whose idiosyncrasies and techniques he knew as even photohistorians did not. In 1990, Mark rephotographed Muybridge's seventeen-foot-long 360-degree 1878 panorama of San Francisco. Muybridge's panorama is a monumental achievement, and a strange one. Most panoramas then and now show 180 degrees or so, more or less what you your-

self can see from a single vantage point. In making a 360-degree view, Muybridge made available a superhuman vision in which you could see in all directions at once, but in which space was strangely represented. Streets running east in one section reappear running west in others. The whole city is there, splayed out in all directions. The 1878 panorama is also peculiar because of the way time is folded or unfolded in its thirteen photographs. The panorama looks at first glance like a single masterful gaze that spun around and saw everything at once. But the thirteen separate images were made over the course of several hours, as the light and shadows changed. Thus what looks simultaneous is actually several moments over the course of a day, spliced together like pieces of a film to make a continuity out of disparate moments. And one panel was taken at a distinctly different time from those flanking it. The buildings mesh perfectly from one edge to another, but the shadows clash dramatically. Mark became fascinated by that detail of Muybridge's panorama, and it started him thinking about the representation of time, particularly the ways multiple moments in time could be brought together into a seamless space. After this work with Muybridge, Mark would explore further the ways panoramas are laboratories and expositions of time. (In one project, he photographed the nation's capital from the same point repeatedly and spliced the results together so that the era of the first George Bush shifted into Bill Clinton's first inauguration.) But only in our project, in *Yosemite in Time,* would rephotography and panorama-making fully merge as methods of exploring time.

Sometime ago I had written, "Landscape's most crucial condition is considered to be space, but its deepest theme is time." This is where all our interests dovetailed and where rephotography became an instrument to explore more than befores and afters.

A rephotograph requires not only getting the camera to the precise (that is, from within a few feet to a few inches) location of one's predecessor and approximating the same lens width, but as Mark and company have done it, getting the time of day and time of year right. To line up time of day and year is also to line up place. If the time of day is the same, the earth is in the same place in its twenty-four-hour rotation. If it's the same time of year, then the earth is in the same place in its orbit around the sun. Or as close as possible, because as earth, sun, and galaxy all stream across the cosmos, nothing is ever in exactly the same place. Time in this model, Mark likes to say, is neither circular nor linear, but a spiral, and change is the measure of time.

Rephotography as Mark and his *Second View* collaborators redefined it as artistic practice could have been situated as a spectacularly postmodern exercise. But that era's New York theorists were impervious to the conceptual ramifications of something made in places so far removed from the urban and indoor arenas of most postmodern making and thinking. One of the key texts cited by postmodernist theorists is Borges's short fiction "Pierre Menard, Author of the Quixote." It's a tale about a man who prepares himself through elaborate and obscure means to write *Don Quixote*, not a commentary or revision, but exactly the same book, and succeeds in doing so. Borges comments ironically on how Menard's new version is emotionally richer than the original, on the idea that meaning comes from context. If Pierre Menard had been a rephotographer, he would have been thwarted by the impossibility of repeating a photograph, which is situated exactly in time and

place as writing and painting are not. You cannot step into the same photographic river twice.

In the 1980s, postmodernist art star Sherry Levine solved this by reproducing iconic photographs by Walker Evans and Edward Weston without any alteration but for the meaning of her act of appropriation—they were exhibited as her work. Such appropriation was meant to challenge ideas of originality and emphasize how much context shapes meaning. Rephotography turned its back on originality and investigated context, but its goals were different. With "Pierre Menard, Author of the Muybridge Mammoth Plates," what might count is the journey without its arrivals: the photographer seeks to stand in exactly the place Muybridge did, the place that confirms you can't go home again, that every instant of every day, home as it was ceases to exist and becomes somewhere else, that you can't make the same photograph twice, though you can return to some version of the same river.

Yosemite is postmodern, is simulacral, in another way: the restoration of the landscape has relied on old photographs to say what shape the river was, what grew in the meadows, where the trees were. This means that in restoring Yosemite to what they hope was its natural past, the National Park Service ecologists are altering the place to resemble its own nineteenth-century photographic image. The place is turning into its portrait, or into someone else's portrait, as though you were made up to resemble your great-grandmother. But here, the belief is that the great-grandmother is not only truer but more valuable, more natural. So human labor reconstructs the Yosemite landscape to become a version of nature that is based on photography, which raises interesting questions. The only past we have, in many cases, is photographic: when we go backward we go into pictures. This is one of the ways in which photography doesn't just record time, but shapes it.

Sometimes Yosemite seemed to be made out of photography to me: I pictured those waterfalls flowing with photochemicals, pictured an infinity of phantasmagorical rectangular frames hanging in midair around every hallowed view, wondered how many photographs were taken there each day, wondered what it meant that the place was shedding its image so constantly for cameras from around the world to take home. Byron considered developing a "photodensity map" to show where the most photographs were taken in the park, one of the many forking paths we did not take in the course of this project. (Another effect of the *Second View* project had been to make Byron decide to take up photography and to study with Mark, a crucial turn on the path that would bring the three of us together for this book.)

Rephotography did what postmodernism did, and did it early on. It developed a practice that dispenses with the anxious pursuit of originality in favor of a playful but problematic relationship to the past and the ancestors. While the *Second View* project was under way, Mark and Ellen Manchester took some of the work to Ansel Adams, ensconced in his home in Carmel with a huge bottle of bourbon to dole out to the pilgrims coming by. Of their rephotographic work, he pronounced, "It's interesting, but it's not art." Ellen bristled and opened her mouth to argue. Mark kicked her under the table. And as Virginia Adams showed them out she said with fond wifely disrespect, "Don't pay any attention to what Ansel says. He's set in his ways." In saying it wasn't art, Adams confirmed not what it was but what he was. He came of age in an era

when photography was at best art's illegitimate stepchild, and he was one of the modernists who had pushed photography uphill to the high plateau called art. Subsequent generations were less worried about where their work might be located, however much they benefited from his staking out that territory. In the nineteenth century, photographers had cared less about whether or not they were artists or their medium could produce art, though Muybridge called himself and always was clearly an artist for whom recognition, originality, and self-expression were important, even in his commissioned work.

At the turn of the twenty-first century, Mark had returned to the sites of *Second View* with a new team of collaborators, including Byron, and used new technologies to produce *Third View,* extending the documentation beyond photography and the sequences beyond simple before-and-after. They set up the project so that subsequent photographers can return to the sites, and in another few decades there can be a fourth view, then a fifth, and so on. It was a fine transformation of the simple then-and-now versions of time rephotography has often presented.

With *Yosemite in Time*, the possibilities became wilder in another way. Much of the history of photography, or at least landscape photography, was encapsulated in Yosemite, so that to rephotograph in Yosemite was to engage not just with geography, ecology, and history, but also with art history. We found Adams, Weston, Muybridge, and Watkins haunting the places at which we arrived. Their recurrent presence in the landscape meant that there were already many photographic versions and many moments of a given scene's past. We eventually realized that we would be doing third views and sometimes fourth views—as in the case of Cathedral Rocks, which had been photographed from similar vantage points by

Watkins in 1861, Muybridge in 1872, and Adams in 1944. Had we dived into the archives to find images from more moments of the past by more photographers, thirty-eighth or seventy-seventh views could have been possible, while even to think about the numbers of views taken by tourists from certain vista points of certain subjects is dizzying. Photography has a concentrated presence in Yosemite.

Rephotography there was complicated in other ways. With his moodiness and his manipulation, Muybridge undermined the sense of a straightforward original to which a straightforward response was adequate. His manipulations included adding clouds to the whited-out skies. The wet-plate photography of the era used glass-plate negatives freshly coated in the field (the wet plates). Because the medium was hypersensitive to blue, it routinely created overexposed skies, and so some photographers added clouds. Photographers often kept a supply of cloud negatives on hand; there's a group of Watkins photographs of Yosemite, presumably printed by someone else, with the same set of clouds in place after place. Muybridge seems to have considered added clouds a deluxe feature. We worked with the holdings in the Bancroft Library, University of California at Berkeley, of his Yosemite mammoth plate photographs, but in the collections of the George Eastman House in Rochester, New York, many of the images that are cloudless in the Bancroft collection have magnificently cloudy skies. Muybridge also added a rock to the shallows of a Lake Tenaya image, presumably to cover up damage to the negative. He took a whole mountain out of the background of Helmet Dome and Little Grizzly Fall (p. 38). Rephotographing modernists who also had a highly personal aesthetic vision posed some of the same questions: how do you rephotograph an image taken with a colored filter or

extensively reworked in the darkroom? All photographs are documents in some sense, but these were documents of tastes and choices as much as they were documents of places.

What we didn't find was also significant. Most photographers wishing to examine Yosemite's social and ecological spaces would probably photograph the places where change—impact, infrastructure, development—had taken place. But in the particular views we were working with, little of the development of the place was visible, at least not as built additions. The most common and obvious mark of human impact we found was forest encroaching on open areas as a result of a century or more of fire suppression. Trees had sprung up in many, many sites in and around Yosemite from this lack of burning. These new forests meant that nineteenth-century points of view often literally did not exist, or that from their vantage point we could only see a few fragments through the trees blocking what had once been a spectacular vista (pp. 64–65). What might be true literally also seemed metaphorical: we obscured their views, and nowadays most of us choose other locations from which to look.

We like to decry our own accelerating destruction of the landscape, and consequently one might expect rephotography to consist largely of splendidly pristine befores and ravaged afters, but rephotography produces more ambivalent results. The sites are at least partially selected for you, so your own biases, your own narrative about the effects of time, are partially undermined. A place may have changed very little or look more vital or be almost unrecognizable. Or the place may have been developed, but that's not such an inevitability as one might think, and the developed sites might not be in the original photographs. Though Yosemite is far more built up in our time than in Muybridge's, some of the buildings there in his time have vanished, leaving behind seemingly pristine sites. Time might be a river, but not everything in it moves predictably or in the same direction.

At the end of our first expedition, as we completed rephotographing Muybridge's first image in his 1872 series, "Yosemite Valley from Moonlight Rock," we realized that some of Ansel Adams's most iconic images had been made nearby, looking at similar things (p. 8). On that expedition we decided that Adams was no longer the Great Oedipal Father of landscape photography, against whom a generation of photographers had reacted in the 1970s and 1980s. Mostly they had reacted by showing what he had left out: sometimes sardonically—the tourists, ironies, infrastructures, banalities of a place like Yosemite; sometimes passionately—the destruction of development, military incursion, chemical contamination, dams. Either way it was an uglier world, if one more true to the time.

But in that era there were also photographers undoing the dichotomy in Adams's work, the one in which nature's purity was nothing more or less than a mark of its separation from the human. These counterimages were sometimes lyrical, spiritual, playful, gentle; in them, some humans and their traces might belong in the natural landscape. In them, not every contact was a violation, and nature and culture were not a dichotomy.

But we realized that Adams had become a grandfather: his shadow no longer reached us, the era of reacting against him and against modernism was itself history, which might be why we could reenter Yosemite and approach Adams without opposition.

The future was wide open, and we had chosen to try to travel there through the past.

As it turned out, we spent two days at the place that in 1872 had been the riverbank Muybridge photographed from. At the end of lunch and our heated conversation about the nature of time and the relocation of the river, Mark abruptly turned to me and said, "ghost river." I held up the paper on which I had just written Ghost River, and the term became the working title for the project.

A collaboration is a boat steered by more than one party, so you don't know exactly where you're heading, or more profoundly it's a boat floating down a shared conversation so that it is, of its essence, improvisational. Early in the project, someone sent me an e-mail quoting the Reverend Mas Kodani, of the Senshin Buddhist Temple in Los Angeles, saying, "One does not stand still looking for a path. One walks; and as one walks, a path comes into being."

At the ghost of Muybridge's river, our path began to come into being. There Mark and Byron realized that Muybridge's images of El Capitan reflected in the Merced and of Three Brothers had been made only a few yards away from each other, though with the camera pointed downriver for the former, upriver for the latter. Mark decided to fill in the space between with a panorama that would connect the two sites, and so we settled in. Panoramas would become a means to measure the time and space between photographs in those many places where the photographic density meant that Adams and Weston and Watkins and Muybridge were crossing paths and overlapping, each in his own time, all in the same place.

My own interest in time has been focused on speed and slowness. I wrote a book about walking that was about the uses of the slow, the meandering, the apparently useless, the unquantifiable, about the sidelong ways ideas take shape, the gradual accumulations of knowledge of place and self, and about what was left behind in an accelerated, disembodied world. I'm interested in the intangibles and subtleties that appear slowly, that can't be controlled, and that don't appear on demand. Certain qualities of experience, of recognition, of consciousness seem to appear only gradually—or appear like a bolt of lightning, but only if you have found the place that will be struck and have settled there. The history of walking led me to Muybridge, because he was tied to the nineteenth-century industrialization of time and space: first by his involvement with that radical new technology for capturing shadows and moments, photography; then with his experiments in accelerating photography to capture and reconstitute the motion of bodies running, leaping, splashing, a project sponsored by Leland Stanford, who, as one of the builders of the transcontinental railroad that sped up travel time across the continent, had transformed the experience of space and time profoundly. With that project Muybridge and Stanford laid the foundation of cinema. And Muybridge, in his photographs of the Indian wars, of glacial traces, of water, of ruins, with his penchant for sequences, series, and panoramas, was always playing with what time looked like in photography, with what photography could make of time.

So I sat on the banks of a river that was no longer there, watched Mark and Byron work, watched the view, mused, and read the University of California science professor Joseph LeConte's account of his first visit to Yosemite. On July 31, 1870, LeConte got up "at peep of day" and went to Glacier Point on the south rim of Yosemite Valley to watch the sunrise. He and his students from the young university had left the Bay Area ten days before and traveled by horseback,

camping along the way. Though railroad service most of the way there had recently opened, they chose to ignore it. LeConte watched the sunrise as his companions joined him. In his book, he recounts that "after about one and a half hours' rapturous gaze, we returned to camp and breakfasted. . . . After breakfast we returned to Glacier Point, and spent the whole of the beautiful Sunday morning in the presence of grand mountains, yawning chasms and magnificent falls." For the Victorians, seeing was an act that often took hours, and they had radically different thresholds of boredom and impatience.

A year later Byron, Mark, and I would go to Glacier Point to photograph and spend several hours unsuccessfully looking for a site below the rim from which Muybridge photographed the spectacular view. (Because of his quest for new and dramatic views, Muybridge had a penchant for precarious and difficult vantage points; Mark had a penchant for muttering "crazy bastard" as we followed Muybridge through thickets of manzanita or slid down duff to a narrow ledge above a thousand-foot precipice.) We came back to look for the Glacier Point site again, and this time I stayed above the rim, watching tourists arrive to glance at the view, take a photograph, and leave. Out of this came my desire to represent how long people looked at something, which Mark and Byron satisfied with an extended intermittent exposure photograph in which the longer people loitered the more opaque they became. Most of the visitors thus captured were nothing but insubstantial phantasms and ghosts (p. 10).

And just as these tourists barely registered on the film, so I suspect places seen quickly barely register on mind and memory. At a rephotographic site, we would sit for long hours, and afterward the places stuck with me. Perhaps our language needs distinct words for looking and seeing. Looking might be the business of glancing at things long enough to take them in as information; seeing the art of soaking them up, of letting them sink in, of feeling them. For what I found during our slow photographic sessions is that afterward each place had imprinted on me—it wasn't that I could recall the place with some sort of photographic accuracy, but that it had become part of me, that when I thought of it there was a definite feeling, not an image but a sense of place. Imprinted: one could think of the mind as akin to photographic paper, it takes time, it takes a long exposure, generally, for something to make an impression, which suggests that we who hurry go around blank, unimpressed.

Painters, photographers, anglers, and birdwatchers, among others, seem to have developed their pursuits in part as sidelong strategies to do nothing, to be in a place long enough to see it. If there's one place where others stand still in Yosemite Valley, it's in the meadows near El Capitan, where they look like believers witnessing their gods as they gaze upward, faces unselfconsciously full of awe or horror, at the climbers tiny on the 3,300-foot-high rockface whose summit most will take days to reach. And climbers have their own slow, careful pace, as they advance one move at a time, body pressed to the vertical surface of the earth, the abyss behind and below them, danger enhancing their concentration on the here and now.

Factory workers used to protest or strike with a work slowdown, a refusal to keep up with the management's demands. As the world comes to resemble a factory more and more, every act of lingering, of deep engagement, of doing nothing, of neither producing nor consuming according to any marketable rate, is a metaphysical work strike for higher pay from the surrounding world. It's a strike that earns its pay, since slowness is the labor of attention. A good consumer has

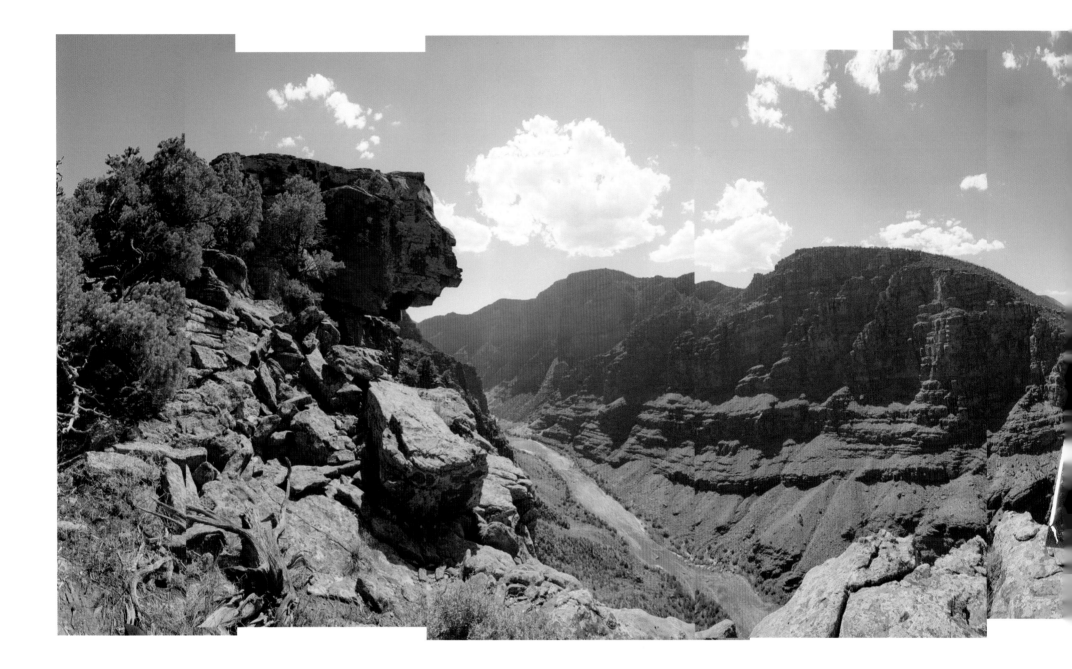

24 Byron Wolfe and Mark Klett, *Panorama from Timothy O'Sullivan's 1872* Canyons of Lodore,
 Dinosaur National Monument, Colorado, 2000.

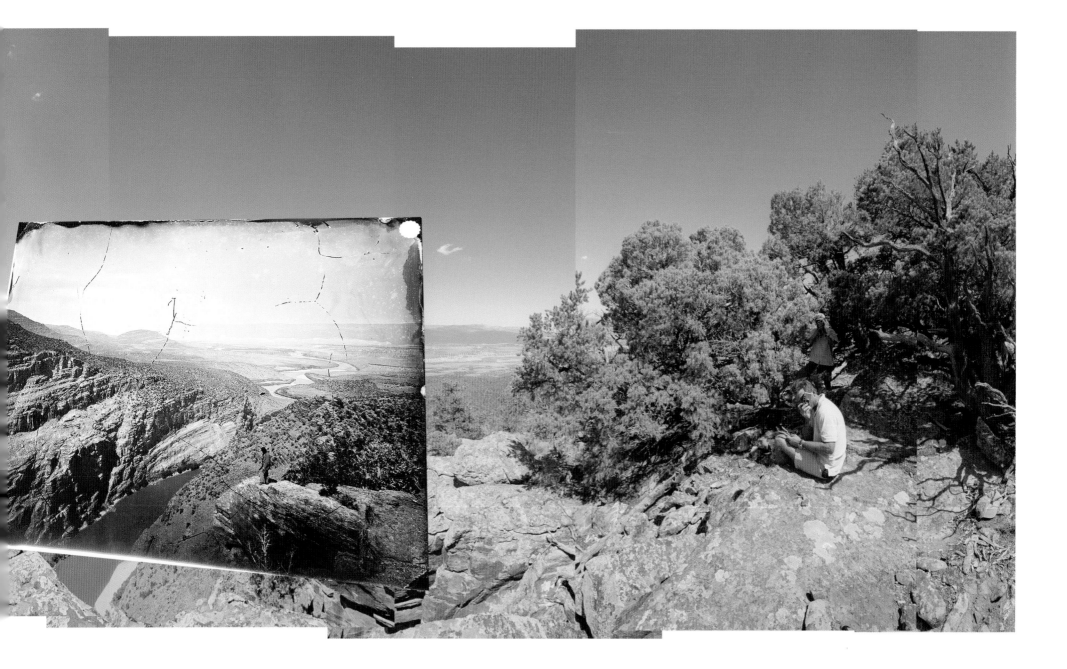

a short attention span, forever requiring the next thing, and touristic Yosemite often seems to encourage this hecticness, with the marked vista points easily accessible, easily photographed, easily left for the next experience. In recent years, more and more visitors have begun to make day trips rather than overnight trips to the place.

But slowness is the discipline of pleasure. Perhaps the most important reason to work as an artist is the attention demanded: the careful study of a subject yields up epiphanies and reveals patterns that are rewards and source material. The artwork seeks to provide some of the same concentration and revelation to readers and onlookers, but only if they give it their attention, their time. A central function of art is to slow people down, to call their attention to the subtleties, complexities, or riches of what they might otherwise not notice. A central discomfort with visual art is that, unlike film and television and even reading, it doesn't unfold over time; you have to decide what time to give it, when the act of looking is complete.

On that first *Yosemite in Time* expedition, we spent two days on the banks of what was no longer a river, and though we could hear the road, though we were near heavily trafficked parts of the park, no one visited us, and we saw no one there in all that time. Perhaps in 1872, there had been traffic on the banks of the river, but there was none on the banks of its ghost. This was another of the charms of rephotography: it steered us to locations that had been abandoned, and we discovered ruins, dumps, communications infrastructure, and unpeopled tranquil spots. Sometimes the overgrowth of trees had made a scenic viewpoint just another part of a thicket; sometimes a trail had been rerouted—for example, the lumpy spire called Agassiz Rock, also known as the Ninepin, was

often photographed in the nineteenth century but hardly seen, mentioned, or photographed in the several decades since the Four-Mile Trail had been rerouted away from it. Most visitors stick to the roads and trails (which is a good thing for the flora, fauna, and erosion prevention), so if you strayed only a few dozen yards or so, you could find an entirely unfrequented place in this valley that receives four million visitors a year.

So there we were on the Ghost River, where Mark and Byron constructed a panorama that filled in the space between Muybridge's two photographs made from this stretch of its banks (pp. 66 and 70). When the picture was assembled, I was jolted. The piece looked a little like a fan: the two horizontal endpieces were connected by a series of narrower images that seemed to fold and compress the space, a little like cubism. I was in one panel, in a dress, on Tuesday, looking at myself in shorts on Wednesday looking at LeConte's book from 1870 as we looked for Muybridge walking from one tripod point to another in 1872. If time was space, it seemed possible to fold it, so that times came closer to one another, so that you could see Wednesday from Tuesday and 1872 from 2001. This panorama had many moments, two days, two summers thirteen decades apart, in one semicontinuous space.

Everyone is used to being photographed nowadays, to having their own image appear in endless snapshots (and surveillance footage), but to find my own image looking away like a figure in a painting by the German romantic Caspar David Friedrich within something so philosophically complex was different from showing up in a snapshot. I had the sense people must have had when photography was still new and unsettling: that a part of me, a ghost of me, had come to a halt

forever in an image, in the stopped time that is photography's moment. Photography had always conquered time by preserving a moment of the past for the future, but this panorama conquered it another way, by bringing many scattered moments into one visible present. The rephotographic end panels could be swapped out with their originals, so that the distance between Muybridge's two vantage points in 1872 could be in the present. Time was arcing like a spark between two live wires.

As it turned out, there were many places where two or more photographers had worked in close proximity, though at different times. We first found this at the very gates of Yosemite on that first expedition, when Mark realized that Muybridge's view from Moonlight Rock was perhaps a hundred yards upslope from Adams's famous "Clearing Winter Storm" (pp. 6 and 8). These crossed paths became densest and most entangled around and above Lake Tenaya, the beautiful little blue body of water halfway between Yosemite valley and Tuolumne Meadows. There a juniper tree Weston had photographed in 1937 was perhaps a hundred yards from the glacial polish Muybridge photographed in 1872 (pp. 125–26). (Weston, serendipitously, was there exactly sixty-five years after Muybridge, sixty-five more before us, a perfect halfway mark suggesting we were as far from high modernism as was Muybridge.) Mark and Byron made another panorama exploring the space between the two sites, and by this time they had learned to bend and fold space like Cubists in order to condense the distance between Weston's tree and Muybridge's rocks.

At Lake Tenaya itself, the most spectacular panorama arose from their recognition that Adams, Weston, and Muybridge had all photographed from the same cove, the latter two, astoundingly, within two feet of each other. Mark and Byron made a panorama that incorporated the three earlier images, so that the four times seemed to exist simultaneously. In a Muybridge panorama several moments of a day seem to exist as one superhuman glance; in this one, 130 years are present and visible at once, and the photographers across those years condense the history of photography into one gargantuan glance. Time was a fan to fold, an accordion to squeeze, a collapsible ladder, a hand of cards.

Another way of envisioning the place came to me toward the end of the project, after we had traveled far and wide in the park to find sites and make rephotographs. Because of the plethora of sites I had seen as both photographs and actualities, the whole park came to feel like a vast Advent calendar to me—one of those paper calendars showing a holiday scene punctuated with faintly visible windows that open to reveal other scenes, another world behind the surface. In the weeks before Christmas, an Advent calendar's windows are opened up, one window per day, so that by Christmas all the windows are flung open. It was as though the real, three-dimensional, full-color landscape of Yosemite was a vast Advent calendar whose photographic sites were windows behind which the past was visible as black-and-white photographs. To locate the site of a photograph is to open a window in time. The photographs become temporal discontinuities, ruptures, holes, scars in the continuity of time once you learn to see them in situ, to feel the ghosts of these old photographers haunting the landscape. We were making the ghosts visible, opening one window after another in the Advent calendar that was photographed Yosemite, and those were windows onto photography's history and time's slippage.

TREES ARE CLOCKS

After one of our trips, Mark e-mailed us from his home in Arizona:

Rebecca, Byron,

I miss the long steep trail already.

I made it to Tonopah the first night. That made the next day a little easier. I thought a lot about time on that long drive, about three models for time that work well in photography: the circle (or the cycle and the spiral), the river (with its various rates of flow, obstructions and backwards eddies), and the stacking of single planes or points of time (Julian Barbour's "now's"). I think we see them all in Yosemite.

And I wrote back:

Funny, a few hours into the drive home I scribbled at a gas station, "Time is like a river; it flows. No, like a tree, each annual ring encircling the past and enlarging from it. Or rocks, eroding and growing at once." Same general thought that the place is giving us all those models, visually and metaphorically.

Often we could track individual trees between the original photograph and the rephotograph, see the biography of a tree unfold over decades or a century and a third. Trees are often spoken of as though they grow with stately regularity, a belief that might be as recent as exhibits of cross-sections of tree trunks and dendrochronology, the science of reading tree rings for their recording of their own age and experience. There was such a cross-section of a sequoia in front of the Yosemite Indian Museum, with small markers affixed to pinpoint historical events over the several hundred years the tree had lived. A tree adds one ring a year, so that its age can be counted in rings, a calendar open only after death (or by coring; the tree-corer is the principal tool of dendrochronology). Thus the rings of the tree are a calendar that suggests time is cumulative, the present surrounds and contains the past. Though they accumulate annually without fail, the rings themselves are often uneven. Drought makes for a thinner ring, and the difference between summer and winter growth is what makes rings in the first place rather than continuous enlargement (climate history over the past millennium has been reconstructed by studying the record of the tree rings).

But the tree as a whole does not proceed so predictably. In 1868 or 1872, Muybridge made a stereo photograph of a Jeffrey pine atop Sentinel Dome, a wind-bowed half-horizontal lone tree that would become a celebrated, much-photographed icon of the place. In 1940, Ansel Adams photographed the tree from the opposite direction (p. 32), and it didn't look like much had happened to the tree between Muybridge and Adams. That it had ever thrived at all in a nearly soilless location scoured by sun and winter storms, 4,000 feet above the valley floor, 8,000 feet above sea level, was remarkable, and the tree's toughness as well as its beauty drew people. But the tree died in the great California drought of 1976–77. (Even dead it remained a popular landmark whose image appeared in postcards for sale in the valley below.) By the time we got there, the tree wasn't just dead; it was wearing down to a stump with only its thicker branches remaining and its bark scoured off. Nevertheless, a couple got married under the skeletal tree while Mark and Byron lined up Muybridge's stereo photograph; some still found the pine, or what was left

of it, beautiful. Shortly thereafter, in mid-August 2003, the tree collapsed completely.

Plate 51 of Muybridge's mammoth plates depicts a sequoia in the Mariposa Grove at the southwest end of the park (as its boundaries now exist; in Muybridge's time only the valley was parkland). His picture shows the base of a huge tree whose trunk provided one wall for the small log cabin treelover Galen Clark had built, and a bearded man who might have been Clark himself stood in front of the building. We went to look for the tree and found that though records documented which tree it was, nothing remained to identify it adequately enough to rephotograph it: telltale dimples and scars had grown out, the soil level might have risen or fallen so that the base of the tree was unrecognizable. Nothing was the same, at least for the first dozen feet or so from the ground, of these icons of stability, though other sequoias in the area could be recognized by their limbs high above the ground. The "Grizzly Giant" Watkins had photographed was still recognizable by a great bent limb thicker than most trees (p. 36), but it was a surprise to realize that even these ancient trees could become unrecognizable.

The first image we rephotographed, of glacial polish above Lake Tenaya, showed that the lodgepole pines growing in soil pockets looked tired and scruffy in Muybridge's time; in our time they were young and healthy-looking (pp. 122–23). The difference could have resulted from harsh weather that year, an insect infestation, the life cycles of trees, or the climate change that has made our era warmer and milder than his. Whatever the explanation, trees looking more sprightly in our time than his is not what most of us would expect.

In 1937, on his Guggenheim-funded tour that resulted in the book *California and the West,* Edward Weston pho-tographed a massive juniper above Lake Tenaya (p. 124). Byron found it standing almost unchanged to the eye. To see the elegant formalism of a Weston photograph turn back into the full-color subject (with chartreuse moss on its trunk) was one shock; to see that time had left no obvious traces in sixty-five years of wind, snow, and sun was another. Often an identifiable pine or oak in Muybridge's or Adams's time was visibly altered but still recognizable in ours—young trees had reached their prime, mature ones had become snags or had begun to decline. All this suggested how much trees' long lives, like our own, shorter ones, speed up, slow down, change dramatically, come to an end. In the same timespan, trees vanished, appeared, died, became unrecognizable, or hardly changed at all. Trees mark time, but as we do. If we are clocks, we tell only our own time.

The greatest shock came during the second expedition in June 2002. We had ended our first expedition with a camp in the Jeffrey pine forest on the south shore of Mono Lake, on the other side of the Sierra, east of the park (whose stringent campsite rules and solidly booked campsites meant that we got through the whole project without staying in a campground there). The Mono forest seemed enchanted. Each tree, presumably because of huge roots sipping what scarce water there was in that arid land east of the Sierra Nevada, stood far from the others, rising above a dark circle made of its own fallen cones and needles. The landscape was a sloping plain stretching away, scattered with these dark circles and conical trees, a place almost as pure as geometry. The trees were far apart, but it was hard to see beyond them. Perhaps because Mark mentioned that one of his daughters was reading the Chronicles of Narnia, I thought of the serene Wood Between the Worlds in one of those books, and of the Forest of Name-

lessness in *Through the Looking-Glass: And What Alice Saw There*. The place was silent, unpopulated, unregulated, and beautiful. The wonderful butterscotch-vanilla aroma of Jeffrey pines that you can usually only smell by putting your nose close to the bark perfumed the still air. We ended the first expedition there.

Ten months later, we returned to the very spot. I had been looking forward to reentering its serenity and its stillness. But since we had departed, half the forest had been burnt. On one side of the unpaved road through the gray volcanic sand and gravel, there was still a fragrant green forest. On the other, there was also a forest, of black trunks with stumpy branches.

Mark Klett, *Black sun, Mono Lake camp*, 2002.

The first expedition was a month before September 11; the second one took place in June 2002, after the bombing of Afghanistan and all the other changes in the world. I had thought that somehow, perhaps just in that fragrant, remote, silent forest, we could step away from the history of our own time. I was wrong.

Photographer Man Ray was one of the many surrealists to seek refuge from the Nazis in the United States. During the Second World War, he lived in Los Angeles and visited a Sierra sequoia grove, of which he wrote:

> Wishing to record my impressions, I spent a day photographing them. The result was disappointing. They looked like ordinary trees. A cabin, a car, a person alongside one, put in to show the scale, became items out of a Lilliputian world. There was only one way to indicate the dimensions: to make a photograph as large as the tree itself. But even a photograph could not show the most important aspect of these giants. They are the oldest living things in nature, going back to Egyptian antiquity, their warm-colored, tender bark seems soft as flesh. Their silence is more eloquent than the roaring torrents and Niagaras, than the reverberating thunder in Grand Canyon, than the bursting of bombs; and is without menace. The gossiping leaves of the sequoias, one hundred yards above one's head, are too far away to be heard. I recalled a stroll in the Luxembourg Gardens during the first months of the outbreak of war, stopping under an old chestnut tree that had probably survived the French Revolution, a mere pygmy, wishing I could be transformed into a tree until peace came again.

He too had thought of forests as refuges. But forests were never outside time, and they have their own history. And we have a history of changing ideas about forests.

On the day, June 10, 2002, when we rephotographed Weston's juniper, I said, "These must be the rocks that Adams and Weston were photographing when the French photographer Henri Cartier-Bresson exclaimed, 'The whole world is falling to pieces, and Adams and Weston are photographing rocks!' " In the 1930s, Cartier-Bresson was outraged at these peers of his; a photographer's duty, he seemed to think in that decade of depression, utopian socialism, rising fascism, and a future that looked urban, was to the social and the political. In that moment, rocks were neither. Certainly as Weston and Adams photographed them, they were sometimes hardly even rocks.

Weston, after all, had developed a formalism in which a toilet's porcelain base, a bell pepper, and a woman's body were equally available for aestheticizing as pure form. He and Adams had helped shape an era in which photography demonstrated its power by its ability to abstract, to find formal beauty and pattern, to free itself from facts and become pure expression. Adams often teetered uneasily between his politics as a conservationist and his aesthetics as a modernist and used the purity of his images to lobby for protecting nature as a

place apart. Weston never seemed worried. It was for these reasons that their work often seemed further away than that of the Victorians, of Muybridge and Watkins. Their contemporary Man Ray, in his yearnings among trees, seemed to imagine such places as Cartier-Bresson did, as outside history and politics, as somehow timeless.

When I quoted Cartier-Bresson in 2002, Mark quipped back, "Yeah, and here we are photographing rocks, and look at the world now!" We thought of Watkins here during the Civil War; Muybridge here during the peak of the Indian wars, not long after the Paris Commune and the Franco-Prussian War; of the Spanish Civil War going on while Weston was here; Adams roaming the place during the rise of fascism and through the Second World War into the Vietnam era. I'd first investigated Yosemite just after the first U.S.-Iraq war. Yosemite is largely outside these histories, but it is not outside history. Its histories are about ecology, aesthetics, and ethics, and often the place becomes a mirror reflecting back a whole nation's wrestlings with time and place and race. It has had wars, and the Indian war that led the first whites into the valley is an unfinished, important, neglected history now taking place as struggles over rights and representations. Yosemite is often regarded as a refuge from the world, but it can also be a vantage point from which to look at the world.

—Rebecca Solnit

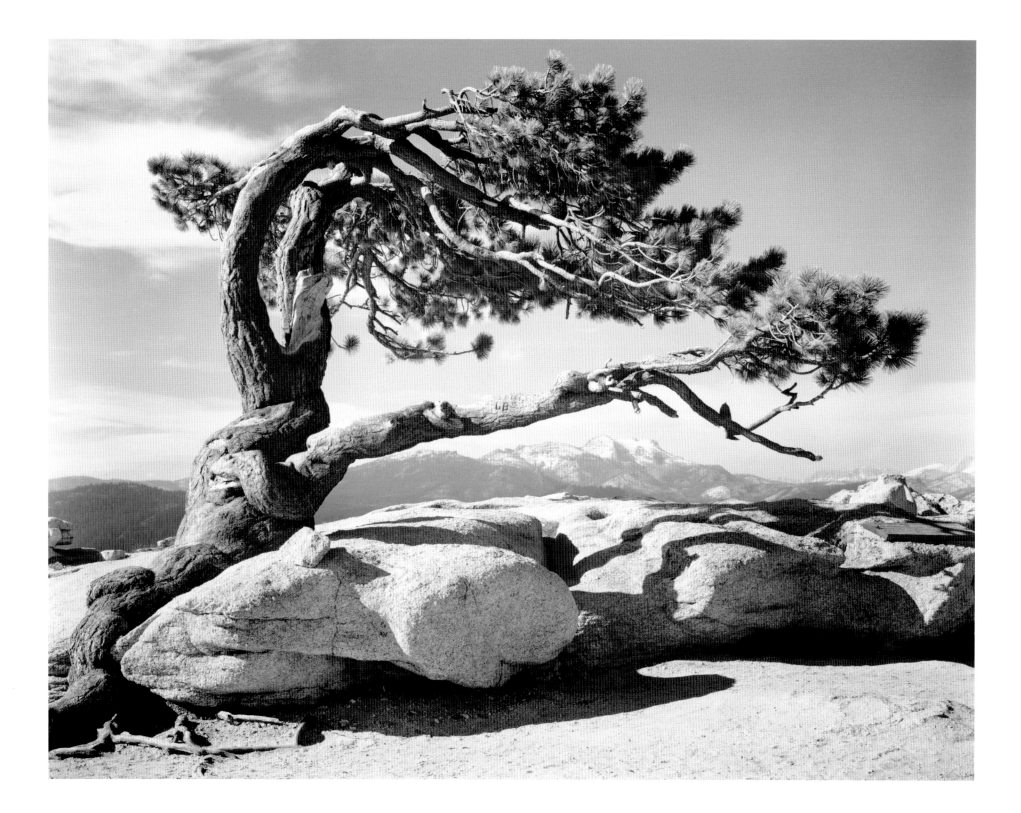

32 Ansel Adams, *Jeffrey Pine, Sentinel Dome, Yosemite National Park, California*, c. 1940.

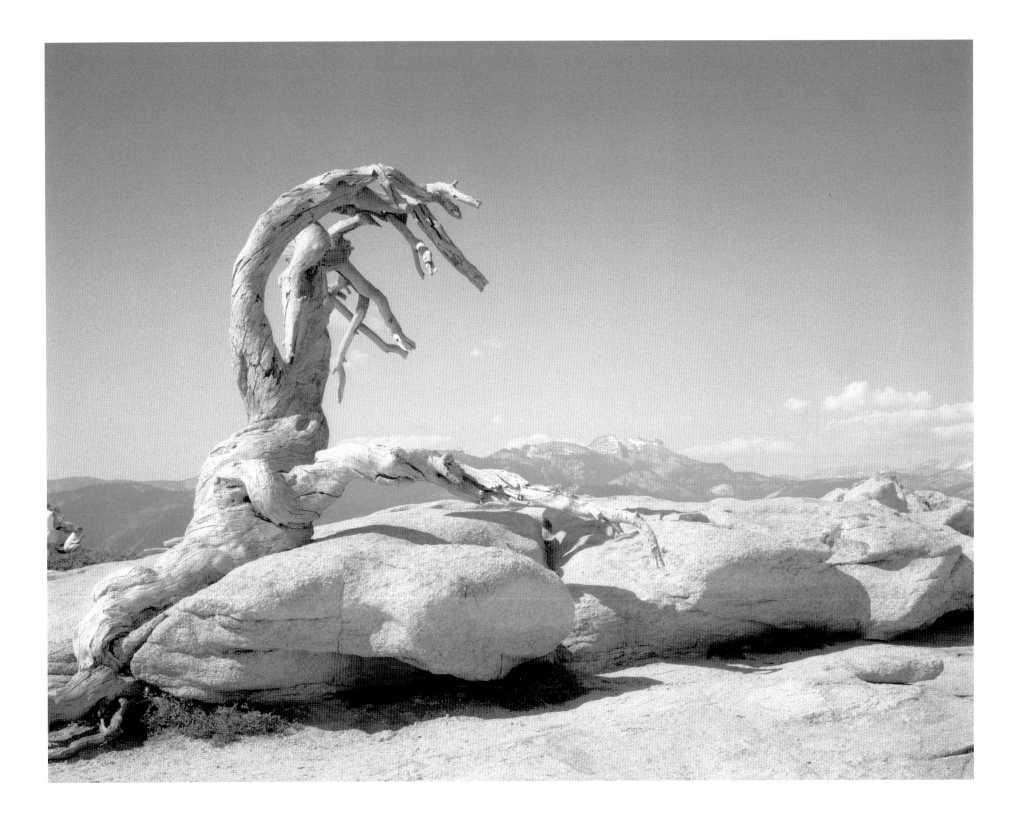

Mark Klett and Byron Wolfe, *The trunk of the Jeffrey pine, killed by drought, Sentinel Dome*, 2002. 33

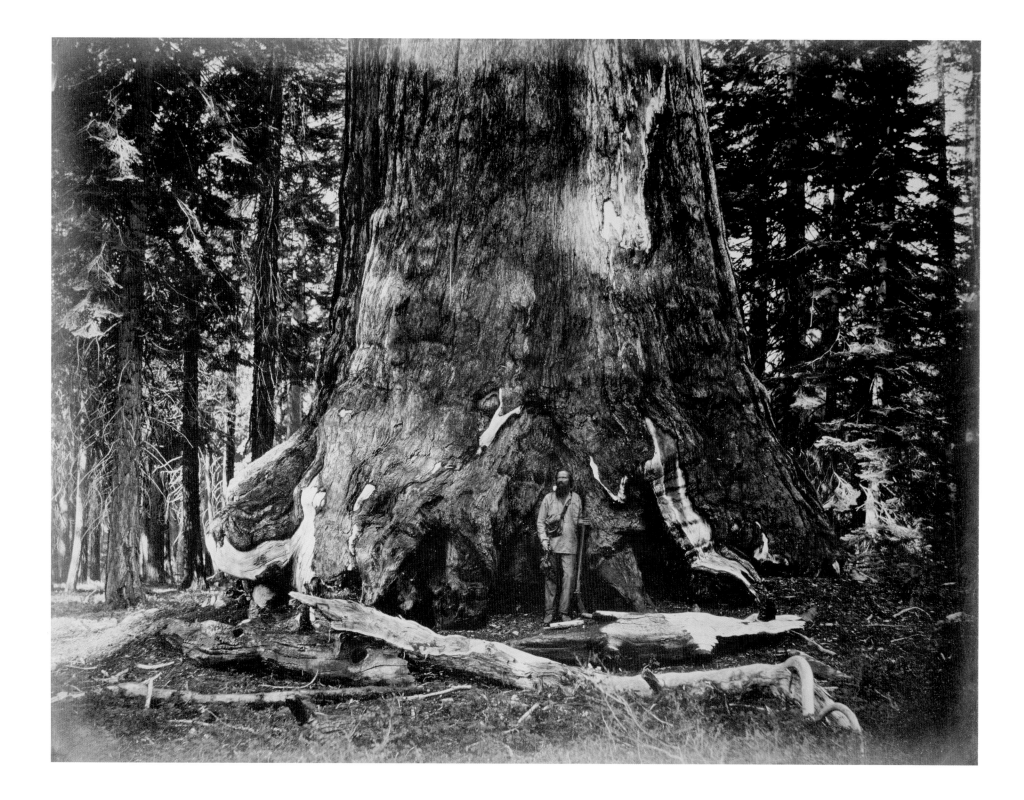

34 Carleton E. Watkins, *Part of the Trunk of the "Grizzly Giant" with Clark-Mariposa Grove-33 feet diameter*, 1861.

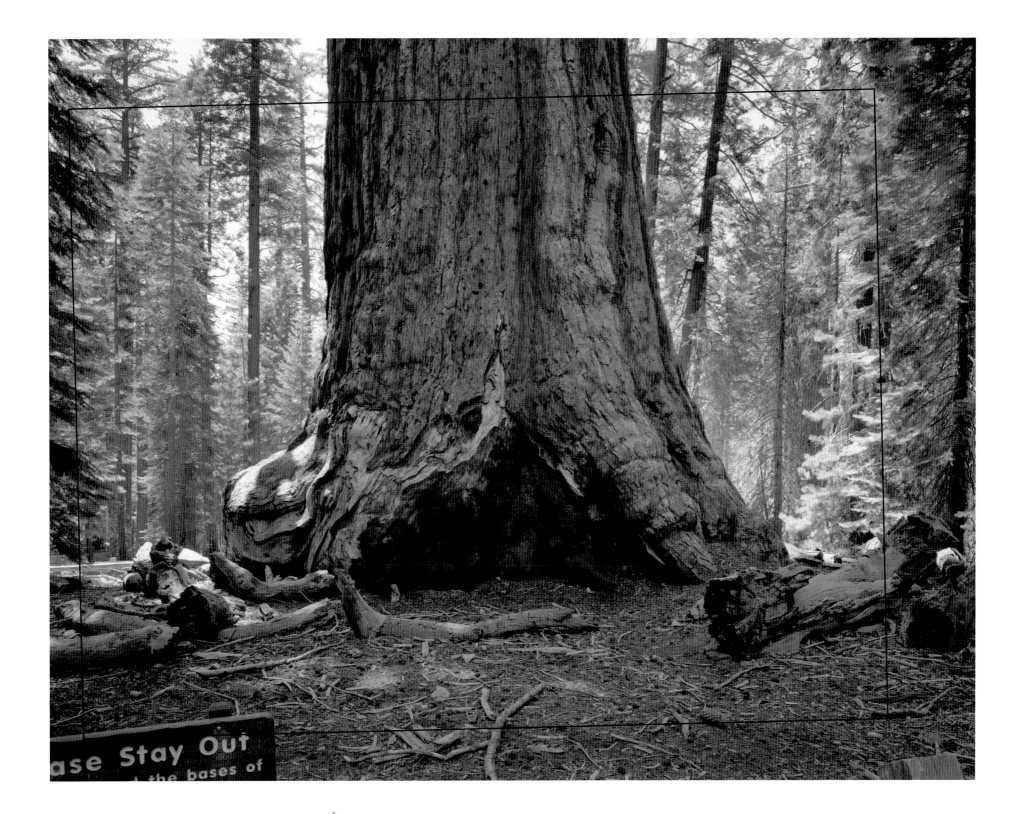

Mark Klett and Byron Wolfe, *Grizzly Giant from as close as visitors are allowed to get to the tree's base*, 2003. (Rectangle indicates cropping of Watkins's photograph.) 35

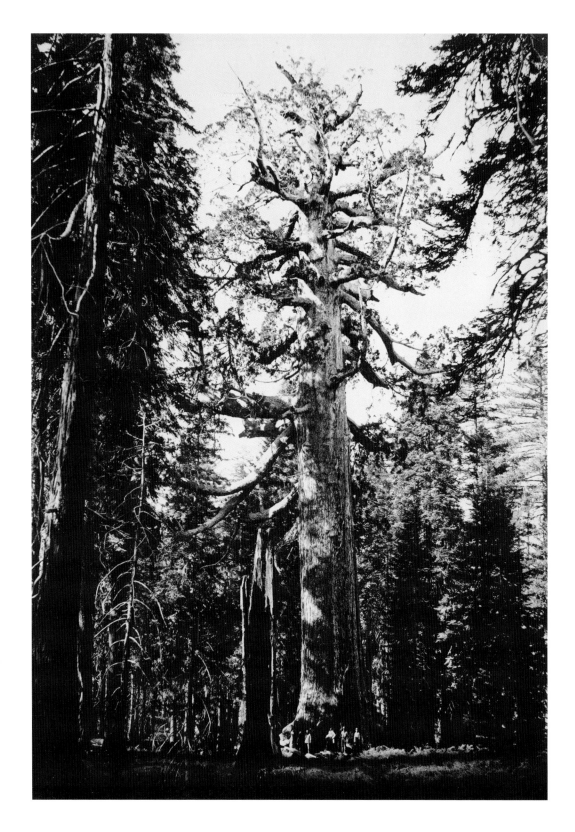

36 Carleton E. Watkins. *Grizzly Giant, Mariposa Grove, 33 Ft. Diam.*, 1861.

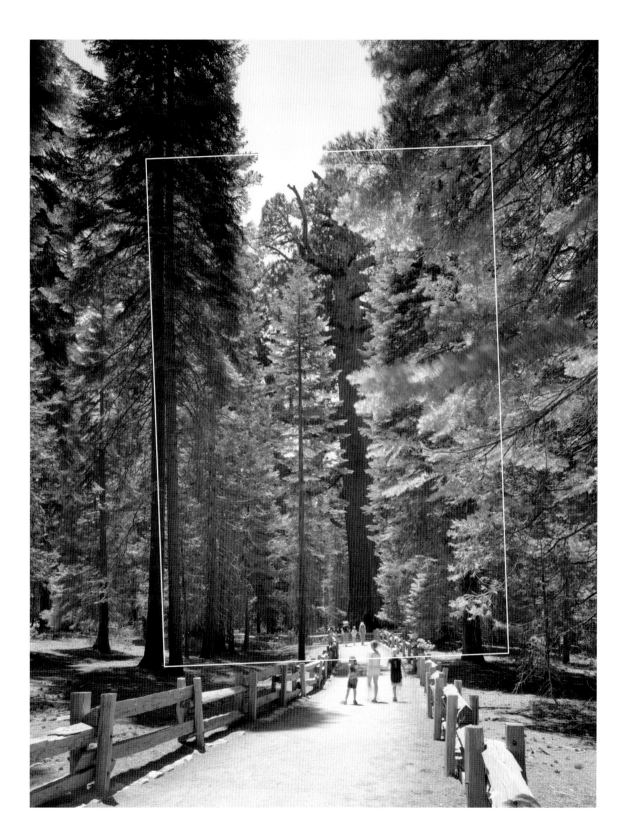

Mark Klett and Byron Wolfe, *Grizzly Giant from the walkway through the Mariposa Grove,* 2003. 37
(Rectangle indicates cropping of Watkins's photograph.)

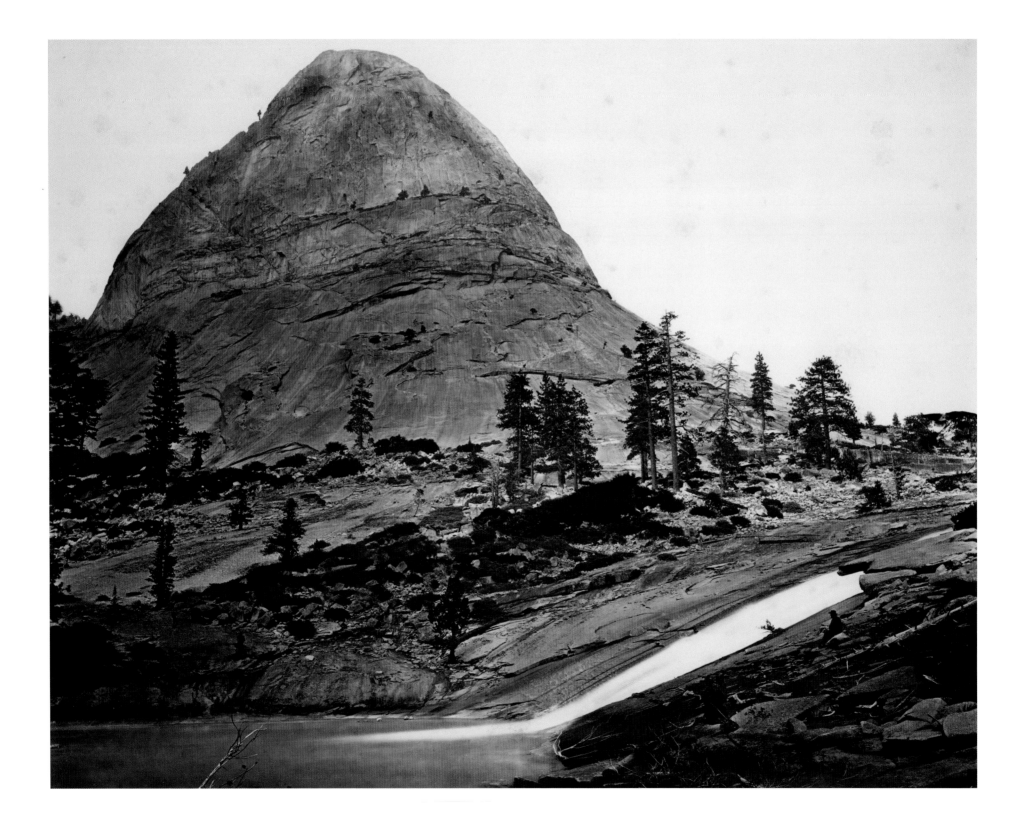

38 Eadweard Muybridge, *Helmet Dome and Little Grizzly Fall. No. 42*, 1872.

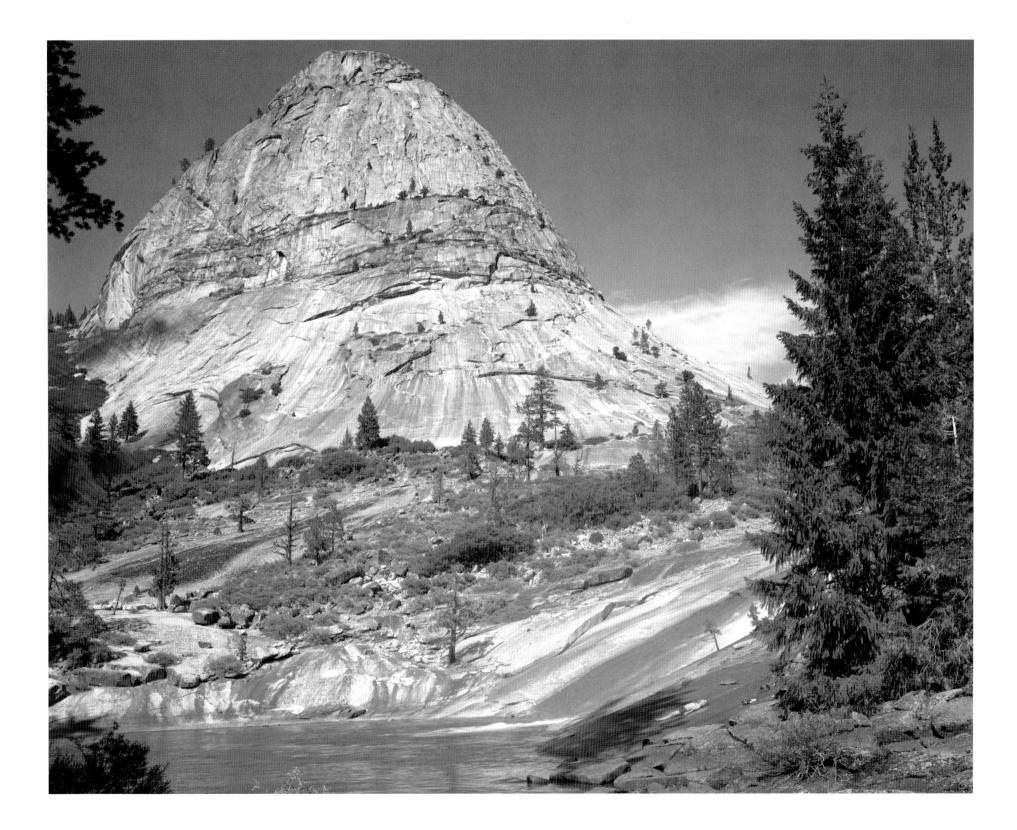

Mark Klett and Byron Wolfe, *Sugar Loaf and Bunnell Cascade, Little Yosemite Valley*, 2003.

40 Eighteen trees isolated from Muybridge's *Helmet Dome and Little Grizzly Fall. No. 42,* 1872 (p. 38).

The same eighteen trees as clocks, 131 years later, from *Sugar Loaf and Bunnell Cascade,* 2003 (p. 39). 41

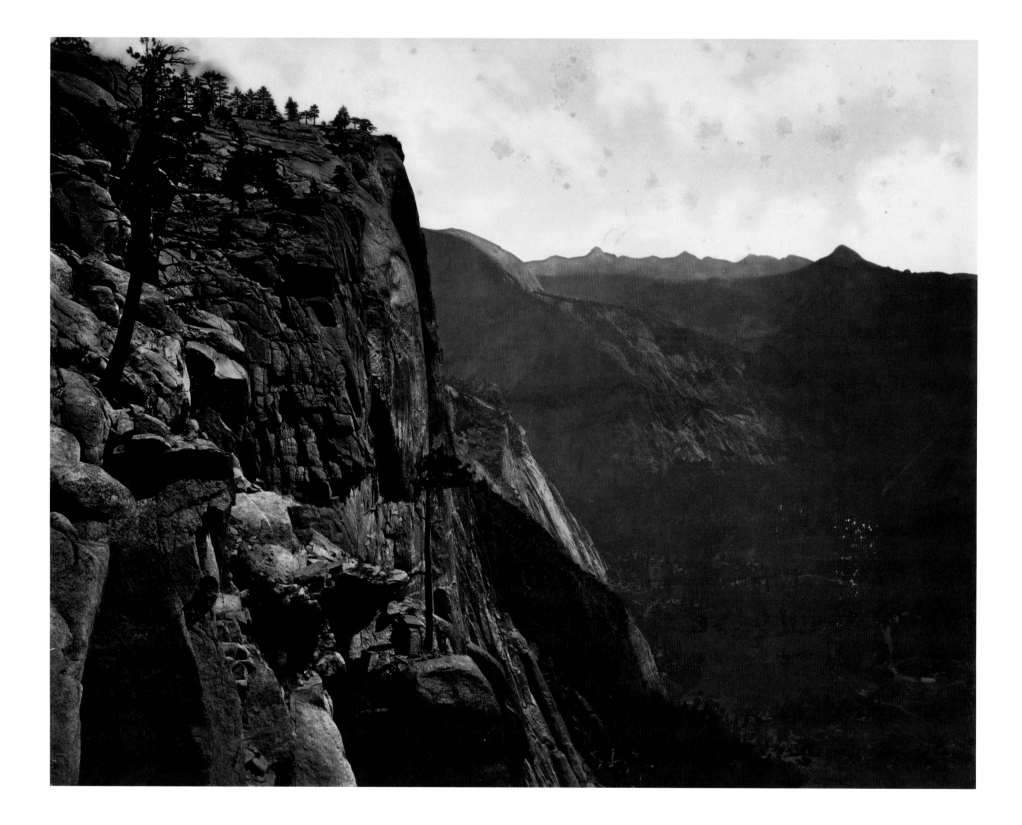

42 Eadweard Muybridge, *Yosemite Cliff. At Summit of Falls. No. 45,* 1872.

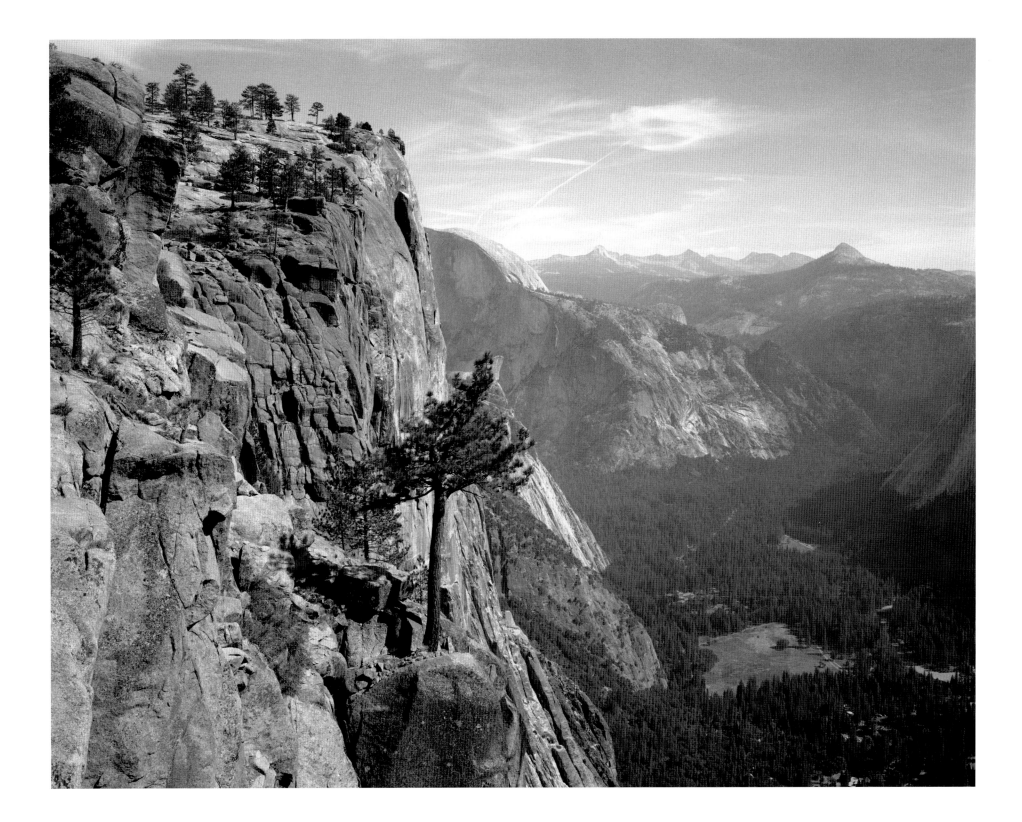

Mark Klett and Byron Wolfe, *Overhanging the edge of the north rim wall, looking toward the drop-off of Yosemite Falls*, 2002. 43

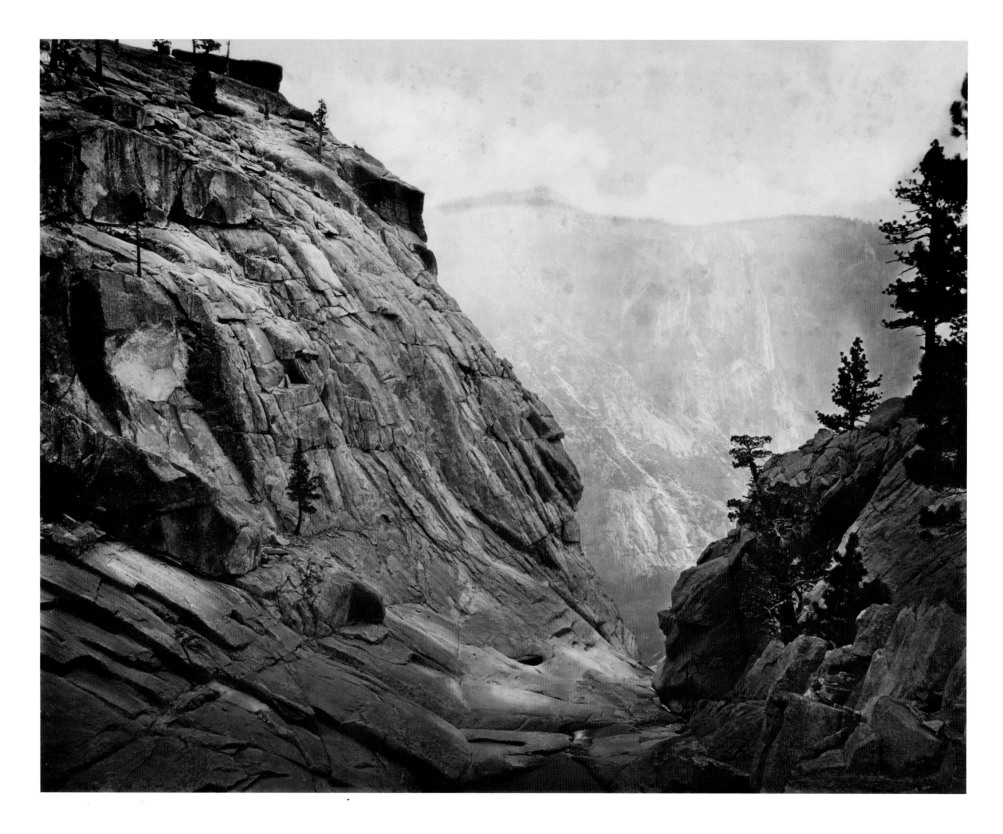

44　　Eadweard Muybridge, *Yosemite Creek. Summit of Falls at Low Water. No. 44*, 1872.

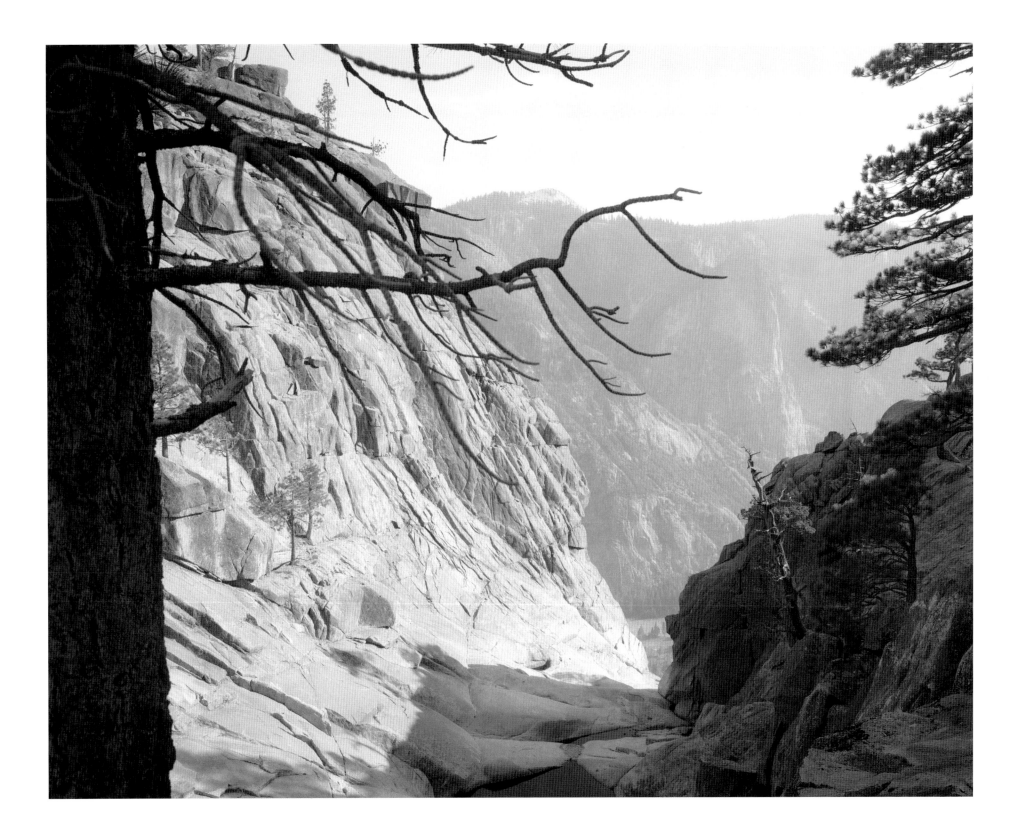

Mark Klett and Byron Wolfe, *Yosemite Creek at the summit of the falls, in the dry season*, 2002. 45

Ancient Glacier Channel, at Lake Tenaya B&R 47
Yosemite National Park Museum

46 Mark Klett and Byron Wolfe, *Solar eclipse projected onto the printed-in clouds of Muybridge's*
Ancient Glacier Channel, *from a book at the site of the photograph,* June 10, 2002.

GLACIERS AND GODS

OR SCIENCE IN THE SIERRA NEVADA

. . . that coherence we call God . . .
—Barry Lopez *in conversation, October 2002*

There were times in this project when Mark would tell me his camera was within inches of Muybridge's and times when he said that he was a lot more approximate—somewhere within several feet, precise enough by anyone else's standards. He and Byron saw things that were entirely invisible or unreadable to me, not only the details of rock formations in relation to each other that let them come close to the exact spot where a photograph was taken, but the angle of light that determined what time of year and day Muybridge had been there. Once, standing by the rock in the foreground of his Bridalveil Falls photograph, though with young forest occluding everything else between us and the falls that had been visible in 1872, Mark commented: "Right time of year, but he

was here half an hour earlier than us," and I pictured that artist hastening away before us, just out of reach.

But once spatial distance is eliminated, the span of time can begin to be measured, and temporal distance is often immeasurably vast. Visible in the landscape are changes in trees, rocks, waterways, for no landscape stays the same even for an hour, let alone a century. But the person who stood there in the same spot also stood in a different world. When Muybridge worked in Yosemite, a great roadless unindustrialized expanse stretched away in all directions from a place that could be reached only on horseback or on foot, a place still being mapped, a place whose indigenous inhabitants were still unobtrusively gathering acorns and living in cedarbark structures in the valley. Muybridge, with his hobnail boots and mule caravan of photographic equipment, was in a very remote place indeed, as I realized one day when Byron took a GPS reading of our site, for the California skies in 1872 still belonged to birds, clouds, and the beyond, while ours are cluttered with signals, satellites, airplanes, smog, and anxieties.

Yet looking back at them from the early twenty-first century, the Victorians who came tramping through Yosemite seem closer to us than many of the figures of the mid–twentieth century because the urgent intensity with which they scrutinized the landscape is not so far from our own. For them the crisis of meaning came about with the collapse of an old order, in which humanity was distinct from the rest of the species and at the center of a world presided over by an actively involved God. For at least the environmentally inclined among us, the alarming questions now are about our own rise to near-divine status. We have changed the weather, wiped out species, modified the genetic code, paved over vast expanses of landscape. For the Victorians, the past was a desta-

bilized zone that threatened to radically redefine their sense of self and place in the world. The Darwinian revolution frightened people by reducing their scale. Now we are giants. Our doubts are located in a nebulous future whose crises can also be found in Yosemite. It is as though our predecessors were looking down into a tremendous chasm opening at their feet. We look up at a bricked-over sky against which we may smash our heads.

In 1872, Yosemite was compelling for two reasons. One was its great natural beauty, its lofty cliffs, magnificent waterfalls, and soaring sequoia trees, a concentration of scenic grandeur unlike anyplace else in the world. Most of the elements of Yosemite's beauty were not only vast in size but spoke of vast quantities of time: of the geological ages that had formed its naked expanses of granite, of the millennia the sequoias had been growing. This visible deep time gave Victorians a sense of the sublime vastness of the world and a little of the seductive terror the sublime brings with it. The other reason people flocked to Yosemite was to read the history of the earth evident in those rock faces, glacial traces, watercourses, and botanical phenomena. Yosemite was then a sort of outdoor laboratory for investigating all the most pressing theories about time and change.

In 1872, Asa Gray, Joseph LeConte, Clarence King, John Torrey, and John Tyndall were among the scientists who visited the place, all but King guided by John Muir, who also guided the photographer J. J. Reilly that summer and the painter William Keith that fall. The writer Helen Hunt Jackson arrived as an ordinary tourist, though she wrote reports for the *New York Independent* newspaper about what she saw; painter Albert Bierstadt traveled with King, and the photogra-

phers Eadweard Muybridge and Carleton Watkins led their own expeditions there. These were the people who would shape American ideas about nature and landscape, and their crossed paths in 1872 suggest that a sort of wilderness symposium was afoot.

It was a stirring, disturbing moment when aesthetics, theology, and geology were braided together into one rope to tie around the truth. "In the early nineteenth century," writes art historian Barbara Novak, "nature couldn't do without God, and God apparently couldn't do without nature. By the time Emerson wrote *Nature* in 1836, the terms 'God' and 'nature' were often the same thing, and could be used interchangeably." Beauty was popularly read as a sign of the divine in nature, but nature was yielding up more and more evidence that conflicted with conventional ideas about God. Darwin's 1859 *Origin of Species* would generate as epochal a shift as the Copernican revolution, and a shift that affected far more people in that age of vastly increased education and circulation of ideas. In 1860, a Harvard science student wrote to a friend, "Now John stop and think of it for a moment and don't you perceive that if his theory were true it would leave one without a God? Most certainly it would, for the origin of species according to his idea would be simple chance and nothing else." This is why the Victorians looked at landscape with such anxious intensity: it was the site in which their belief was both affirmed and undermined, the testing ground for God. Some found a different god there, some found doubt, some fudged the evidence or segregated their imaginations.

The geologist John S. Newberry, in his 1867 presidential address to the American Association for the Advancement of Science, said Darwin's theory was "shaking the moral and intellectual world as by an earthquake." The picture of the world had already been changing fast in the nineteenth century. Geologists kept expanding the age of the earth, pushing it back from the thousands of years of biblical time into the millions it took for erosion, uplift, accretion, and eruption to shape the surface of the earth, the span of time required for the unfolding of the processes Darwin described. The fossil record was being eagerly studied, too, though the relationship between the strange creatures found in the rocks and the present was still being argued. Darwin's most radical notion was that of the mutability of species through natural selection, which made some of those fossils into ancestors of the living. Other scientists had proposed that one species may become another, that change is not an outside event introduced by God, but Darwin argued a new cause for change that seemed grim and materialistic to his peers. In Darwin's view, species had interior reasons for change generated by the competition for survival; evolution was nothing more or less than the combination of characteristics passed down by the survivors. Now this seems like a coherent internal order of sorts, a cosmology of responsiveness, but then it seemed like chaos, chance, creatures doing as they would driven by undistinguished urges rather than the mind of God.

For almost a week in the middle of July 1872, John Muir guided Asa Gray, one of the most distinguished botanists of the era, around Yosemite. Muir had retreated to Yosemite a few years before to invent himself in comparative solitude and obscurity and to explore the Sierra Nevada. First a sheepherder and then a woodcutter in the Sierra, Muir was working as a guide and starting to earn a living as a writer. He was a shaggy young man with a Scots burr, an inexhaustible enthusiasm for nature in general and Yosemite in particular,

Byron Wolfe, *Eggshells discovered in a meadow near Lake Tenaya*, 2002.

fied for decades. On July 16, Muir wrote to his sister Sarah, "I have had a great day in meeting Dr. Asa Gray, the first botanist in the world . . . While waiting for Gray this afternoon on the mountain side I climbed the Sentinel rock, 3000 feet high. Here is an oak sprig from the top. I hope to see Agassiz this summer, and if I can get him away into the outside mountains among the old glacier wombs alone, I shall have a glorious time." The Swiss geologist Louis Agassiz was Gray's fellow Harvard professor and chief rival.

At sixty-two, Asa Gray was tall, serious, with a square, honest face, and a rapid gait that more nearly matched Muir's own than that of most of the people he guided. He was a close friend of the English botanist Sir Joseph Hooker and through him had become a confidante of Darwin's long before *The Origin of Species* was published and, afterward, a defender of the man and his theory. He had done spectacular work sorting out North American plant species and connecting them to their relations in Asia and other parts of North America. This mapping of plants was one of the earliest and best sources of evidence for evolution, since far-apart similar species were best explained by a common ancestor and subsequent adaptation to differing conditions. During his week with Muir, Gray went to look at sequoias, either the Tuolumne Grove near Yosemite Valley or the more spectacular Mariposa Grove about twenty-five miles south of there. Then the president of the American Association for the Advancement of Science, he gave the keynote talk at the organization's annual meeting that summer and made sequoias his subject.

The trees—the largest visible living things on earth—had attracted considerable public attention since European-Americans had first become aware of them in the 1850s. People liked to talk about their age, to speculate that the greatest of

and an unarmored emotionality, and he had only a few short pieces in publication. But he had kept up a voluminous correspondence with his friends in the outside world, most notably Jeanne Carr, the wife of the scientist under whom he had studied at the University of Wisconsin a decade before (the Carrs had since moved to the University of California in Berkeley). She functioned as much as a manager as a muse, sending his writings out into the world and sending the distinguished men she met to Muir in Yosemite. He had guided Ralph Waldo Emerson around Yosemite in 1871 and kept up a correspondence with "the sage of Concord." Earlier in the summer of 1872, he had guided the botanist John Torrey and introduced him to a plant that would not be formally identi-

them were growing when Christ was on earth, and Muybridge and Watkins sold photographs of them, but little serious study of the trees had been done. Sequoias—not to be confused with the more common and taller but less bulky coast redwood—are rare, occurring only in a few dozen groves in the midlevel Sierra Nevada. "Were they created thus local and lonely, denizens of California only?" Gray asked in his keynote address to America's scientists, "or are they remnants, sole and scanty survivors of a race that has played a grander part in the past, but is now verging to extinction? . . . Time was, and not long ago, when such questions as these were regarded as useless and vain—when students of natural history, unmindful of what the name denotes, were content with a knowledge of things as they are now, but gave little heed to how they came to be."

Gray plunged into this deep past to show that sequoias were remnants of a family of trees whose fossils revealed that they had once been widespread and that some of their closest living relatives were in Asia. The sequoias became further evidence of evolution, of the transformation of species and their migration around the world. The botanist closed with a beautiful image: "Organic Nature—by which I mean the system and totality of living things, and their adaptation to each other and to the world—with all its apparent and indeed real stability, should be likened, not to the ocean, which varies only by tidal oscillations from a fixed level to which it is always returning, but rather to a river, so vast that we can neither discern its shores nor reach its sources, whose onward flow is not less actual because too slow to be observed by the ephemerae which hover over its surface, or are borne on its bosom." Time is often imagined as a river, but Gray had made the leap to imagine all nature as fluid and flowing in the river of time.

This effort to find meaning and pattern in the Darwinian vision of the world was beginning to make it inhabitable by the imagination; science leaped the divide to land in poetry.

Byron Wolfe, *Worm-eaten oak leaf on the trail to Upper Yosemite Falls*, 2002.

Gray was a retiring man most at home in his herbarium, and in his youth he often stuttered when he lectured. He was nothing at all like his colleague at Harvard's Lawrence Scientific School, Louis Agassiz, a Swiss immigrant who had taken the United States by storm in the 1840s and thereafter settled in to be lionized by Boston society for the rest of his life. Agassiz had a confident, gregarious air of well-being that charmed most who met him, though he left a trail of bitter and betrayed fellow scientists and students behind him. Gray wryly noted that he "is always writing and talking ad popu-

lum—fond of addressing himself to an incompetent tribunal." Agassiz made science, or at least his version of it, exciting to the general public, who flocked to see him, and he preferred such audiences to serious dialogue with his peers. Emerson revered him, and Thoreau sent him specimens. He had done research of genuine and profound merit, starting with his monumental study of fossil fishes published when he was twenty-six. His biographer notes, "In an era of transition in the interpretation of nature, Agassiz lived as a man who provided basic insights and discoveries that helped effect such change and at the same time as one who fought against the implications of those insights for the new framework of natural history."

Agassiz insisted that the species of fossil fishes he so thoroughly documented had no descendants presently on earth. For much of his long life (he died in late 1873), he preached that species were created by God as they now are and placed where they are currently found in the quantities in which they currently occur. In this view, there was no migration and no evolution. Nature, at least as biology, was static and passive, while God, the sole agent of change, was very busy creating and destroying. Gray's picture of the river of time was a direct assault on this view. Geologists read the rocks as evidence of a narrative, reconstructing in their imaginations vast swaths of time and change, but the content of the narrative was a contentious subject then. Devout scientists had abandoned Genesis and its singular creation, but they kept creating new stories to keep God in the picture. Some made the six days of creation into six geological epochs, some made inland seashell fossils evidence of the Flood, some argued that God created and extinguished all life several times, and the British naturalist Philip Gosse made himself a figure of ridicule when he suggested that God put the fossils in the rocks when he made the world. Agassiz based his arguments on ice.

Agassiz had made one other great scientific breakthrough while he was still a young man, and he coasted for the rest of his life on the rewards for that early work. Not long after his work on fishes, he began to look at the glaciers in his native Switzerland and at the traces they had left behind—scoured and horizontally scored valleys and rock surfaces, huge boulders found far from their point of geologic origin, and other enigmas. Though others (who felt he inadequately credited them) had collected bits and pieces of the big picture, it was Agassiz who assembled the data into what has ever since been called the Ice Age (which is, technically, only the most recent of many ice ages). That term, too, he borrowed from a poet friend for his *Etudes sur les glaciers*. The Ice Age, according to Agassiz, was a dramatic catastrophe overtaking the world so fast that creatures were frozen before they could decay. He wrote to a colleague, "Since I saw the glaciers I am quite of a snowy humor, and will have the whole surface of the earth covered with ice, and the whole prior creation dead by cold."

The idea of the huge glaciers that had advanced to cover much of Northern Europe and North America explained puzzling features in the landscape, and the scientific world went glacier-mad. The romantics had already instilled a taste for mountain scenery in European imaginations; glaciers and geology added scientific interest to the same scenes. But Agassiz went looking for glaciers in the tropics, mounting in the mid-1860s an expedition to Brazil, where he claimed to find evidence that the southern hemisphere too had been overtaken by ice (it had, but long, long before the Ice Age). Agassiz, the principal voice against Darwinism in the United States, needed the Ice Age to be a complete annihilation of all

Mark Klett and Byron Wolfe, *Last picture of the project, August 15, 2003: all that was left of a lens that fell down an avalanche chute during an attempt to rephotograph Agassiz Rock.*

life on earth to support his beliefs in the immutability of species and in the several successive creations.

Agassiz and Gray became bitter enemies, in part because of their widely differing personalities, in part because of power struggles within the small world of American science, but most of all because of their wildly differing theories of the history of the earth. When Agassiz finally let himself be drawn into a public debate, Gray promptly trounced him. Agassiz reportedly then challenged him to a duel. Darwin once wrote to a friend that Sir Charles Lyell, the greatest geologist of the age, "told me that he was so delighted with one of his [Agassiz's] lectures that he went to him afterward and told him, 'that it was so delightful that he could not help all the time wishing it was true.'"

Nineteenth-century American scientific society is mapped onto Yosemite: the name of the distinguished Harvard geologist James Dwight Dana was given to one mountain by William Brewer and Charles Hoffman of the California Geological Survey, the name of Lyell to another, and Brewer and Hoffman themselves became peaks in Yosemite, as did the photographer Carleton Watkins, who worked with the scientists on the California Geological Survey in the 1860s. (Gray's name was given to a peak in the Rockies on which he later had the pleasure of hiking and botanizing, while Mount Ansel Adams and the Ansel Adams Wilderness are recent additions to the High Sierra.) But Agassiz Rock is only a sort of obelisk jutting out of a slope above Yosemite Valley, isolated, a little absurd, but often photographed—before 1928, when the trail was rerouted to put it back among the bushes. Agassiz's reputation has had a similar history.

In the twentieth century, Muir's name was appended to a trail that stretches from Yosemite Valley to Mount Whitney, the peak named for the director of the California Geological Survey. Muir himself had begun to make a significant transition in the early 1870s, from botany to geology and glaciology, a change that distanced him from the botanically inclined Mrs. Carr and moved him into a far more argumentative realm. The California Geological Survey had noted the glacier-carved landscape around Yosemite in the 1860s, but Muir was the first to report that some of what had been taken for Sierra snowbanks were actually glaciers. "On one of the yellow days of October 1871," he began his account, "when I was among the mountains of the 'Merced group,' following the footprints of the ancient glaciers that once flowed grandly from their ample fountains, reading what I could of their history as written in moraines, canyons, lakes, and carved rocks, I came upon a small stream that was carrying mud of a kind I had never seen." When he got to the source of the mud, Muir shouted, "A living glacier!" He went on, "I came to a crevasse, down a wide and jagged portion of which I succeeded in making my way, and discovered that my so-called snow-bank was clear, green ice. . . . Then I went to the 'snow-banks' of Mts. Lyell and McClure, and, on examination, was convinced that they also were true glaciers, and that a dozen other snowbanks seen from the summit of Mt. Lyell, crouching in shadow, were glaciers, living as any in the world, and busily engaged in completing that vast work of mountain-making accomplished by their giant relations now dead, which united and covered all the range from summit to sea." He then subscribed to Agassiz's exaggerated picture of the Ice Age and gloried in it.

For Muir, the discovery was passionately exciting, and for him science was never far from poetry and the personal. He wrote a friend, "The grandeur of these forces & their glorious

results overpower me and inhabit my whole being, waking or sleeping I have no rest. In dreams I read blurred sheets of glacial writing or follow lines of cleavage or struggle with the difficulties of some extraordinary rock form." After his 1872 tour with Gray, he wrote Mrs. Carr, "I've had a very noble time with Gray. . . . He is a most cordial lover of purity and truth, but the angular factiness of his pursuits has kept him at too cold a distance from the spirit world." He and Gray corresponded, Gray sending him books on botany, requests for specimens, and invitations to come east and become part of the scientific institutions, but Muir balked at this invitation as he had at the similar one that Emerson had proffered a year before. He wanted recognition but he was committed to something other than ordinary science. He was looking for meaning and spirituality with a directness that was hardly orthodox for scientists. He valued direct experience more than they did and tried to lure them to Yosemite to feel as well as study the place.

Muir had hoped to get Agassiz to Yosemite too, for the Swiss scientist had come to San Francisco, where the AAAS had initially planned to hold its annual conference (unable to persuade the transcontinental railroad to give its members free passes, they settled instead on Dubuque, Iowa, for the event). He was disappointed that Agassiz was too infirm to take any of the steep horse trails into Yosemite, but he couldn't bring himself to leave his investigations to meet the famous man. Agassiz visited his former students in the Bay Area, Joseph LeConte and Ezra Carr, both professors at the newly founded University of California. LeConte was just back from a geological expedition in Yosemite and the high country and had that year begun publishing articles on the sites and their formation. He praised his friend and guide Muir to Agassiz, and Mrs. Carr plied Agassiz with Muir's enthusiastic reports on

glaciers. Muir's long letters from the era are full of drawings of glacial formations and fuller of enthusiasm for the subject. He was undoubtedly gratified when Elizabeth Agassiz reported that her husband had said, "Here is the first man who has any adequate conception of glacial action," and that he hoped to return the following summer to meet with Muir and his mountains. However, commendation from Agassiz on glacier theory was not necessarily a good thing.

Muir's glacier work would land him in a conflict as bitter as that between Gray and the Swiss scientist. Josiah D. Whitney, director of the California Geological Survey, had argued that Yosemite Valley was an anomaly in the Sierra Nevada, the result of a sudden cataclysmic subsidence without any glacial impact at all. In other words, the steep-walled canyonlike valley had formed when the bottom suddenly dropped out. Even Whitney's then-assistant Clarence King, a graduate of Yale who had studied briefly with Agassiz at Harvard, found this theory hard to believe and argued correctly (though quietly) that the valley was carved out through a combination of glacial and water erosion. But King and Whitney, both university-groomed easterners from established families, jeered at Muir as an amateur interloper. Whitney famously referred to him as a "mere sheepherder, an ignoramus."

By the 1870s, King had become director of the massive Survey of the Fortieth Parallel—the line along which the transcontinental railroad ran, opening the area and making its geological and other resources ripe for exploitation. His own first book, *Mountaineering in the Sierra Nevada*, had been published in 1872, and its accounts of explorations in the sublime vastness of the mountains and encounters with absurd characters formed a fine portrait of King himself, a brilliant geologist, an intrepid explorer, and an aristocrat with a genuine

Mark Klett, *Looking at pictures above Lake Tenaya*, 2002.

bulky equipment of a landscape photographer—Watkins traveled with as much as a ton of gear—into the High Sierra along King's routes had to be abandoned. In the great catalogue of artwork never made, the High Sierra glacial photographs of Watkins and O'Sullivan hold a place of honor. King wrote his superiors, "Owing to the snow and difficulty of reaching points, I deem it wise to give that up, and am the more willing as Mr. Bierstadt, the artist, has joined the party and will give me liberty to copy any or all of his studies." Albert Bierstadt was one of the most celebrated landscape painters in the country, and he had made his reputation in part with paintings of Yosemite early in the 1860s. But Bierstadt's art glamorized and generalized its subjects; it's hard to imagine that even his sketches would serve science well.

Perhaps for this reason King asked Muybridge to photograph the spectacular glacial traces around Lake Tenaya, halfway between the valley and the high country of Tuolumne Meadows. And Bierstadt, already a friend of Muybridge's, asked him to photograph Echo Peak in that high country, as well as the Native Californians who still dwelt quietly in the midst of touristed Yosemite Valley. Muybridge was an astute man, and he seems to have understood well the controversies of Yosemite at the time, for he afterward described his work there as "illustrating the geology of the Sierras." The catalogue Muybridge's gallery issued in 1873 announced, "At no very remote period a vast area of these mountains was covered with glaciers on the grandest scale, and in numerous canyons the surface of the rock along the beds of the rivers, and for many hundred feet above, is worn into deep grooves and polished as a mirror by the immense body of ice as it slowly forced its way into the valleys below." Muybridge's photographs were also about beauty, terror, cloud formations, water

passion for terrain but an amused disdain for most of the people found there.

King too came to Yosemite in September 1872, chasing the glacial record. Yosemite and the high Sierra were southwest of the region he was supposed to be surveying, but they were ideal places to pursue glacial questions. King had attempted all that year to engage a photographer to document what he found in the Sierra, but his first plan to get the incomparable San Francisco landscapist Carleton Watkins went astray, as did his second one, to send Timothy O'Sullivan, who did such remarkable work all along the fortieth parallel. The snow was unusually deep and long-lasting in 1872, and plans to get the

and waterfalls, light, unusual compositions and never-before photographed places, but he too was participating in the geological controversies of the time, in part at King's request. It's hard to say his photographs bear out any scientific theory more specific than that there was indeed massive glaciation in the Yosemite high country, which is among the most fantastic of ice-carved landscapes, with its acres of glacial polish as smooth as pavement and its glacial horns—peaks carved by glaciers into an unusual spikiness (among them Echo and Cathedral Peaks, which he photographed in 1872). But his work testifies to the pervasive interest in glaciers.

Bierstadt was painting God into his landscapes as streams of light, as perfected composition, as rich color, as the kind of lush, serene natural beauty that was associated with religion then. Watkins, in a quieter and more restrained way, was doing something similar, for a profound stillness and serenity is present in nearly all his photographs. Muybridge was doing the opposite. His pictures are sometimes terrifying: many were taken from the edge of precipices, and they play up the violence, the emptiness, the vastness, and the force in this landscape—they are sublime rather than beautiful. The year 1872 had been a violent one, with a tremendous earthquake that sent boulders bouncing into the valley and with very high water from the winter's record snowfalls, so that even Muybridge's most tranquil river pictures have tangles and heaps of washed-up branches and trees in their foregrounds. His photographs look like the nineteenth-century landscape without God.

Everyone else was anxiously trying to put God back into the landscape, though their god was becoming what science historian C. A. Coulson calls "the God of the Gaps"—the deity who explained whatever couldn't be explained by science, a shrinking role as science explained more and more.

Darwinism describes a process that seemed brutal and random to his early readers, but the results of that process seemed something altogether different: a beautifully intricate order. This disparity became the gap in which many located God. Gray and LeConte would make their deity into a force beneficently guiding evolution, what Coulson calls "God behind"—the overseer of what seem like independent processes. Upon his first sight of Yosemite, LeConte had written, "Was there ever so venerable, majestic, and eloquent a minister of natural religion as the grand old Half Dome?" LeConte was not ready to abandon conventional Christianity and instead wrote a book and many articles trying to reconcile theology and science.

King had his own position, and whether or not it reconciled theology and science, it found a middle ground between the two leading theories of geological change, catastrophism and uniformitarianism. King approached something like the modern picture of evolution called "punctuated equilibrium" (of which Stephen J. Gould was an advocate), in which there were intervals of dramatic change with die-offs and adaptations, and he found a redemptiveness in cataclysm akin to what Muir found in glaciology. King asserted that his years of study of the fortieth parallel revealed that changes in the fossil record correspond to cataclysmic environmental changes. Those species with the flexibility to adapt and yield to changing circumstance survived best, so that a gentle "plasticity," as he called it, became survival equipment equal to or greater than the violent struggle implied by the Darwinian picture of "the survival of the fittest" in a uniformitarian landscape. In other words, he emphasized adaptation to environment as a survival factor equal to competition within species. If time was a river, King saw some whitewater rapids in it, but those

discontinuities served a more benign vision of nature that didn't require a God of the gaps. In other circumstances, he and Muir might have seen eye to eye. And it was Muir who would have the plasticity to form a new theology adapted to the new science, though Muir was as quarrelsome as the rest of the Victorian scientists in the Sierra.

After King's Sierra sojourn he returned to duty on the fortieth parallel. His report was issued beginning 1877 in seven bulky volumes, the first of which, *Systematic Geology*, he wrote himself. He devoted considerable space to the effects of the Ice Age, but remarked, quite wrongly, that "although the peaks [of the Sierra Nevada] are among the most elevated in the West, there are no existing glaciers." King confidently insulted Muir's glacial findings as "absurd" in a tone far more vindictive than anything ordinarily found in government reports. In a footnote, he added, "It is to be hoped that Mr. Muir's vagaries will not deceive geologists who are personally unacquainted with California, and that the ambitious amateur himself may divert his evident enthusiastic love of nature into a channel, if there is one, in which his attainments would save him from hopeless floundering." King had some grounds for being personal, for Muir had been making pointed remarks about how easy he had found it to ascend peaks and traverse canyons where King had turned back. King was a better-trained scientist but Muir was a better mountaineer, and he explored the Sierra Nevada more thoroughly. Recent estimates suggest there may be—depending on definition—nearly a hundred glaciers in the Sierra, though like glaciers everywhere they are melting.

The historian Stephen Fox remarks, "When Muir rejected the Whitney theory 'most devoutly,' he used the word with precision. Proving the glacial origin of Yosemite became an act of devotion to him." Muir exaggerated the influence of glaciers in the Sierra generally and Yosemite Valley in particular, but he was right about living glaciers and that glaciers played a major role in shaping the region. Like Gray, he saw all nature as changing rather than static, and he loved the glaciers because they were themselves frozen rivers (ice on the small scale appears solid, but on the scale of glaciers it slowly flows, and this flow is what scours and carves the landscape). He had tried to woo the botanical Jeanne Carr into his enthusiasm by describing snowflakes as snow flowers and glaciers as vast rivers of snow flowers carving out a more beautiful Sierra. He was shaping natural history into theology, and like Gray he ended up with the image of a river: "Contemplating the lace-like fabric of streams outspread over the mountains, we are reminded that everything is flowing—going somewhere, animals and so-called lifeless rocks as well as water. Thus the snow flows fast or slow in grand beauty-making glaciers and avalanches; the air in majestic floods carrying minerals, plant leaves, seeds, spores, with streams of music and fragrance; water streams carrying rocks both in solution and in the form of mud particles, sand, pebbles, and boulders. Rocks flow from volcanoes like water from springs, and animals flock together and flow in currents modified by stepping, leaping, gliding, flying, swimming, etc. While the stars go streaming through space pulsed on and on forever like blood globules in Nature's warm heart."

Despite all the squabbles, the most significant debate was between two characters who never argued and never met, Muir and Agassiz. Agassiz understood what LeConte and Gray tried to smooth over: that to accept Darwinism and this picture of a changeable world with its own internal logic was to displace God or rather the conventional notion of the divine

author and operator that had endured for so many centuries. Muir understood it, too, with delight, because his pantheistic spirituality was far removed from church religion, most emphatically from the harsh Presbyterianism of his father. He embraced with enthusiasm the far vaster world with its own internal forces and purposes that science and Darwinian theory revealed, the world that looked abandoned and chaotic to Agassiz. The pious trying to reconcile theology and geology looked for evidence of the creator, rather like detectives looking for fingerprints and telltale clues of a departed perpetrator; Muir found every encounter with beauty, pattern, and glory evidence enough of holy presence.

And the debate between Muir and Agassiz has yet to be resolved. Into the twenty-first century, fundamentalist Christians still try to stop the teaching of evolution or to dilute and contain it as only a theory equal at best to Genesis (or to propose, under the rubric "intelligent design," pretty much what LeConte did, that there is a divine director backstage somewhere). Darwin found doubt not only in evolution but in the minutia: of a parasite, he wrote to Gray, "I cannot persuade myself that a beneficent and omnipotent God would have designedly created the Ichneumonidae with the express intention of their feeding with the living bodies of Caterpillars." But Muir had dealt with such questions before he arrived in Yosemite, on his thousand-mile walk to Florida from Indiana. He exclaimed, "How narrow we selfish, conceited creatures are in our sympathies! How blind to the rights of all the rest of creation! Though alligators, snakes, etc., naturally repel us, they are not mysterious evils. They dwell happily in these flowery wilds, are part of God's family, unfallen, undepraved, and cared for with the same species of tenderness and love as is bestowed on angels in heaven or saints on earth." Alligators he called "honorable representatives of the great saurians of an older creation." So, perhaps three worldviews emerge from the debates of 1872: recalcitrant Christianity, cold Darwinian science, and a spiritual and emotional sense of order drawn from the revelations of science and from immediate encounter.

A fourth cosmology had been in place for thousands of years before the first whites had marched into the valley, one that might have grounded or at least complicated Muir's had he been interested in it. But if one thing unites nearly all the characters roaming Yosemite in 1872, it's their scorn for Native Americans. Agassiz had already given scientific sanction to the racial theories suggesting that there had been separate creations in separate parts of the earth, and that no common ancestry united whites with Africans, Asians, or Native Americans—which made it possible to regard the latter as other than and less than human. Slaveowners had liked his theories. Those who objected were more often offended by the science than the politics, though a few like Gray abhorred both.

King wrote flippantly about the Native Americans he came across, remarking in *Mountaineering in the Sierra Nevada,* "The Quakers will have to work a great reformation in the Indian before he is really fit to be exterminated." Muir wrote of Yosemite's indigenous population in the same language of disdain: "It is when the deer are coming down that the Indians set out on their grand fall hunt. Too lazy to go into the recesses of the mountains away from trails, they wait for the deer to come out, and then waylay them. . . . But the Indians are passing away here as everywhere, and their red camps on the mountains are fewer every year." Various vaguely Darwinian arguments were put to work to argue that native people

were less fit, less evolved, or less capable of adapting and that if they were disappearing it was natural inevitability, not problematic racial politics, at play. Like glaciers and sequoias, the native inhabitants became part of the Yosemite landscape on which visitors tested their theories of time. For if there was one reassuring compensation in Darwinism, it was the opportunity it supplied for regarding time as progress. Rather than declining from Eden and a state of grace, human beings were rising from the mire, some more than others, educated white male Victorians most of all. It was a way of claiming, after all, some of the centrality that Darwinism had undone.

One more luminary was in the valley in the summer of 1872—the writer Helen Hunt, who would become Helen Hunt Jackson upon her remarriage a few years later and a close friend of Muir's after that. She came to Yosemite from San Francisco, where she had admired Muybridge's photographs, and entered the park familiar with its landmarks. Conventional in her responses to Indians, she described one of the valley's inhabitants thus: "Half naked, dirty beyond words, her stiff, vicious-looking hair falling about her forehead like fringed eaves, her soulless eyes darting quick glances to right and left, in search of a possible charity, she strides through the plaza, and disappears among the thickets and bowlders." Despising Indians was politically expedient, and white Americans were almost universal in their scorn. Europeans often did not share it, and the immigrant Muybridge's dozen and a half stereo pictures of these inhabitants of the valley seem to at least reserve judgment: the Indians in his pictures carry out their daily lives with dignity and independence, as do the indigenous inhabitants of his photographs of the Modoc War a year later and of Central America in 1875.

But Jackson was to do an about-face. After hearing a group of Ponca Indians from Nebraska speak of the wrongs done to them, she became the most vehement white activist for native rights in her time, publishing in 1881 the scathing report *A Century of Dishonor*, and then when that book failed to galvanize the nation, she wrote the novel *Ramona*. The 1884 novel was about the injustices done to the Indians of Southern California, and though it became a huge bestseller, readers responded with voluptuous melancholy rather than outraged activism. Her work tentatively rejected the justifications for social Darwinism, the notion that human beings, too, are evolving and the more fit and better survive. In portraying virtuous Indians undone by vicious Euro-Americans she questioned progress itself.

For most Christian Victorians, the past opened at their feet like a terrifying abyss; indeed one history of geological ideas is called *The Abyss of Time*. But in 1872, not so far away from Yosemite, a Paiute prophet at Walker Lake in Nevada was preaching the Ghost Dance religion that spread among tribes across northern Nevada and California (the second wave of the Ghost Dance, in the 1890s, became far better known and far more widespread). According to his vision, if native people purified themselves and performed certain rituals, the whites would disappear and the dead and the wild animals would come back. It was a desperate vision of redemption from the annihilations brought by whites even then, a sense that the native people were living at the end of time, and a recognition that the homelands whites liked to portray as pristine wilderness were already losing their wildlife. Muir and the Ghost Dancers would have never found common ground in the circumstances of their time, but they shared the view that our peril

lay in the future (what upset Muir about Gray's AAAS talk on sequoias was his suggestion that they were a dwindling species whose vanishing from the earth would be hastened along by man; Gray may well be right). In 1892 Muir, Joseph LeConte, the painter William Keith, and some of their friends founded the Sierra Club, in part to forestall some of that devastation.

Now, a century and a third later, a Paiute woman named Debra Harry runs the Indigenous People's Council on Biocolonialism from her home at Pyramid Lake in Nevada, and she too seems to be preaching against the foreclosure of the future. I get e-mail updates from her every week. Her concern about what legacy we will leave to future generations is pragmatic, and it wrestles with science—not the science of observation that prevailed in Yosemite but the science of manipulation and intervention. For the science of our time, corporations seem to have replaced religion in giving scientists reasons to reject information or interpret it according to certain premises, and some defenders of the safety of chemicals, drugs, genetic manipulations, and the nonexistence of global warming have a vested interest, though others argue sincerely. The means and rate of transforming nature have accelerated all through the twentieth century, and by the 1960s it was clear the effects were entering into the biochemistry of the wild world, back when DDT was thinning the eggshells of raptors. The Mexican birthplace of domesticated corn has of late been plagued by transgenic corn, whose genes are pollinating and mutating the original varieties of the grain. Ignacio Chapela, the Berkeley scientist who first reported this loss of biodiversity, was persecuted by his peers, vindicated by a second study, and denied tenure anyway. This week as I write, a news story Harry forwarded to her list-serve opens, "An Italian fertility doctor who has claimed that several women are carrying cloned babies said Tuesday that one of the children would be born in early January." (This story was never confirmed.) A newspaper story today reports that "when naturalists first hiked through Glacier National Park more than a century ago, 150 glaciers graced its high cliffs and jagged peaks. Today, there are 35. The cold slivers that remain are disintegrating so fast that scientists estimate that the park will have no glaciers in thirty years. . . . The melting in Montana is being mimicked around the world, from the snows of Mount Kilimanjaro in Tanzania to the ice fields beneath Mount Everest in the Himalayas." Weather and the sky are nature on the grandest scale, and to find that we have altered them is to see human beings cease to be midsize mammals and become a kind of miasma spreading to the heavens, just as nuclear physics and genetic engineering have penetrated the microcosmos.

Perhaps the conflict is about how much faith we have in man, in the ability of scientists and managers to make sane decisions—and how far into the future the impact of those decisions should be measured, how long a sense of time is required. Environmentalists and Indians are often arguing for the big picture, for the right choices for the millennia; their opponents are focused on maintaining profits and the present order, though that order is the culmination of extreme changes in technology, geography, and population in the past century. In Yosemite, I've seen military overflights that a park naturalist told me chased the peregrines from their nests, seen smog from the urban coast blow into the valley, seen smoke from hundreds of campfires rise into an asthma-inducing inversion layer by midmorning.

When we rephotographed Ansel Adams's view of Cathedral Rocks (p. 76), I was surprised how close to the road his standpoint was, but charmed by the noisy frogs in the meadow pool visible in the picture, until I found that these bullfrogs were an introduced species displacing the endangered red-legged frog. Yosemite itself has been developed again and again to accommodate mass tourism in this version of Paradise. Most of the changes have been constructions, but one great removal is invisible, the dynamiting of the terminal moraine at the west end of the valley. The moraine functioned as a natural dam, keeping the soil wetter and the river wider. When it was removed, the great flooded reflective

expanses of Bierstadt's Yosemite paintings vanished too. It's easy to watch the sky with suspicion and wonder about how natural the weather is, and it's not unusual to scan the landscape and wonder what's missing, what species, what patterns, what order has been eviscerated. The most beautiful and wild places can raise these questions most intensely, because we value these places not for being independent of us—that credo wore out—but at least for making us only part of a larger order. The Victorians found their shrinking role on earth terrifying and saw a world without God as chaotic, but our enlargement to fill the earth and displace everything else can bring despair and a different sense of chaos. Yet that's not all there is.

What comes back to me is a short trip I made with some other friends the Easter before our second rephotographic trip to Yosemite. We pitched our tents at Camp Four, the walk-in campground near El Capitan that the climbers all stay at, and they wandered by in the dark, their racks of caribiners and other gear making them clank like knights in armor. We had bought the same wood at the store everyone else in the campground had, almond wood, which burned with a choking acrid smoke that made me wonder about pesticide absorption. My friends remembered passing signs for "Angel's Orchard Removal," and we realized that this wood was from orchards being cut down for development (sprawl into the incomparably rich farmland of the San Joaquin and Sacramento valleys is among California's many unfolding disasters). In other words, we urbanites pretending to be in the wilderness were helping to burn down the truly rural being overtaken by suburbia, and that was a realization as foul as the smoke.

But early in the morning, twice, from that campground, I dashed up the Yosemite Falls trail to the closest point it gets to

Byron Wolfe, *Stone staircase, late afternoon descent from Upper Yosemite Falls*, 2002.

the bottom of the upper fall, a third or half of the way up. Springtime's high water made the fall thunder amazingly, and its mist reached me long before I got anywhere close. The roaring water from the cliff's edge thinned, swayed like drapery, dispersed into mist as it fell those hundreds of feet. It looked as though none of it actually reached the bottom of the fall, but was swallowed up by the air. At the base of that fall was a huge cone of ice, from which another torrent flowed into the second fall, as though the ice were a holy grail that could pour forth water forever without running dry. Water was water, was ice, was mist, vanished into air, emerged out of it, seemingly dying and being reborn in that strange space, as though other forces governed it than the usual ones, or as though those forces were somehow concentrated there into something uncanny. And this kind of experience happens over and over again in places like Yosemite: the place reminds you that it is bigger and more mysterious than your descriptions, your pictures, your theories, your predictions, that your own timescale is tiny compared to the forces of geology, erosion, evolution. You can measure destruction but not glory. This, I think, is what Muir felt, and it's why his real work was as a poet, not a scientist, why his factual descriptions are always sliding over into invocation and evocation, and why joy is so important in his writing. He realized that there are things that exceed our abilities to define or destroy. Thoreau famously said that "in wildness is the preservation of the world"; Muir saw that in some way it lay in human smallness, in the forces that remained beyond us. That eternal beyond was the source of his hope and, though it has been reduced considerably since, is, perhaps, of ours.

—REBECCA SOLNIT

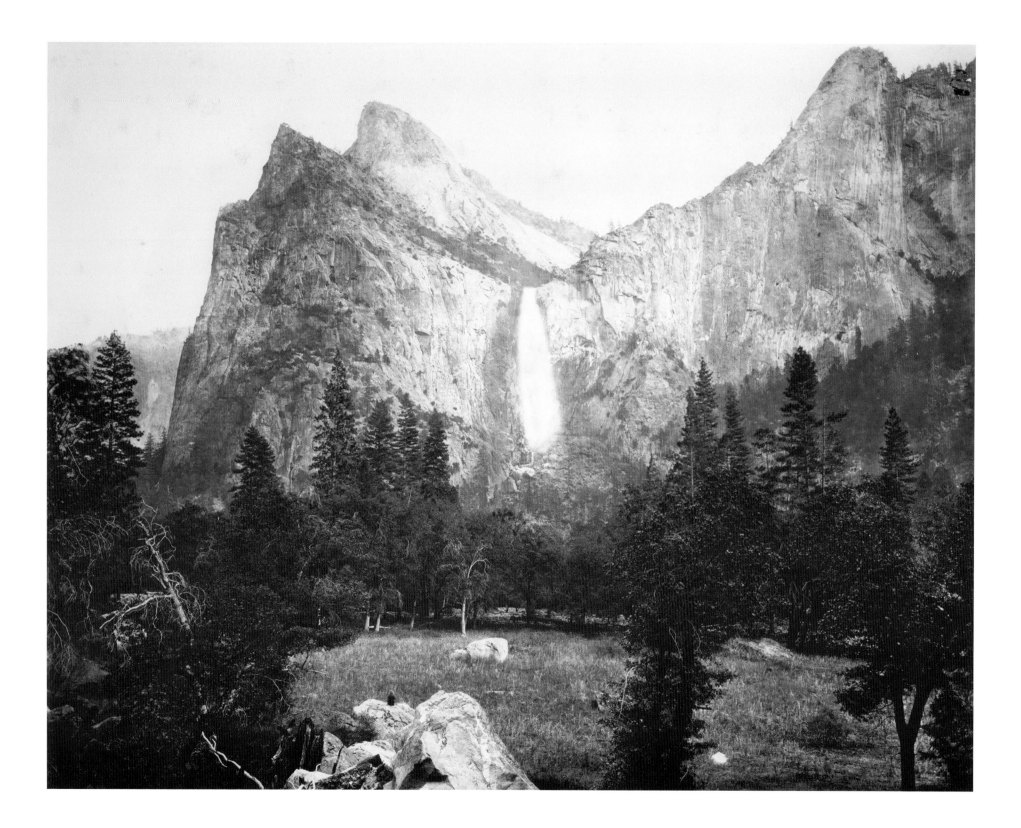

64 Eadweard Muybridge, *Pohona, Valley of the Yosemite. No. 6*, 1872. (More commonly known as Bridalveil Falls.)

Mark Klett and Byron Wolfe, *View from the old road on the valley's north side across an overgrown meadow*, 2002. 65

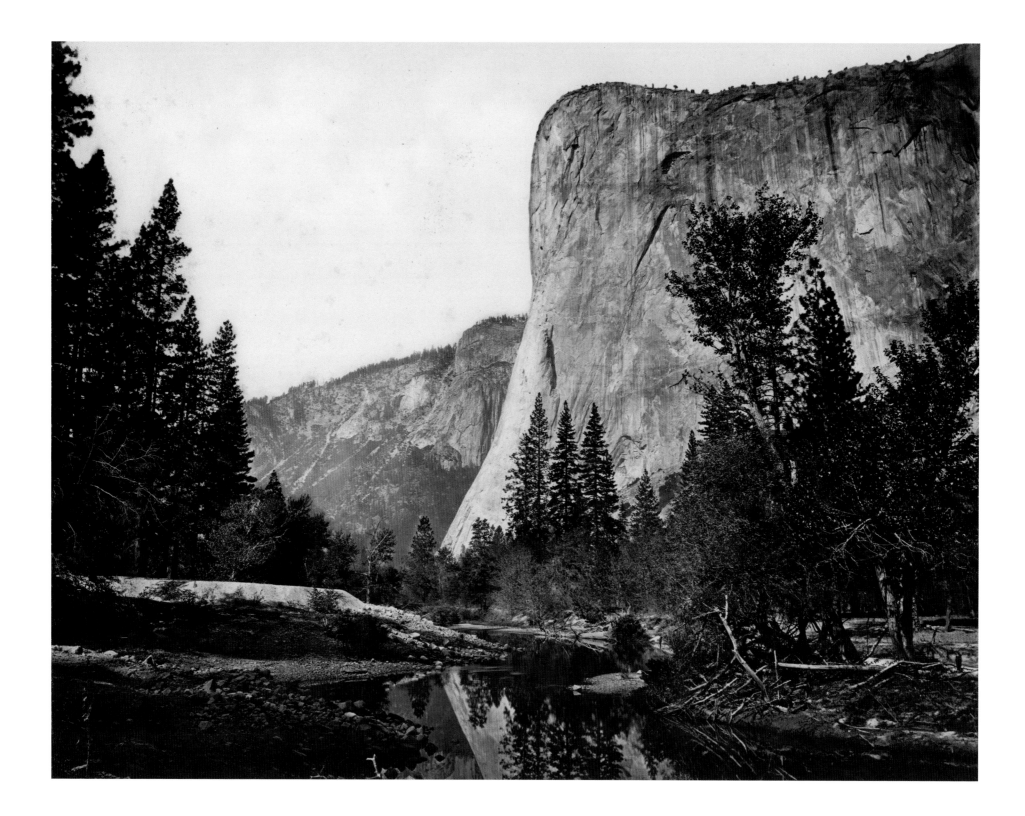

66　Eadweard Muybridge, *Tutocanula, Valley of the Yosemite. The Great Chief "El Capitan." 3500 Feet High. No. 9*, 1872.

Mark Klett and Byron Wolfe, *El Capitan from the bank of the Merced River, Yosemite Valley*, 2002. 67

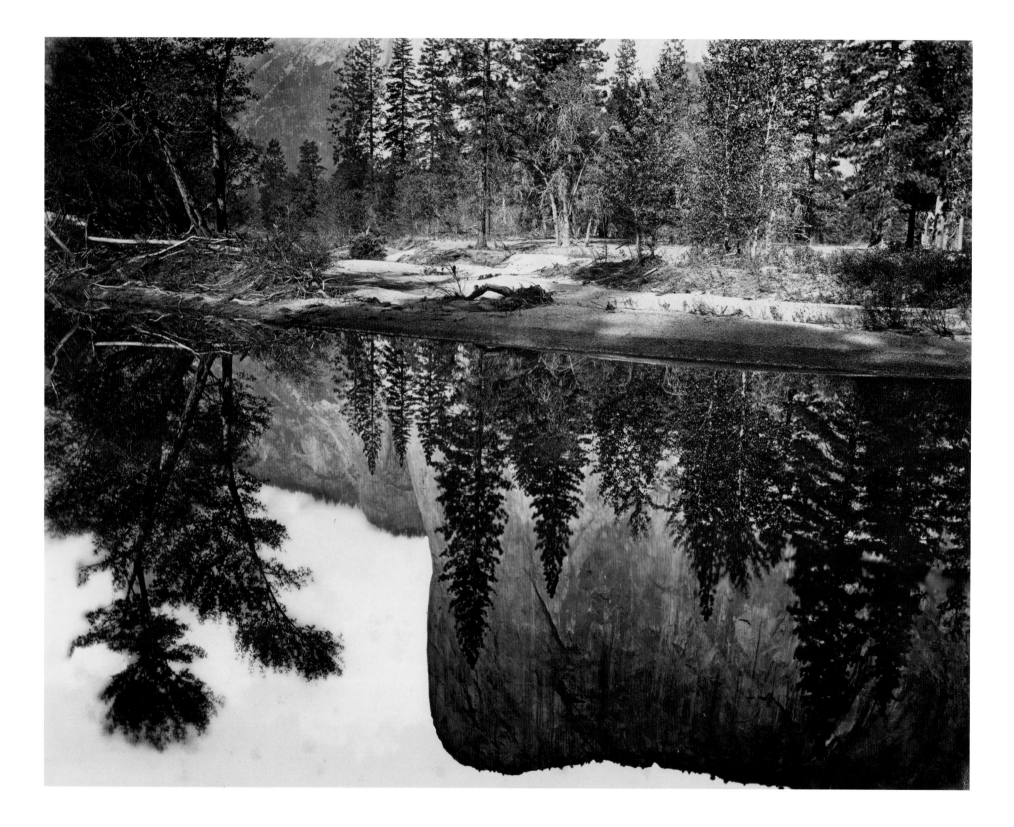

68 Eadweard Muybridge, *Tutocanula, Valley of the Yosemite. (The Great Chief) "El Capitan." Reflected in the Merced. No. 11,* 1872.

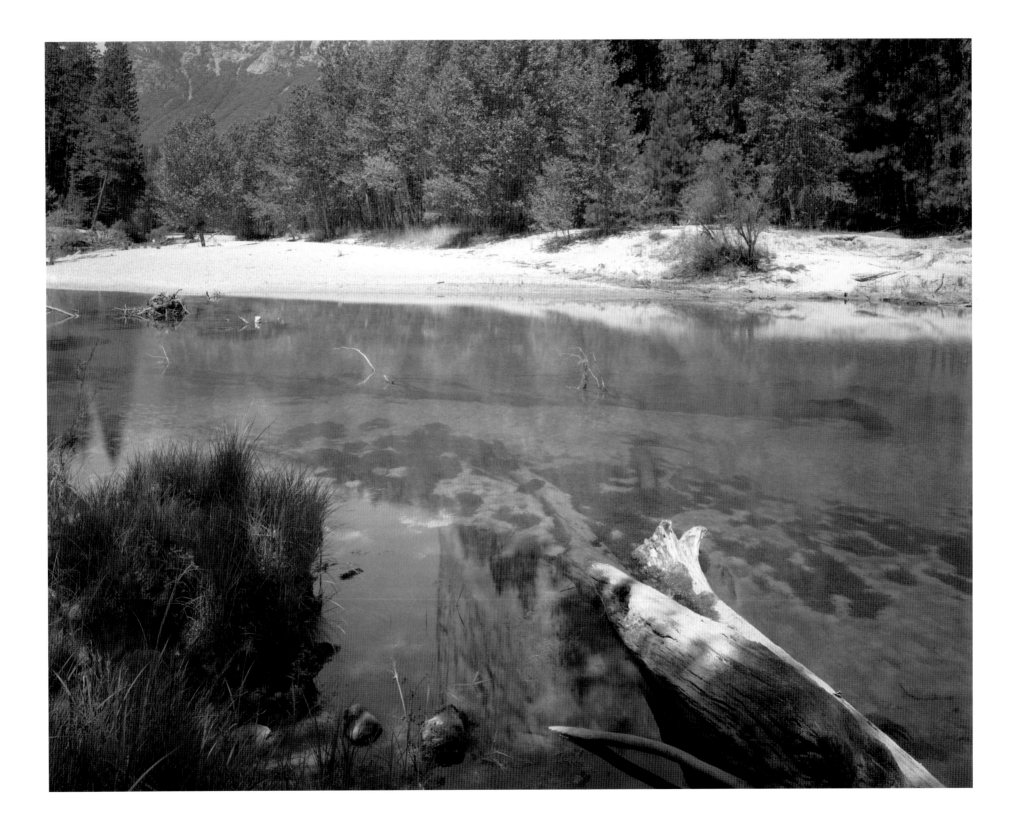

Mark Klett and Byron Wolfe, *Reflection of El Capitan from the waters of the Merced River, using panchromatic film*, 2001. 69

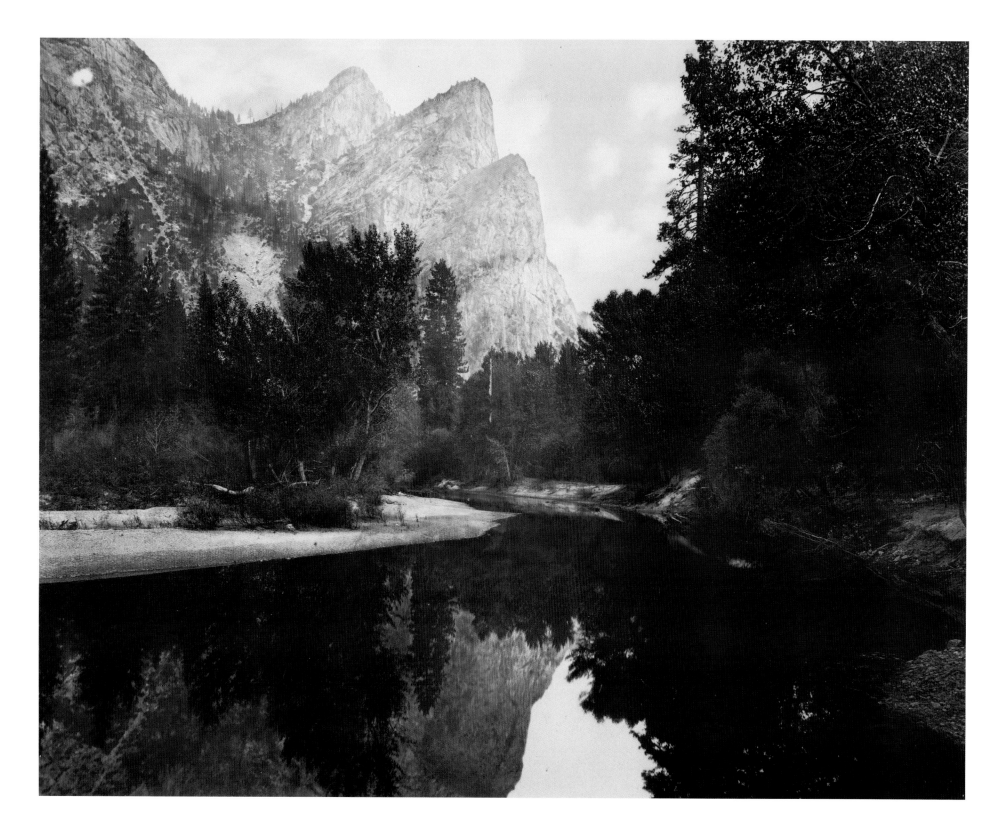

70 Eadweard Muybridge, *The Pompons. Valley of the Yosemite. (The Jumping Frogs) "Three Brothers." 4300 Feet High. No. 12,* 1872.

Mark Klett and Byron Wolfe, *Former bed of the Merced River, approximately 100 meters north of where the river now flows,* 2001.

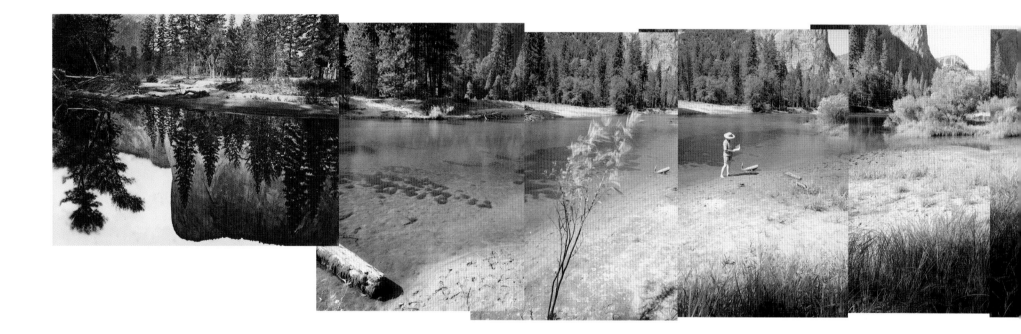

72　Mark Klett and Byron Wolfe. *Panorama of a ghost river, made over 100 meters and two days beginning and ending with Muybridge's mammoth plates No. 11 and No. 12*, 2001.

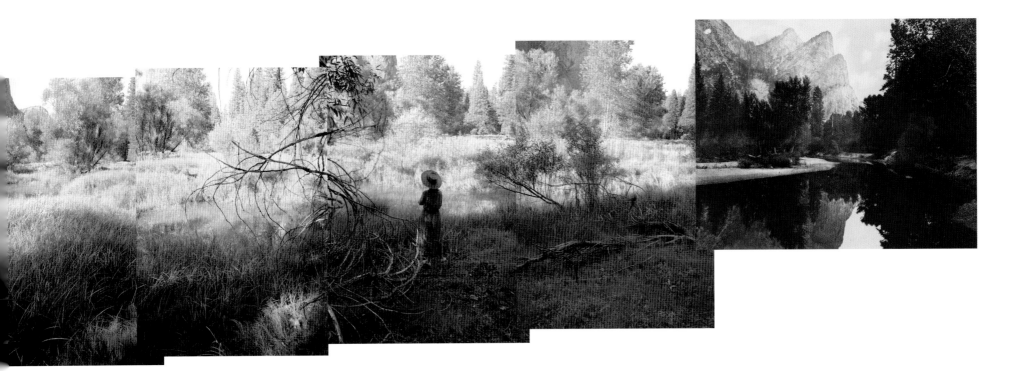

74 Ansel Adams, *Mount Gibbs, Dana Fork, Upper Tuolumne Meadows, Yosemite National Park*, c. 1946.

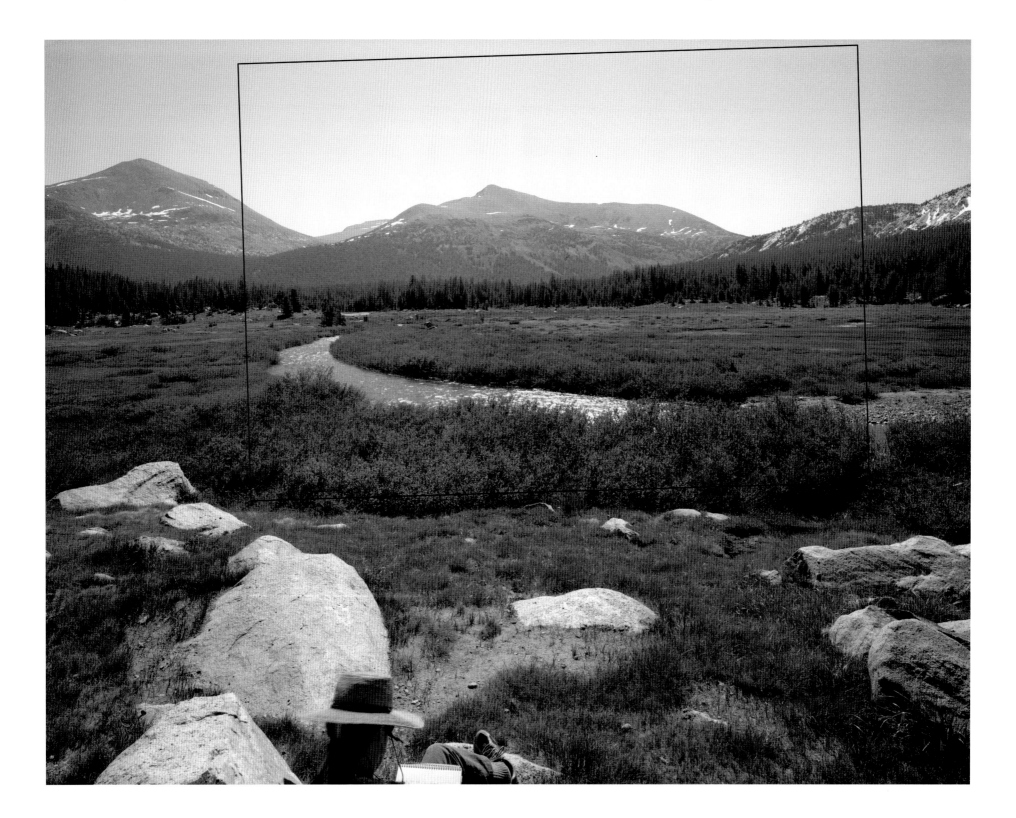

Mark Klett and Byron Wolfe, *Dana Fork, Upper Tuolumne Meadows from the side of the highway,* 2003. (Rectangle indicates cropping of Adams's photograph.) 75

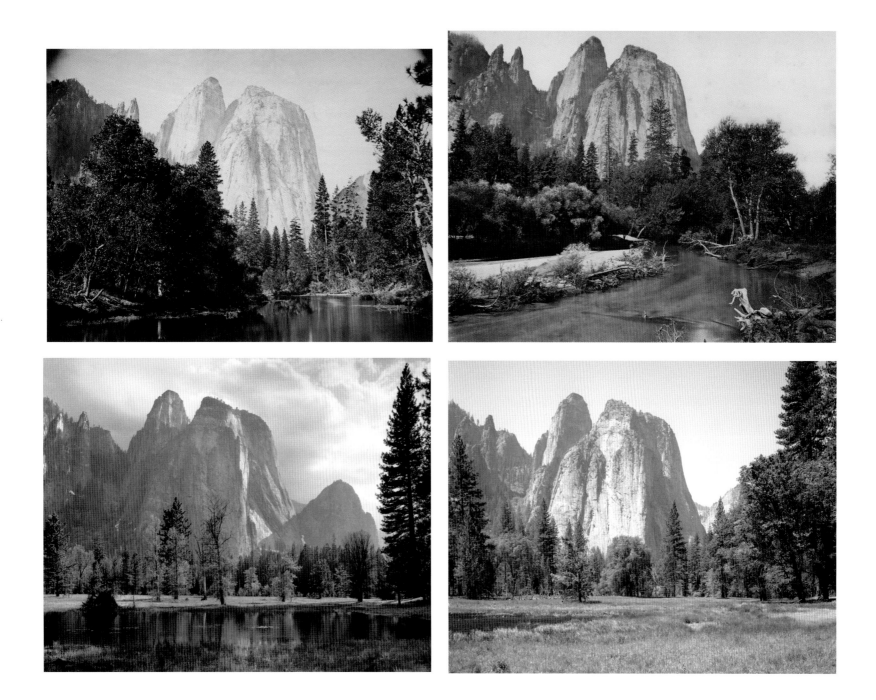

76　*Four Views of Cathedral Rocks.* Top left: Carleton E. Watkins, 1861. Top right: Eadweard Muybridge, 1872. Bottom left: Ansel Adams, c. 1944. Bottom right: Mark Klett and Byron Wolfe, 2002. (The last view is made from Ansel Adams's camera position, using lighting consistent with versions by Eadweard Muybridge and Carleton Watkins.)

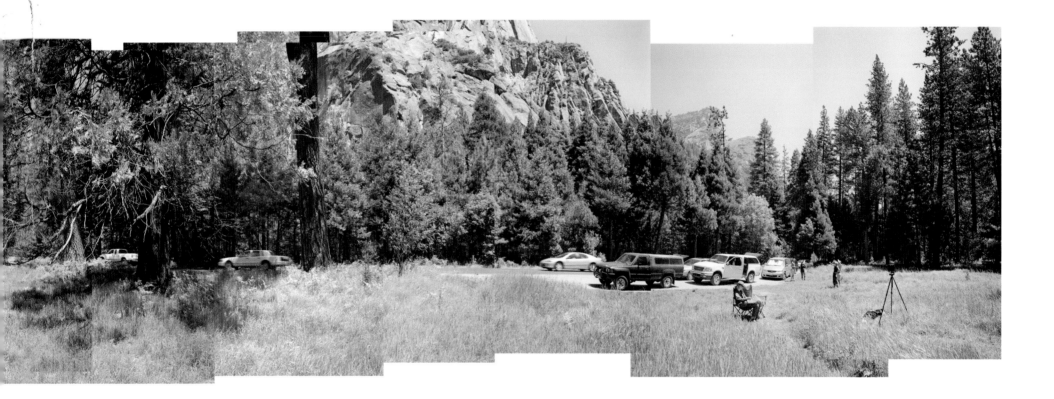

Mark Klett, *Panorama showing Ansel Adams's camera position for Cathedral Rocks, by the side of the road*, 2002. 78

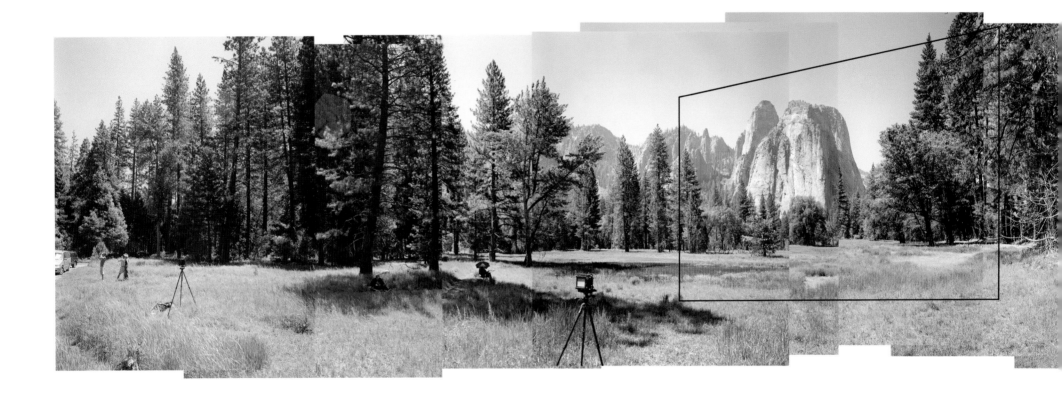

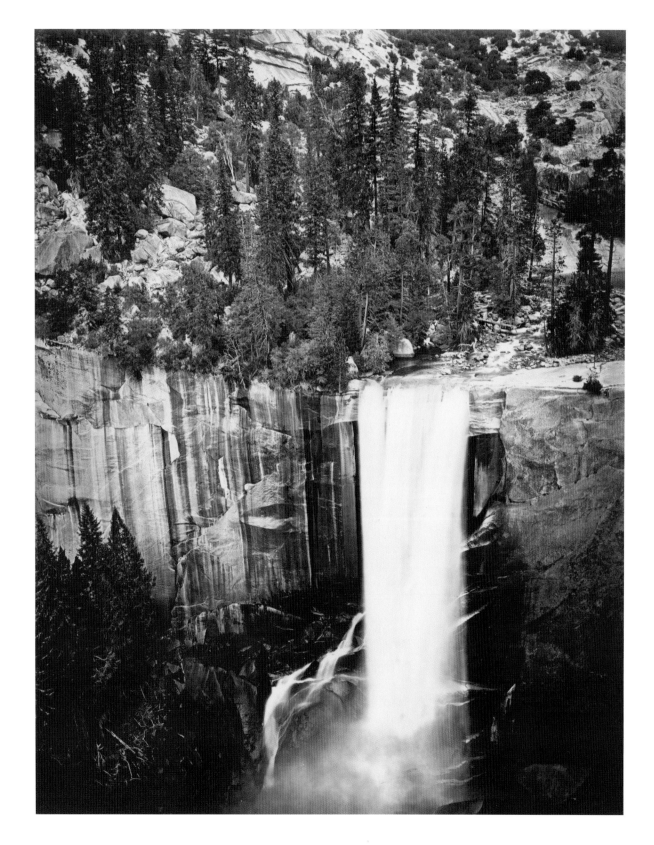

Eadweard Muybridge, *Pi-Wi-Ack (Shower of Stars). "Vernal Fall," 400 Feet Tall. No. 29,* 1872.

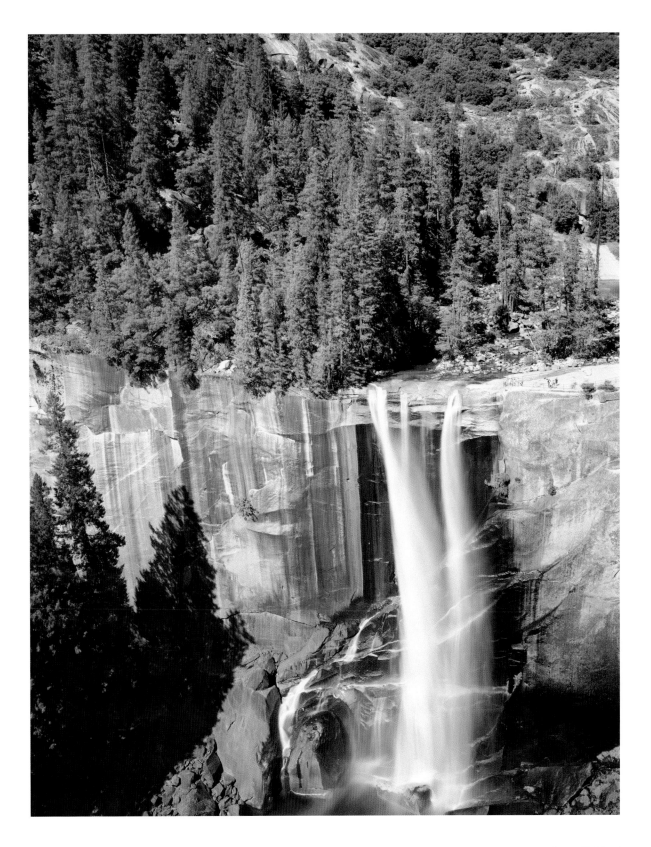

Mark Klett and Byron Wolfe, *Low water at Vernal Falls*, 2001. 81

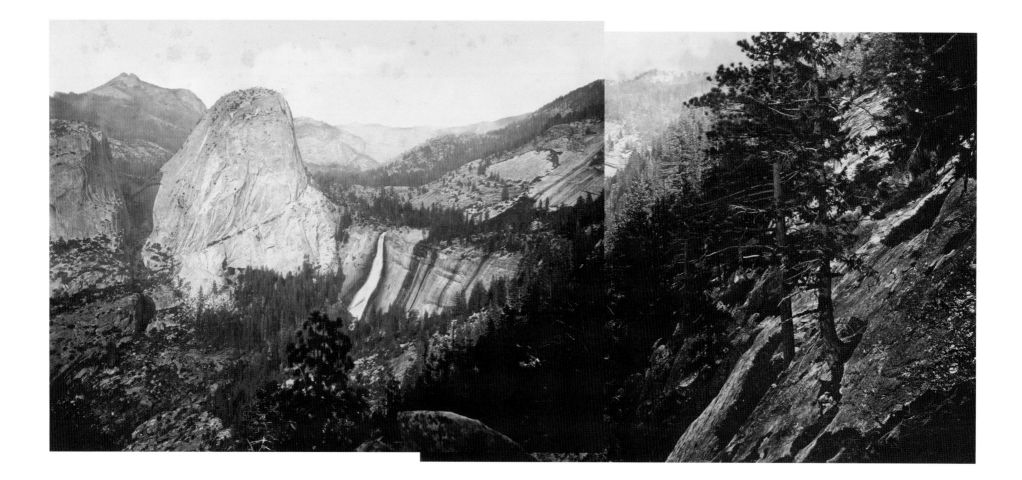

82 Eadweard Muybridge, *Cloud's Rest. Valley of the Yosemite. No. 40;* and *Glacier Channels.*
Valley of the Yosemite. From Panorama Rock. No. 41, 1872. (Combined to form overlapping views.)

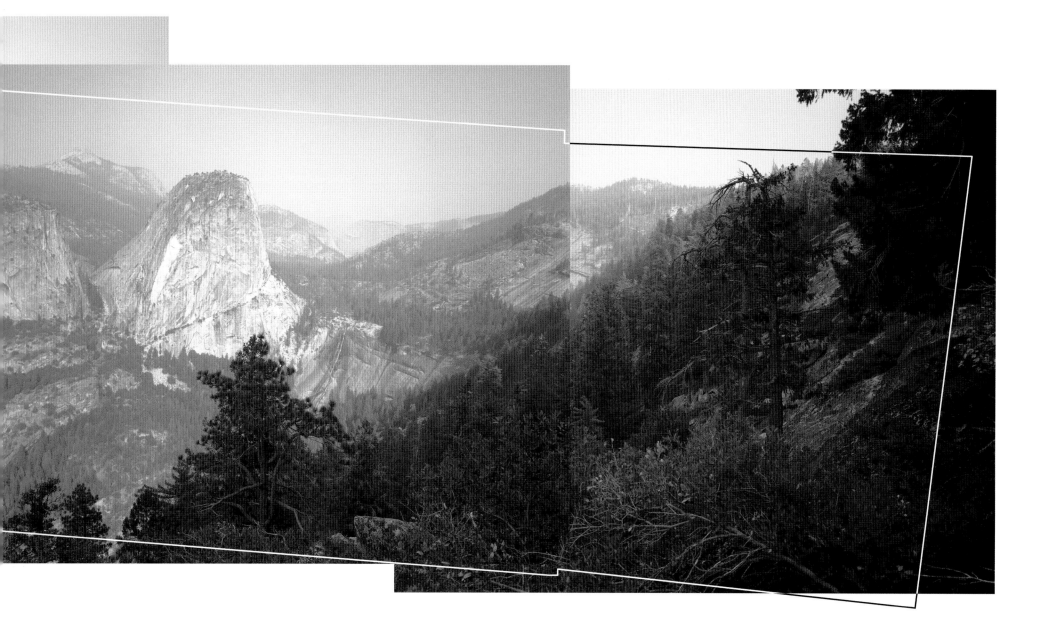

Mark Klett and Byron Wolfe, *Four views from "Panorama Rock," an obscure outcrop off the Panorama Cliff Trail: two* 84 *rephotographs, a speculation on Muybridge's missing plate No. 39, and another photograph added to the left,* 2002.

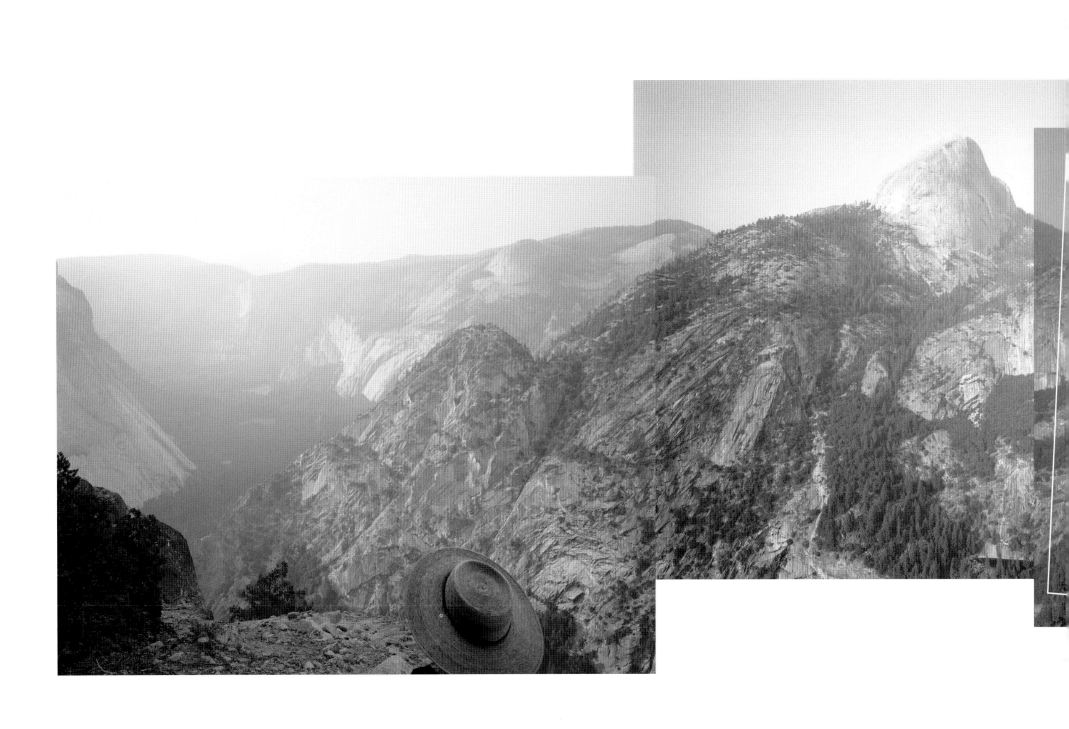

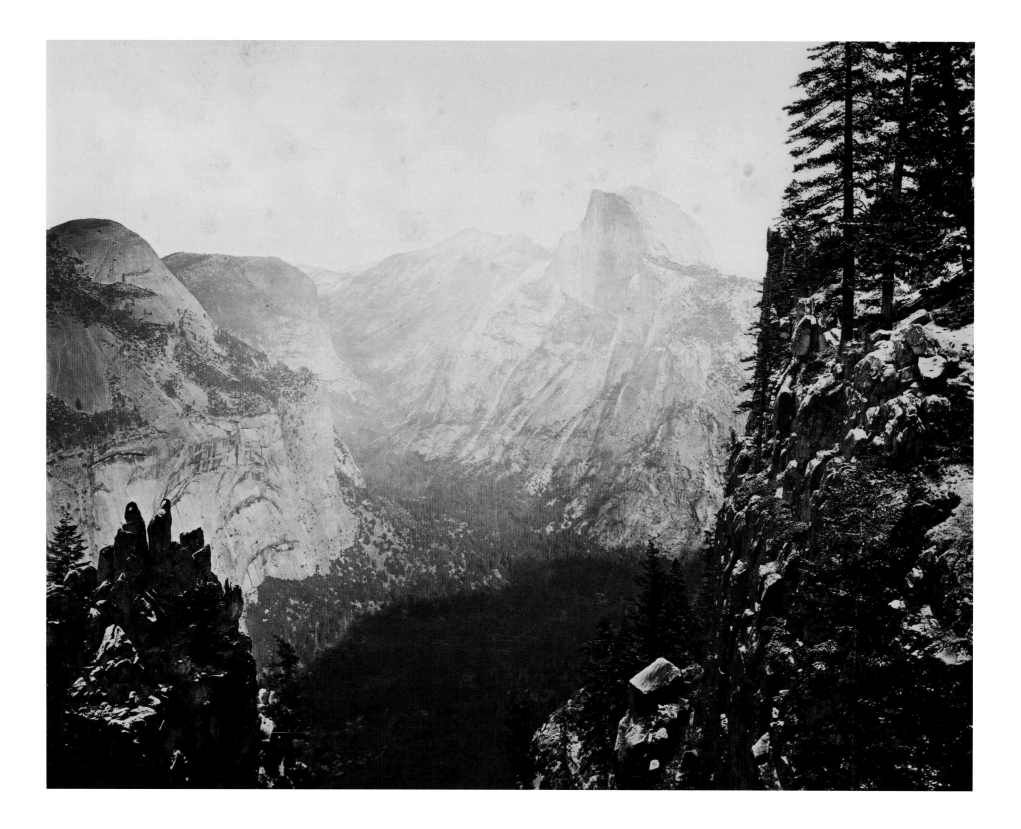

86 Eadweard Muybridge, *The Domes. Valley of the Yosemite. From Glacier Rock. No. 37*, 1872.

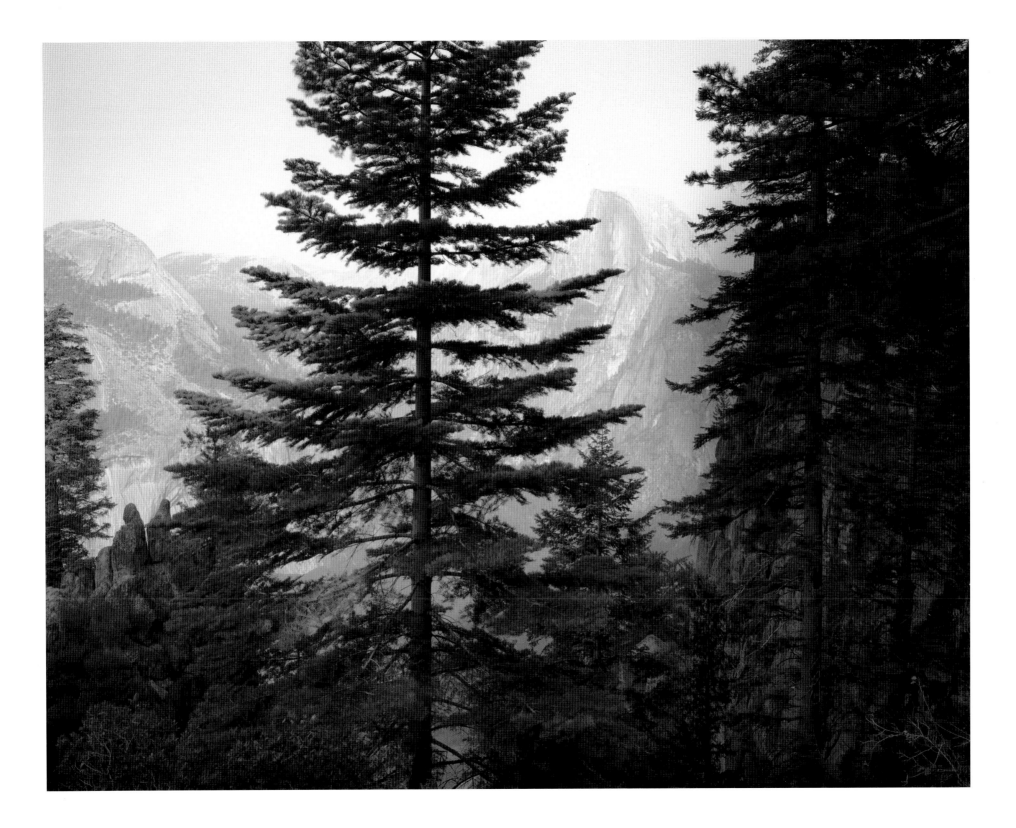

Mark Klett and Byron Wolfe, *View below Glacier Point well off the Four-Mile Trail, now almost obscured by trees*, 2001. 87

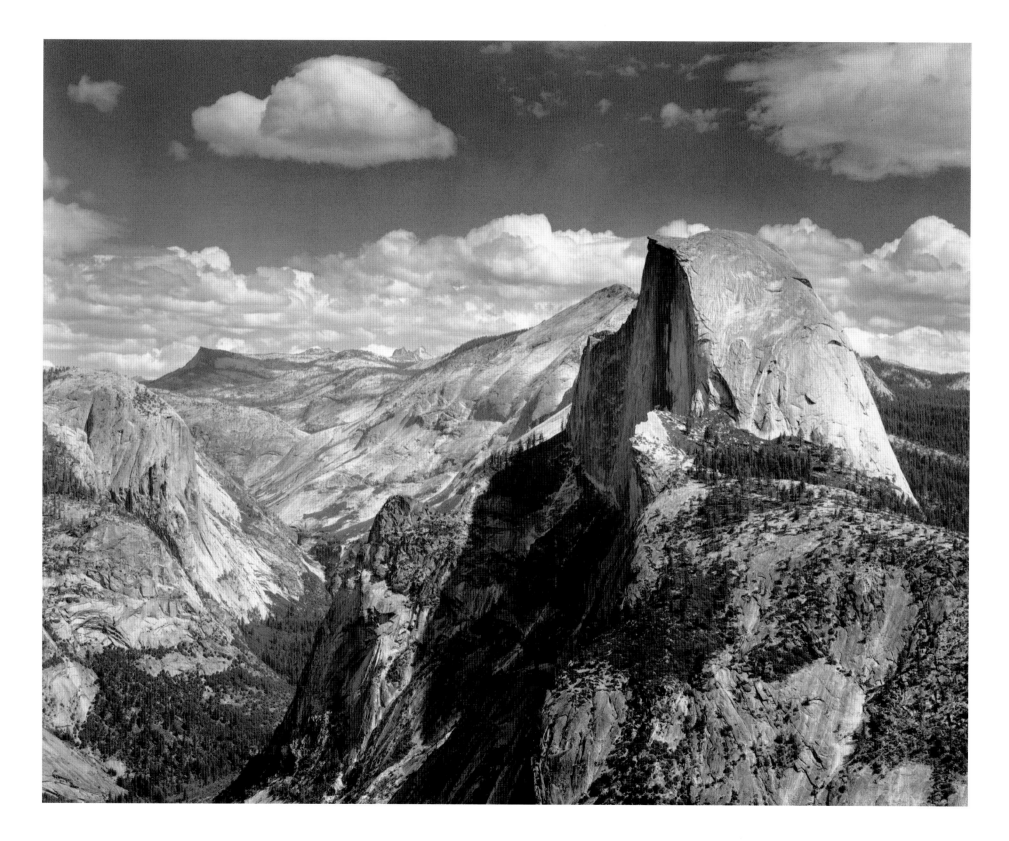

88 Ansel Adams, *Half Dome and Clouds*, 1935.

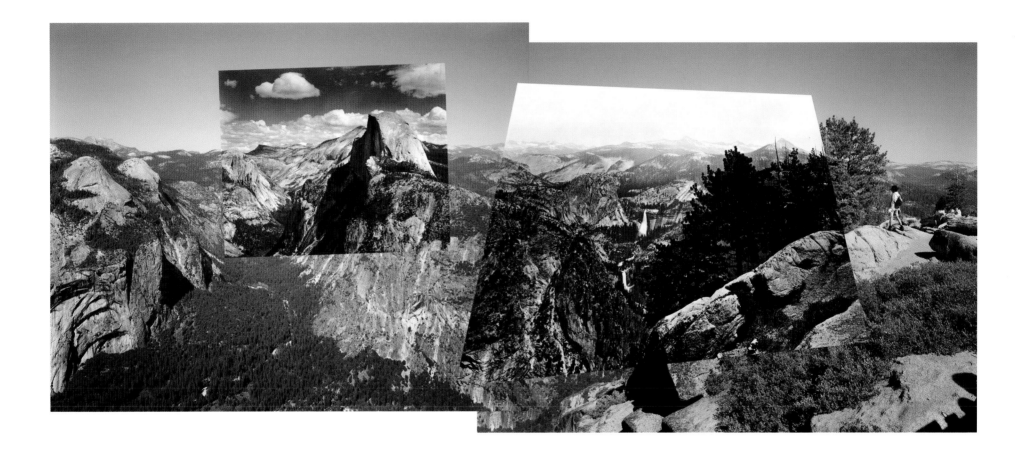

Mark Klett and Byron Wolfe, *View from the handrail at Glacier Point overlook, connecting views from Ansel Adams to Carleton Watkins*, 2003. (Watkins's photograph shows the distorting effects of his camera's movements as he focused the scene.) Left insert: Ansel Adams, c. 1935. Right insert: Carleton E. Watkins, 1861.

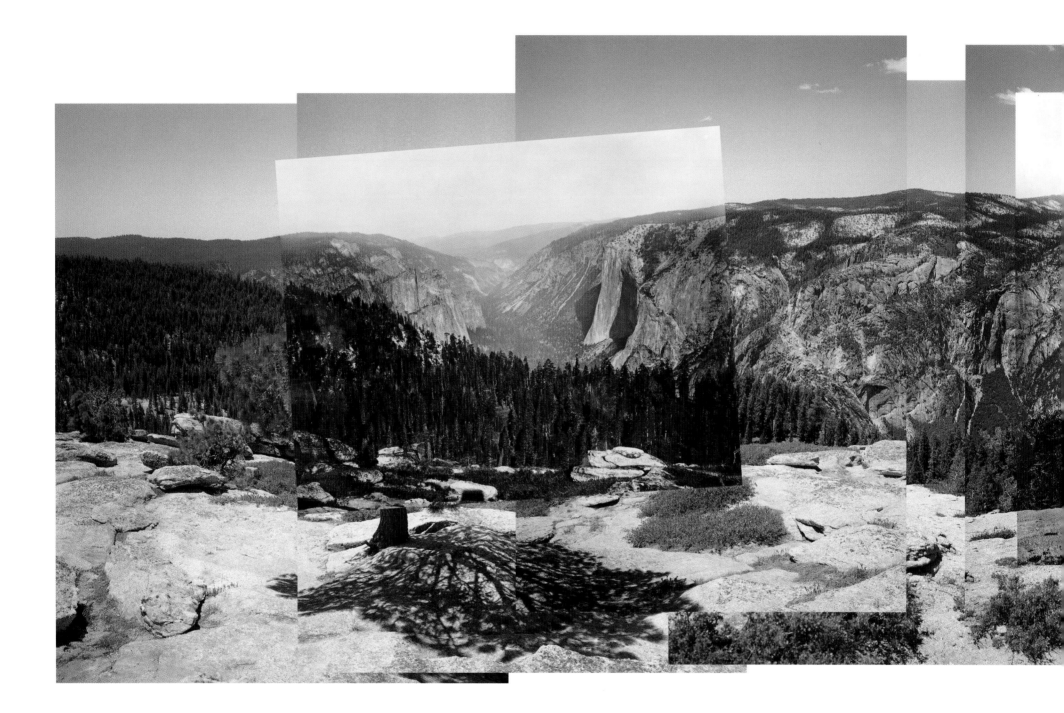

90 Mark Klett and Byron Wolfe, *Panorama from Sentinel Dome connecting three views by Carleton Watkins*, 2003. Left insert: *From the Sentinel Dome, Down the Valley, Yosemite,* 1865–66. Center insert: *Yosemite Falls from the Sentinel Dome,* 1865–66. Right insert: *The Domes, from the Sentinel Dome,* 1865–66.

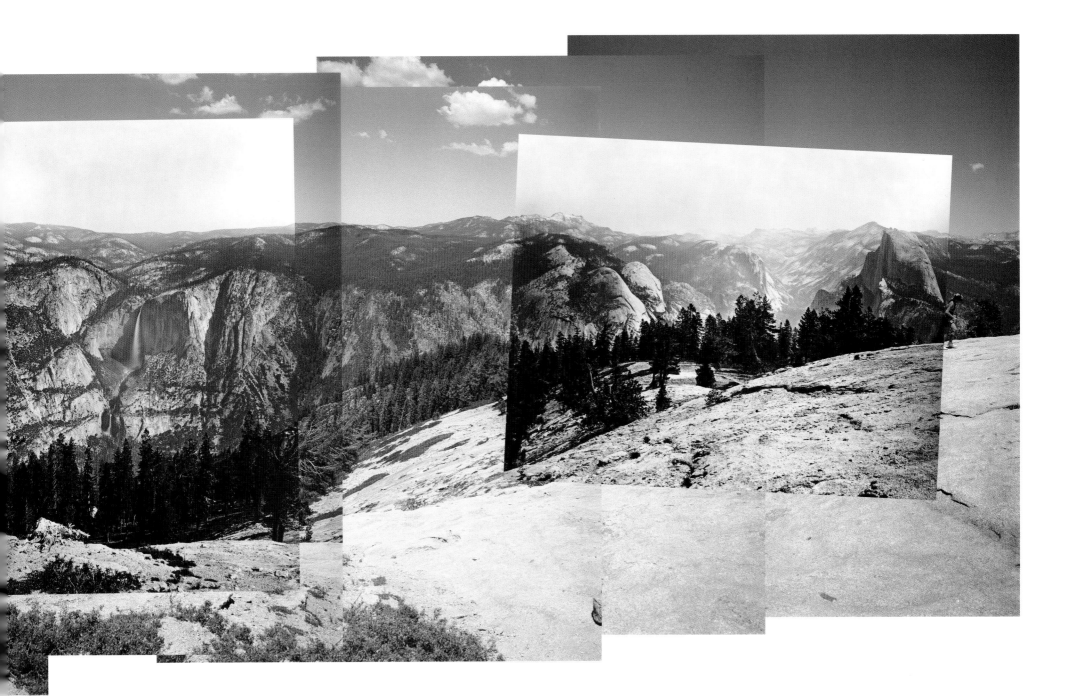

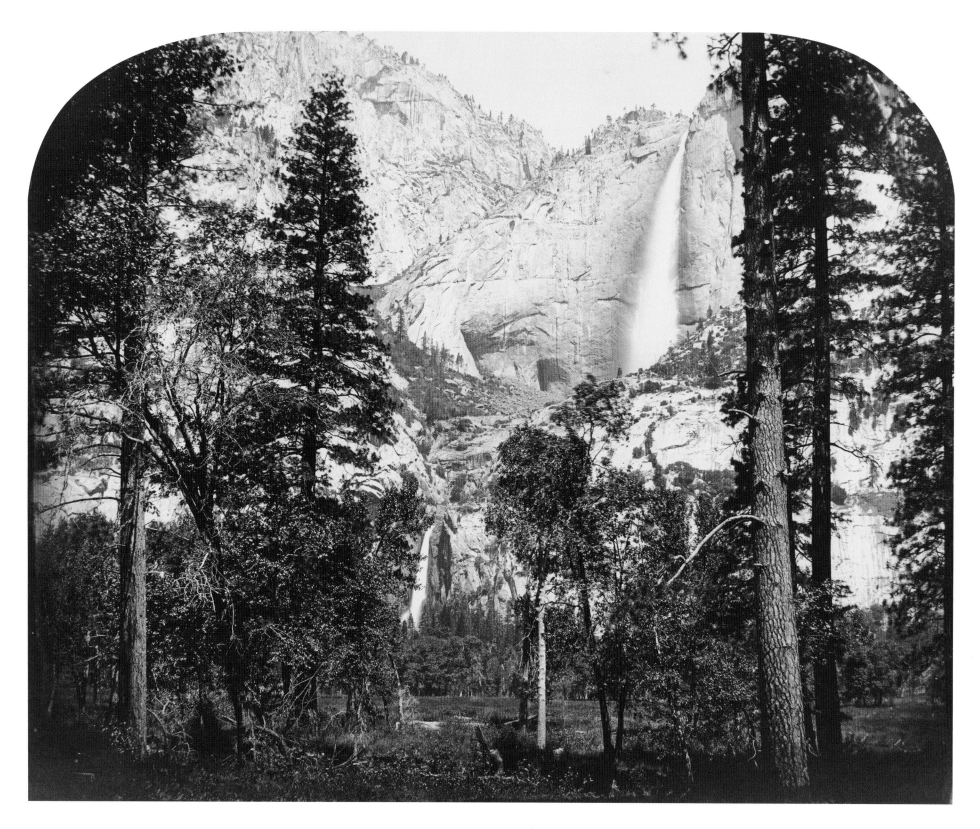

92 Carleton E. Watkins, *Yosemite Falls (From the Upper House), 2477 Ft.*, 1861.

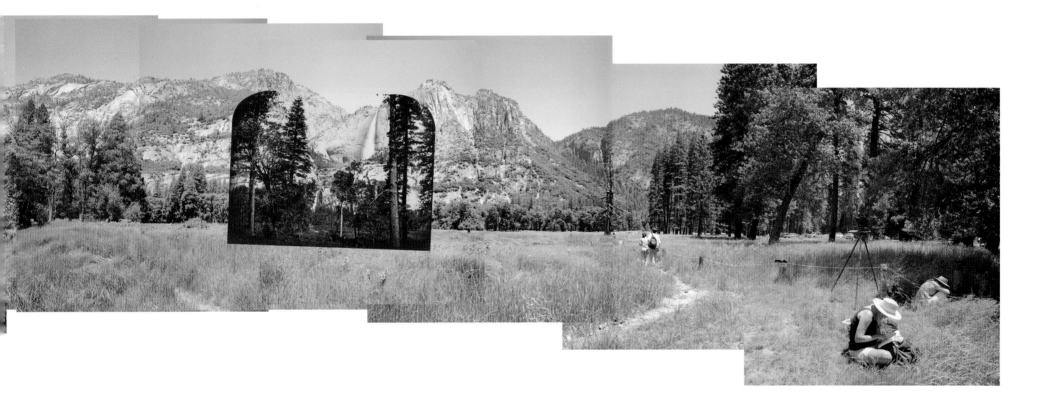

Mark Klett, *Panorama showing Carleton Watkins's camera position for Yosemite Falls and the Merced River*, 2003. 94

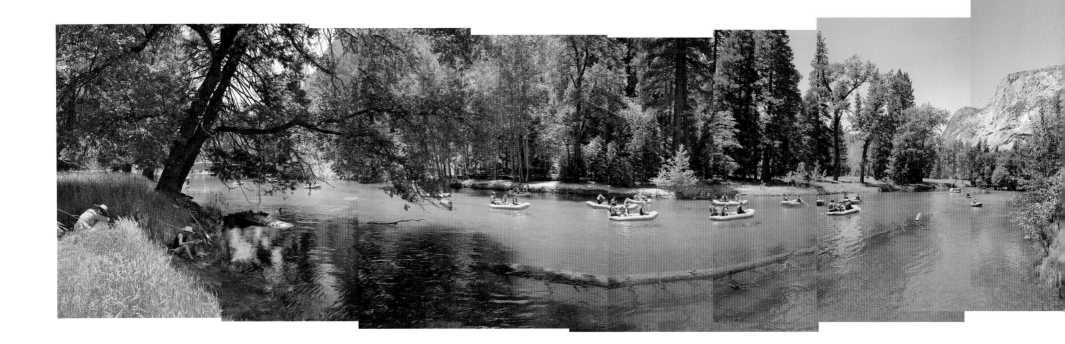

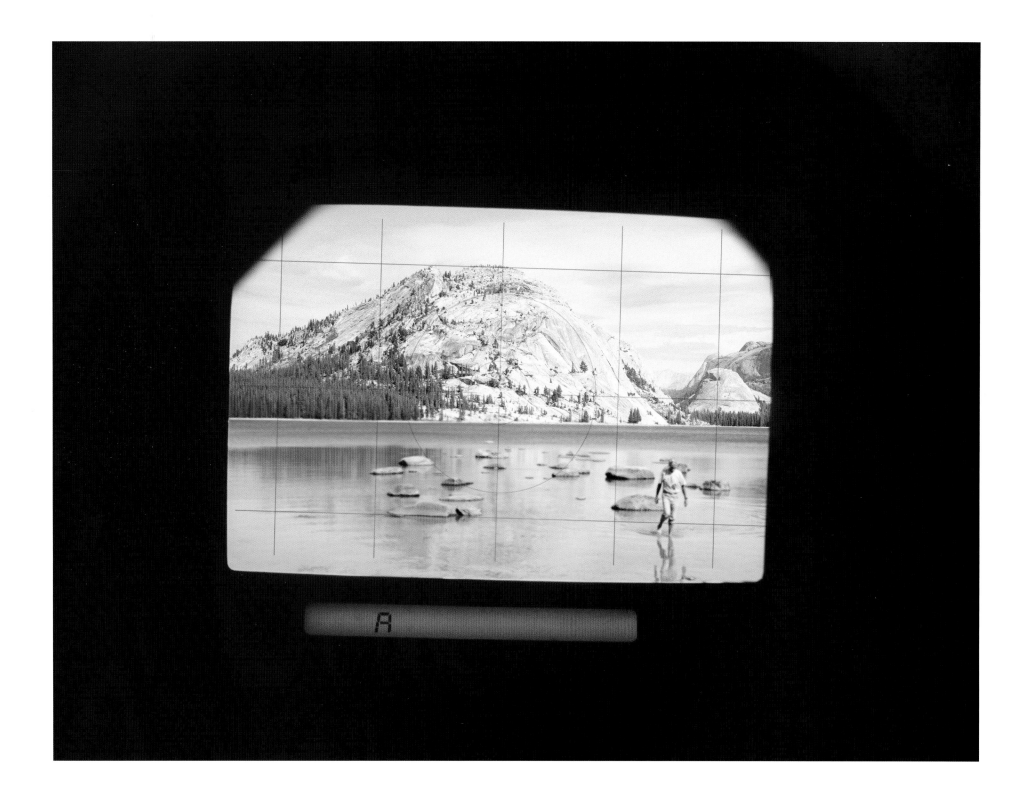

96 Byron Wolfe and Mark Klett, *Through the widower's viewfinder as he returns to shore, Lake Tenaya*, 2002. (Photo illustration.)

BACK AT THE LAKE WITH TWO NAMES

OR THE POLITICS OF THE PLACE

For I have learned
To look on nature, not as in the hour
Of thoughtless youth, but hearing oftentimes
The still, sad music of humanity. . . .

—WORDSWORTH, *"Lines Written a Few Miles Above Tintern Abbey"*

THE WAY THERE

On Monday, July 30, 2001, we located the site where Eadweard Muybridge had, 129 years before, made his photograph *Ancient Glacier Channel at Lake Tenaya*, the first we found and rephotographed (p. 122). Of all the sites of his photographs we explored, this one seemed to show the least change. The same crack ran down the glacial polish, hardly enlarged since his time, and not only the same boulders but some of the same smaller stones were in the same place, though the trees had changed. They were newer in the twenty-first century than they had been in the nineteenth. Where one old lodgepole pine had stood in a small patch of soil, a young one with a thinner, darker trunk grew, and a dense grove of young pines

97

filled in where a stand of older trees had been. Truth is like rock. But meaning is like the pines.

The glaciers that made this place many thousands of years ago made it literally, scooping out the basin of the small lake, rounding the peaks into domes, grinding the long sheets of granite into the finest glacial polish anywhere on earth. The shape and the surface of the Lake Tenaya region come from glaciers. But its meaning comes from things that aren't so solid or so easy to see. On or about June 5, 1851, a contingent of the Mariposa Battalion of volunteer soldiers arrived at this lake. This first white incursion into the area had begun earlier that spring, when the battalion led by James Savage had marched in to remove or annihilate the longtime inhabitants of Yosemite, who were interfering with the economic development of the region. Among the contingent of prisoners and captors who arrived at the lake that early June of 1851 was an old man, sometimes secured by a rope around his waist: Tenaya, the leader of inhabitants of Yosemite Valley. Sometimes holding the other end of the rope was a young man soaked in the romantic landscape traditions of Europe and the East, Lafayette Bunnell. Bunnell's is the main account of what transpired there that bloody spring, and his book is a peculiar mix of rhapsodic responses to the place and indifferent and scornful ones to the landscape's inhabitants. It is in his responses to scenery, not people, that he attempts to demonstrate his humanity and his civility.

"As I lowered my line of vision to the base of the cliff, to trace the source of the smoke, there appeared the Indian village, resting in fancied security, upon the border of a most beautiful little lake, seemingly not more than half a mile away," wrote Bunnell. "The granite knob was so bare, smooth and glistening, that Captain Boling at once pointed it out, and

selected it as a landmark. He designated it as a rallying point for his men, if scattered in pursuit, and said that we should probably camp near it for the night." The inhabitants of the village—all kin of Tenaya—were captured and held overnight. As they led the prisoners away that cold morning, Bunnell decided to name the lake, just as he and his comrades had so many other features they'd encountered on their military campaign, and to name it after the old leader. "I called him up to us," recounted Bunnell, "and told him that we had given his name to the lake and river. At first he seemed unable to comprehend our purpose, and pointing to the group of glistening peaks, near the head of the lake, said 'It already has a name; we call it Py-we-ack.' Upon my telling him that we had named it Ten-ie-ya, because it was upon the shores of the lake that we had found his people, who would never return to it to live, his countenance fell and he at once left our group and joined his family circle. His countenance indicated that he thought the naming of the lake no equivalent for his loss of territory."

The transaction stunned me when I first read it fifteen years ago or so. It seemed an indelible part of what the place meant, and it raised huge questions about what we see in the landscape and how we connect—or don't—those visions. Yosemite became the subject of the second half of my 1994 book *Savage Dreams: A Journey into the Landscape Wars of the American West,* the book where I started to find out how I would write, what my subject was, and what it might take to call the West home. The places I spent time at taught me these things, or demanded these things of me. Of this pivotal encounter I wrote, "Usually annihilating a culture and romanticizing it are done separately, but Bunnell neatly compresses two stages of historical change into one interaction. Bunnell

says, in effect, that there is no room for these people in the present, but they will become a decorative past for someone else's future. Pyweack means shining rocks; like most of Yosemite's original place names, it describes what is present rather than monumentalizing a passing human figure. Tenaya is a name given from outside, neither about the lake nor about the man, but about an unpleasant incident almost entirely forgotten by Yosemite's visitors. Bunnell claims to Tenaya that the new name will give him a kind of immortality, but what he is really doing is obliterating Tenaya's culture from the place and beginning its history over again. Rather than immortality, he is promising Tenaya oblivion."

The name is as permanent as any local place name could be, and it is also the name of the creek that flows out of the lake and the canyon the creek flows through, but the incident is largely forgotten. The 1851 incident is, if not the whole meaning of the place, at least part of it, the missing part. Slaughter sometimes does nothing more in the long run than fertilize the fields, so that the rice or the maples will grow thicker and lusher than before. A battlefield or a crime scene seldom looks violated for very long, if it ever does. Lake Tenaya never did. At the beginning of her novel *Beloved*, Toni Morrison wrote about her protagonist, a runaway slave, reflecting that the slave plantation landscape she had escaped "never looked as terrible as it was, and it made her wonder if hell was a pretty place too. Fire and brimstone all right, but hidden in lacy groves. Boys hanging from the most beautiful sycamores in the world. It shamed her—remembering the wonderful soughing trees rather than the boys." Yosemite is supposed to be a place about wonderful trees rather than, for example, the sons of Chief Tenaya who inspired Bunnell's companions to name the formation on the south rim of the valley Three Brothers, because the three boys were captured and killed there. The meaning of the place is supposed to be visual; it's a national park because it's visually spectacular; and we know it largely through images. Images tell much, leave much untold.

In 1991, I entered Yosemite like a detective on the cold trail of an old crime, and it took me months to find out what had happened after the Mariposa Battalion tried to move the tribe out. Most of the standard accounts I read suggested that the Ahwahneechee had just faded away, so their claims and meanings were no longer an issue. The more I dug, the more the date of their disappearance moved forward, later in the nineteenth century, then the 1920s, the 1930s, the 1960s. Finally I found that many lived in the vicinity, and one direct descendant of the valley's inhabitants had been born there and was living there still, working as a forester and fighting for the rights of his tribe in his spare time. (He was evicted from his Park Service at the end of 1996, when he retired, and the following day epochal floods relandscaped the valley and removed some of the development, pretty much what his father said would happen when their people had all left the valley.)

The Ahwahneechee—a subgroup of the Central Sierra Miwok—hadn't disappeared from anything but the popular imagination and the official version—but those are important arenas to appear in, or not. Bunnell's book was called *The Discovery of the Yosemite and the Indian War of 1851 Which Led to That Event*; the premise of my book was that the war hadn't ended, that the Indian wars that were supposed to be our shameful past were part of the present, just as the nuclear wars—the subject of the other half of *Savage Dreams*—were not a terrible eventuality but the invisible present, with about one nuclear bomb tested every month between 1951 and 1991 at

the Nevada Test Site. These Indian wars long ago just dropped out of sight for most non-native people. They are fought in courtrooms and legislatures and in photographs and poetry and history textbooks. And people still die in these wars.

Yosemite has always been visual, and the visual is of the moment, of the light of this very instant of clearing after the rain, of this very sunrise, of this very season. It would be terrible if history permanently stained the appearance of things, but it is terrible that so often we know nothing more than appearances. That trees survive lynchings means that there's hope for other meanings, other acts, in the landscape, but what places look like is not necessarily what they mean—and investigating through rephotography suggests how many ways one place can look and how what you find depends on what you're looking for. We came to Yosemite in 2001 looking for the accretion of meanings, and one of my tasks was to take on the invisible ones.

The people who came quick on the heels of Bunnell and Tenaya were looking for other things. The California Geological Survey came by a dozen years later, in June 1863, on their way to Soda Springs. For them the place was about the history of rocks and ice, not of cultures. Six years later John Muir passed by for the first time. In his heavily revised journal for July 27, 1869, he writes, "Up and away to Lake Tenaya—another big day, enough for a lifetime. The rocks, the air, everything speaking with audible voice or silent; joyful, wonderful, enchanting, banishing weariness and sense of time. No longing for anything now or hereafter as we go home into the mountain's heart. The level sunbeams are touching the fir-tops, every leaf shining with dew. . . . What joyful streams I have to cross, and how many views are displayed of the Hoffman and Cathedral Peak masonry, and what a wondrous breadth of shining granite pavement to walk over for the first time about the shore of the lake! On I sauntered in freedom complete."

Muir launched from this encounter with the lake into an aside about how the lake was named, the ugly scene between Tenaya and Bunnell, but this history had nothing to do with how he interpreted this place he repeatedly called joyful. From the aside, he flows on into one of his classic epiphanies of the divine goodness of nature, making what may be his definitive philosophical statement. "When we try to pick out anything by itself, we find it hitched to everything else in the universe." On Muir rushes, like one of his beloved brooks, for the next sentence is, "One fancies a heart like our own must be beating in every crystal and cell, and we feel like stopping to speak to the plants and animals as friendly fellow mountaineers." And then he goes back to chronicling the three kinds of meadow in the area.

The African American environmentalist Carl Anthony once wryly observed that a lot of white people find it easier to think like a mountain than like a person of color. (Aldo Leopold's famous phrase "thinking like a mountain" is often used to describe ecological awareness.) By the 1980s, Muir's model of nature as uninhabited and apart from human society was being undermined everywhere, but it prevailed throughout much of the twentieth century. Muir, so visionary, so ahead of his time in other ways, wrote the Indians out of the landscape, as the first-generation conquerors before him could not have. Often praised for being "biocentric" or "ecocentric" rather than anthropocentric, in certain crucial ways, Muir was deeply ethnocentric. He saw the landscape of the Sierra Nevada as a remote place, removed from family life, society, the getting of sustenance, though it nurtured all those things for its long-term inhabitants.

Only in the past couple of decades has the fantasy that the continent was uninhabited and then discovered by Europeans worn out, and only recently have environmentalists embraced working landscapes, the landscapes that sustain us in body as well as spirit. (One of the most intriguing sights in Yosemite is the Curry Village parking lot, an orchard planted by James Lamon in the 1860s whose unpruned, gnarled old apple trees preside over the rows of cars, trees that would have excited a photographer like Eugene Atget though they have been ignored by almost all the well-known imagemakers of Yosemite.) Toward the end of the 1980s, environmentalists in the United States began to address devastation of the tropical rainforests, which were both wilderness and homelands for indigenous populations. The rainforests demanded a different vision of what nature might be and offered a point of intersection for justice, culture, and conservation. At the same time the environmental justice movement arose, which recognized that the poisons and pain of environmental devastation often fell most heavily on the poor, the voiceless, and the nonwhite. It was thus that two paths long separate crossed, that human rights and environmentalism stopped being separate arenas, back in the era when the Berlin Wall came down. Although there was no visible wall to knock down in the collective imagination, the rift that began to heal was at least as great.

I remember Mark at a 1989 conference saying, "The line is not a dividing line, it's just a path." For many photographers, the old vision of landscape as formalist exercise or a place apart no longer worked, and the art of the era was reactive against this version. A lot of them showed that nature wasn't a place apart because it had been developed, polluted, clearcut, ravaged, bombed, and exploited—that nature was no longer a virgin, but a victim, and this suggested that segregation was

after all the only way to protect nature from our evils. I learned a lot from these photographers, but learned most from those trying out another way of seeing, in which landscape began with our bodies, at our feet, on our plates, and in our backyards, and continued right up to the mountaintops, every place connected to everything else by the pervasive systems and by the imagination. We were coming out of an era that had obsessed itself with purity of various kinds, and we were learning to come to terms with the impurity that ultimately meant everything was connected.

As the quincentennial of Columbus's arrival in the Americas approached, Native Americans of both continents began

Mark Klett, *Plastic toy found at the Wawona Tunnel overlook*, 2002.

to speak more audibly about what had happened in 1492: that it hadn't been a discovery, and that it had been for them a catastrophe, one that was still unfolding. "Five hundred years of resistance" was the catch-phrase for that anniversary, and the national holiday has never been the same since. So in the early 1990s, it was time for the rest of us to get over virgin wilderness, an idea that Muir helped start when he sought to imagine and portray the Sierra Nevada as a place apart from human history, from human concerns, from human society, when he saw it as a place hitched to everything else in the universe except other people. It's not hard to see how this served his personal needs—his flight from society into a solitary, spiritualized nature that was the antidote to his fire-and-brimstone evangelist father's farm, which provided food but also harsh authority, grueling labor, and a grim worldview. It's not hard to see how this became the most coherent way to frame a late Victorian argument against development and exploitation and for the birth of the environmental movement and of the national parks and forests. It's not hard to see how it allowed him to cobble together a nature theology that served as an alternative to mechanistic evolutionary science and anthropocentric Christianity. But a century later Muir's vision needs radical revision.

In 1991, I was hot on the trail of the erasure of Yosemite's past, and it was a crime with widespread repercussions. For those who were rendered invisible in their own homeland, it deprived them of the most basic rights, at the same time that it made it easier for them to slip through the system and, well into the twentieth century, continue living in Yosemite Valley. For the ecology of the place it was likewise devastating. Early white visitors had been enchanted by the open, parklike landscape of the valley with its meadows and open oak groves, but they could not or would not comprehend or remember that this openness was maintained by fires set by the original inhabitants as part of their land-management practices (that they had land-management practices and that Yosemite was in part a managed landscape were until recently inconceivable ideas). This forgetting is part of the origin of the century of fire suppression that has led to overgrown and encroaching forests and devastating wildfires across the American West. The fire suppression built up dangerous fuel loads that would make fire catastrophic, and it had other effects. Sequoias, for example, only regenerate after fire, which sterilizes the soil, makes

Mark Klett, *Sun through the smoke of a distant controlled burn, 1990 Foresta fire site,* 2002.

the cones release their seeds, and creates openings in the tree canopy through which sunlight can reach the forest floor.

For the white imagination, belief in uninhabited wilderness and an untouched Yosemite was a more subtle kind of tragedy, the one enshrined in the 1964 Wilderness Act's definition of wilderness "as a place untrammeled by man, where man is a visitor who does not remain." By erasing all other models of human presence in the landscape, it misanthropically asserted that our only relationship to nature is destructive. Writing human beings out of the ecology of the continent helped realize that destruction. It imagined nature as fragile and static, a virgin on a pedestal, rather than a place constantly changing, generating, shifting, breaking down and building up, dancing. The landscape we found through rephotography was too often cluttered and obscured by suppression of this dance of fire.

THE WAY BACK

But the Yosemite we went photographing in was not the place it had been ten years earlier. On the afternoon of October 6, 2002, while a 7,000-acre controlled burn was taking place, Mark and Byron rephotographed Ansel Adams's iconic 1944 "Clearing Winter Storm" as "Clearing Autumn Smoke" (p. 9). Although most of Adams's pictures look as though they were taken by the first Adam on the first day of creation, rephotography of his work often led us to accessible locations, none more surprising than this. The stormy revelation of that picture was taken from a few feet below the retaining wall of the Wawona Tunnel parking lot, a busy place for visitors (and the stone wall was built in 1936, so it was there in Adams's time). My friend Catherine Harris, who grew up backpacking around Yosemite with a father who cofounded the Sierra Club Legal Defense Fund, had joined us for the day, and while Byron and Mark worked, she and I settled in to watch the other visitors walk to the parking lot viewpoint. They were not the same people who had come through in the early 1990s, when it seemed like a place for white people. California has recently become a white-minority state, but the state demographics hadn't shifted as radically in a decade as the visitors to Yosemite had. Clearly something more had changed, people who hadn't felt welcome or interested or who had not had the time or money to visit then were visiting now. I used to think that the romantic landscape tradition Bunnell embraced was problematic because it was the property of one culture, but it looked like it was becoming the property of everyone, the way rock and roll has risen out of its African-Indian-Scots-Irish southern roots to become universal, the way Buddhism and tortillas have become American.

Neat layers of horizontal haze filled the valley, and though some of the distant sites were visible, they were in soft focus. A stout middle-aged woman stepped off one of the green zoo-car conveyances on which the Park Service provides tours and said in a breathy southern accent, "Oh the smoke just *ruins* the view, I'm sure it must be a beautiful view without that." Perhaps because of photographs like Ansel Adams's, the aesthetics of haze and mist have been eclipsed by those of preternatural sharpness. A plaque at the viewpoint quoted Lafayette Bunnell speaking positively of the haze, but I thought of Bashō's poems about atmospheric obscuring and tried to quote a couple to Catherine. In them, he relishes not being able to see the hallowed sights of Japanese tradition, the moon and the mountains, and enjoys the obscuring clouds and mist instead. There had always been other voices and visions in Yosemite, like that of the remarkable painter and

printmaker Chinua Obata, an immigrant who adapted his training in traditional Japanese aesthetics and techniques to make some of the most graceful images of Yosemite ever. He was a Sierra Club member who visited Yosemite from the 1920s to the 1950s and spent a lot of time in the high country (and the Second World War in a prison camp, where he continued to paint). But he was an anomaly then.

At Glacier Point a few months before our session in the Wawona parking lot, I'd sat still for hours and watched small groups process up to a prominent boulder, split into photographer and photographee, and take the requisite picture. In the stream of visitors came two women in red saris who kissed each other lingeringly for the video camera of their rugby-shirted companion. The red looked sensational against the green and blue distance. One thing that struck me about these tourists is that they moved with great sureness, knowing why they'd come and what to do and, seemingly, knowing when they were done. They were done quickly, and most of them seemed to move on after several minutes at most. Yosemite wasn't a wilderness for them, and maybe it wasn't even a vision of sublimity, but it was a place of arrival, and they seemed to have the satisfaction of those who have arrived. Once I would have said all kinds of scornful things about the ironic inauthenticity of their quick experiences, but the happiness seemed genuine enough. And their ritual was social—it needed witnesses and companions, it was as far as you could get from the old fantasy of being the first foot to step in the pristine wilderness (though there were undoubtedly backpackers off in the backcountry dreaming just that).

At Wawona Tunnel, half the fourth graders in the group sketching at one end of the overlook parking lot were Latino. A lot of the tourists taking pictures were Asian. Catherine and I watched a white minivan pull up in the parking lot across the road, and three men and a boy get out. First the man in the turquoise turban who seemed to be the boy's father photographed the boy in the red T-shirt and the man in a white turban with a long white shirt and beard who might have been his father, and then they put on some swirling South Asian music that spilled over to us on the edge of the vast expanse of the valley. At first they seemed to dance for the camera and video camera and then to dance for its own sake. It looked like a victory dance. This Sikh family, like the women in saris, suggested the possibility of seeing an entirely different Yosemite, as Obata did, one whose meaning came from the Himalayas and miniature painting or from Mount Fuji and sumi-e painting (though just as Obata came from San Francisco to Yosemite, so these people more than likely came from Fresno or San Jose). In this Yosemite, northern European romanticism, Wordsworth and the Alps and maybe even Muir were tiny figures obscure in the distance, or over the horizon altogether, or maybe composted into the culture, feeding it by losing their recognizability. "Is this the Yosemite you remember?" I asked Catherine. "It's not what I remember from ten years ago." And she said that it was changed, utterly changed.

Bunnell told Tenaya that he was going to erase his culture and replace it with his own. All wrapped up in this young man's blithe sentence was an agenda of annihilation, and so one era of meaning came to be eclipsed by another, violently and suddenly, though the Ahwahneechee never went away. But now the meaning Bunnell had instated and Muir had enhanced and Adams had photographed and the Park Service and the Sierra Club had protected was also coming to an end, though not so violently. The culture that had supplanted

Tenaya's had begun to become porous, to become everyone's property. It wasn't a remedy, but it was an opening.

All over Yosemite Valley, the way the Ahwahneechee were represented had changed since the Columbus quincentennial. The Indian Village exhibit behind the Indian Museum had been changed in significant ways, and so had the brochure about the valley's indigenous inhabitants. The new version was bilingual, in English and Miwok. This was an extraordinary symbolic shift, since it recognized that the Miwok had their own culture, gave it equal space, and acknowledged them as an audience in the present (even though it's doubtful that anyone reads Miwok by preference to English). Though the tribe had, like so many California tribes, failed to receive federal recognition, they had won long-term rights to a few acres upon which to build their own cultural and spiritual center in the valley—a small thing in itself, but like the brochure a huge step forward in acknowledging what the history of the place had been, who has rights here, and what the place might mean. Signs in many places had been changed, so that the place was no longer "discovered" in 1851. Even a coloring book for sale in the grocery store represented a more accurate version of this history, including the fact that descendants of Tenaya's tribe are still here.

And this wasn't a local change. All across the West, there had been catastrophic forest fires in the summer of 2002, and what was surprising about the debates over the wildfires was the offhand acknowledgment of the widespread native practice of setting fires. In the media reports and editorials, it was a given that native people had had a significant and beneficial impact on a lot of these places and that complete suppression of fire embodied not only bad management but historical ignorance. A decade or so ago, if non-native people even remembered that these places had inhabitants long before, they were imagined as "ecological eunuchs": people who skimmed off the bounty of the land without making an impact on it; and they were usually portrayed as having vanished since. Then, native burning practices were discussed by ethnobotanists in obscure publications, not newspaper editorials. It was fascinating to see the change in the American imagination: fire was once seen as a purely destructive force, but it is now understood as necessary to renewal and regeneration. Fire radically alters the landscape at times, but it often serves to maintain or renew it, unless it's suppressed too long, and then it sometimes becomes as catastrophic as a clearcut. Perhaps the mind that doesn't go through the thinning and cleaning of regular fire is likewise prone to devastation and collapse.

It wasn't that all trouble and strife had come to an end in Yosemite. Shortly after we left, several descendants of Tenaya showed up to protest the Park Service's relandscaping of the tourist infrastructure at the foot of Yosemite Falls. The village where Tenaya's group had lived was being excavated, and some feared that graves would be desecrated (while environmentalists decried it as just more development for more tourists in a park that has long resisted demands to pare back traffic and infrastructure). But Tenaya's descendants had come because Park Service anthropologist Laura Kirn had invited them, and their protest had been news in the *San Francisco Chronicle* as well as the local *Mariposa Tribune*. It wasn't that justice had triumphed or the land been handed back, only that the conversation had changed. Things that not long ago were not even subjects were subject to discussion, and those in the discussion were not who they had been; some who had been excluded had arrived, some who had been included had

changed their minds. A door had opened through which, it seemed, some measure of justice might come and a clearer picture of the past could be seen. It wasn't a vindication but it was a beginning.

All during that October 2002 expedition, the smoke that veiled the clarity the modernists had so prized was a sign of regeneration—not only of forests, but of imaginations. At the site of "Clearing Winter Storm," Mark came out from under his darkcloth, and when we told him about the dancing Sikhs and showed him a "Have Bible Will Travel" card Catherine had found for ministers who performed Yosemite weddings, he said, "This is a ritual place." Then he showed us the toy candelabra he had found (p. 101). Later he wrote me, "I remember a Shinto shrine in Kyoto where the stripped base of a tree, a weathered stump, was still wrapped in ritual cloth and recognized as containing the force of deity. People walked up a steep hill to it, rubbed the gray wood, and then their backs: the tree was known to help heal maladies in that part of the body. It didn't matter what it looked like, the power was felt rather than seen. Most of what we value about the landscape has come from the power of sight. Photography has been a major player in a hierarchy of visual beauty. But perhaps now our ritual also recognizes the power of site as well. And this concerns not only the individual experiences we so cherish, but social and collective power. It is the unification of our separateness."

Catherine added in another e-mail, "The photographs are placeholders for a physical memory of place, for the ritual of being in that place. We re-ignite our connection by being in the site, whether we see or not, whether the results of our seeing are the picture perfect images of Ansel or not." The millions of tourist photographs every year seemed ritual, too,

and I finally recognized that their cameras were not there to try to make a masterpiece but to make a moment of eternity in the flow of time, a ritual moment that served its function as much in the making as in the later looking—for who looks at vacation snapshots, after all? When the camera points at you, you stop, you arrive, you are there. And these countless photographs accumulated as gestures toward the transcendence of time, like the offerings at a shrine, coins in a well, gestures wearing smooth a stone in a holy place. Yosemite hadn't been about wilderness for most of its four million visitors a year in a long time. It might not even be about beauty, but about the ceremony of arrival and the ceremony of connection.

When I think back to the radical changes of the late 1980s and early 1990s, the changes in landscape photography, ecological ideas, and the recognition of indigenous presences, as well as those in how western history was being written, it seems like an era of fire—heated, urgent, polemical, and intensely transformative, disposing of much of the accumulation of American assumptions. It was part of the larger conflagration brought about by new thinking on race, gender, representation, power, place, and community. What has come about more subtly, what it took me many returns to this crucial site to recognize, is the aftermath of fire: regeneration. We were, it seemed, entering a cultural landscape whose ground was ashes but whose understory was open and whose heights were renewed.

In another e-mail after this expedition, Mark wrote, "At this point in history and current events we need to reconfirm our relationship to the land more than ever. What's unique here is that we're seeing the opportunity to redefine our connection not simply by tearing away the past, but by looking

through it. We're seeing a window in time that rarely occurs, the moment in which ideas and convictions converge in the same frame and mingle, becoming clear before being scattered once again. We're between landscapes, and we're seeing the overlay clearly in a way that's normally impossible. What we're seeing, I think, is something that's parallel to what happened thirty years ago with a recognition that culture could indeed be seen as a part of the landscape (the work was branded 'New Topographics' and led to a revolution in landscape photography). We're seeing the formation of a new relationship between culture and nature, one less adversarial in focus, one defined by the human need for close connection to place, one that honors iconography and that's as social as it is personal, one that will ultimately redefine our images and messages. We're at the brink of a new era. Now is the time to visualize where we've been and the choices about where we're going." We had come to Yosemite to measure the change between 1872 and the twenty-first century, but even a decade's worth of change was astonishing.

It was in this spirit that we went back to Lake Tenaya on October 10, 2002. It was exactly ten years since I had, on my way to an indigenous environmental gathering on Columbus Day 1992, found a page of virulent missionary literature lying on the gravel of Tenaya Creek, its words waving under the rush of crystalline water. This day, a decade after the quincentennial, I was looking for another omen, for an anniversary that in the cyclical looping of time would overlap that other moment and reveal more to me. Perhaps I could have found one sooner, when we drove past the controlled burn where the trees still stood green and waving above ground that was gray-white with ash, with only a few stumps and snags smoldering in that renewed forest. (Rare fires are catastrophic, hotly burning everything in their way, but regular fires move fast and clear out the underbrush without harming the larger and loftier growth.) Mark had stayed behind to photograph the lush new growth on the site of the devastating 1990 Foresta fire, and when Byron and I got to Lake Tenaya, he stayed behind to read in his truck. I went on toward the creek, truly on my own for the first time in a week.

The moorings of time seemed to come loose on that short walk, as though I might walk through all times at once, as though they could slip into each other, like Mark and Byron's panorama where Muybridge, Weston, and Adams stood side by side in the same Lake Tenaya cove looking across the water and the years together (pp. 116–17). I thought of what I'd want to say to my turbulent younger self, as though in that short walk I could travel to 1992, where I had been trying to feel my way back to 1851. In ten years I had become less eager to find fault, to divide the world up into categories. It was thus I could regard Muir as an irredeemable racist who nevertheless laid groundwork of extraordinary value, some of the ground that I myself walked on, that I could like tourists while deploring industrial tourism, that I could embrace the contrary, complicated, unfinished nature of it all, and its call for improvisation and case-by-case evaluation.

That October of 1992 I had stood on a stepping stone in the middle of Tenaya Creek to try to read the wavering words of the evangelical propaganda under water. In June 2002, the stones were underwater and the creek came up to my thighs when I waded it. Now it had puddled up and I stepped across it easily, but the cartoon from a package of Bazooka bubble gum I found on its near bank was not the message I was looking for. I walked further and started to feel the extraordinary stillness around the lake, out of time, out of eventfulness,

Byron Wolfe, *Pine tree as sundial and pollen rings that mark high water, Lake Tenaya*, 2002.

a serenity that must have been violated but not erased by the Mariposa Brigade. I've circumambulated the lake more than once, and only the western edge, with its shallows lapping at pine-fringed gravel beaches, feels this way, calls people, called Muybridge, Weston, and Adams to the same cove, has this eerie peace. From the west you can see across the lake to the spectacular glacial domes, though you find on that shore something that doesn't find its way into photographs most of the time: silence, tranquility, stillness, a suspension of time and history, unless something of that is in all photographs.

Lake Tenaya's water licked delicately at the shore, the same flakes of mica tumbling in the same faint tide I remember from a decade before. This time the flakes settled in the crevices of pine cones, peach pits, and other debris to delineate their forms in gold. Whole schools of small black pine cones had washed up into the shallows to be gilded. I picked up a yellow rock and tossed it back into the lake when I was done looking at it. It fell into shallow water ten feet out, and the drops that flew up from it made ripples subsumed into the bigger rings radiating from where the stone itself had broken the water. Those rings continued to spread for a while, like the long reverberations of a temple bell, until a breeze played over the surface and the event was over and done. After all the drama and distance of our hikes to high vantage points, the delicate intimacy of this space was intensely absorbing, flute following trumpet. Byron and Mark came strolling from the north, and an old man approached our cove from the south.

With American openness, or perhaps only out of pain, he began to tell us—mostly me—almost immediately that he had camped on the shore of this lake forty-two years ago, on his honeymoon. "She," he said, without saying "my wife" or her name, had died this year of cancer. It was a painful way to go,

he added. And now he had permission from the Park Service to spread some of her ashes here, as long as they were at least ten feet away from trails and water. He talked in bits and pieces about himself as we all meandered along the western coves of Lake Tenaya, or Lake Pyweak, two coves north of where Muybridge, Weston, and Adams had all come to make their pictures over a span of nearly three-quarters of a century. Every time the widower got close to the subject of his wife's death, his voice filled with tears, and sometimes he had to drift off until he could speak normally again. He told me that they had camped for three weeks on their honeymoon "right over there," and he indicated where the landscape begins to slope upward.

He was a straight-backed, trim, tan white man with waving white hair parted in the middle, old-fashioned like his posture, and at one point he told us he was a marathoner. He had, he added, planned to run a marathon this year, but—and his voice broke up again—with his wife's sickness "it wasn't to be." His son had come to spread the ashes with him, he told us, but when we met him he was alone, intensely so, perhaps with the lostness of someone who hasn't been alone like that for decades. Forty-two years, and he never had anything to complain about, he said at one point, and it was clear that this was praise and gratitude in the language of men. And then he told us that he was a professional photographer, but what he asked of us was strictly amateur. He had walked past us into the next cove, taken a tripod out of the canvas bag over his shoulder, and affixed his Nikon to it. He asked if one of us would take a picture. Byron stepped up to the camera, and the widower sat down to pull off his shoes and roll up his jeans. For this commissioned portrait, he waded out into the lake and stood on one of the stones that had appeared on the sur-

face since the water level had dropped. The water must have been icy, but he walked out unflinchingly and stood solemn on his rock. He had situated himself in the view to the east all the artists had been photographing all along, with the glacial domes like bald foreheads behind him, sure as the tourists what the picture was and where he belonged in it.

When the widower came back to shore, he told me he was afraid he wouldn't remember this place where he had spent his honeymoon, but he recognized it right away. When he arrived, he had written the GPS coordinate of that vanished campsite on his palm, because he had no paper. I gave him a scrap I had on me and Byron photographed his palm bearing

Byron Wolfe, *The widower's hand: GPS coordinates that mark her ashes and the couple's honeymoon campsite, Lake Tenaya*, 2002.

the numbers which were the coordinates of memory, of love, of the very place we stood, of this place that for him was haunted by the ghost of a honeymoon long ago with a woman whose ashes were now part of the landscape. Fuji film and GPS had become ritual objects, performing practical operations whose significance was not contained in the snapshot or numbers but was only referenced by it.

I realized that this always was a place for private experience, that Weston's and Muybridge's and Adams's aesthetic response was also a personal response to the enchantment of this particular part of the lake as well as the view across it. The old man had in the intensity of his private happiness and private sorrow here brought the place back to what it should be, back outside of the rupture that Savage's army and Bunnell's naming made in that privacy, which was Tenaya's privacy then. Despite all those magnificent lumps of granite, this place is made out of memory, imagination, and desire, which are as tough, if not as slow to change. Scenic splendor must have first brought the widower to camp in this place, but personal history is what brought him back, and it's on the return, over the long run, that meaning transforms a place into a ritual site or into home. This is not an act of aggression, but one of submission, submission to the spirit of place and the work of time.

Perhaps we don't belong in a place until we've given it our ghosts, an idea only persistence and return could have given me as this place revealed more and more layers of meaning, spreading out from rocks and water, from stories and pictures, like the ripples I had watched earlier. The photographers were ghosts, too, sometimes palpably present in these places they'd chosen to stop at and try to immortalize. We wished the widower well and scrambled up the glacial polish to the ridgetop

Weston site that Catherine had found a few days earlier, north of the lake. The site had a felicitous glacial erratic that had been outside the frame of Weston's camera, a warm-colored boulder sitting on the ridgeline among all that gray granite, another trace of time's hand in this place. Since we'd met the old man, a cloud cover had arrived with a cold breeze, and, in the five days since we'd last visited the lake, the green willows and aspens on this slope had turned gold. Indian summer was over; autumn had arrived. It was an autumnal afternoon made out of silence, ash, completion, return, peace. Mark and Byron recorded the GPS coordinates of the Weston site, and we hadthe last meal of our third expedition in a sheltered area among the rocks. Then Byron went north, Mark went south, and I went west.

The old man and the dancing Sikhs and the controlled burn suggested that the great violence done to the Ahwahneechees by Savage and his successors will be redressed not by the heirs of those conquerors surrendering their dominance in some supreme act of renunciatory virtue. It will instead be redressed by demographic change, gentleness, careful attention, shifts in the collective imagination, and time itself. The rocks in this place are the same, but the meanings continue to change.

—Rebecca Solnit

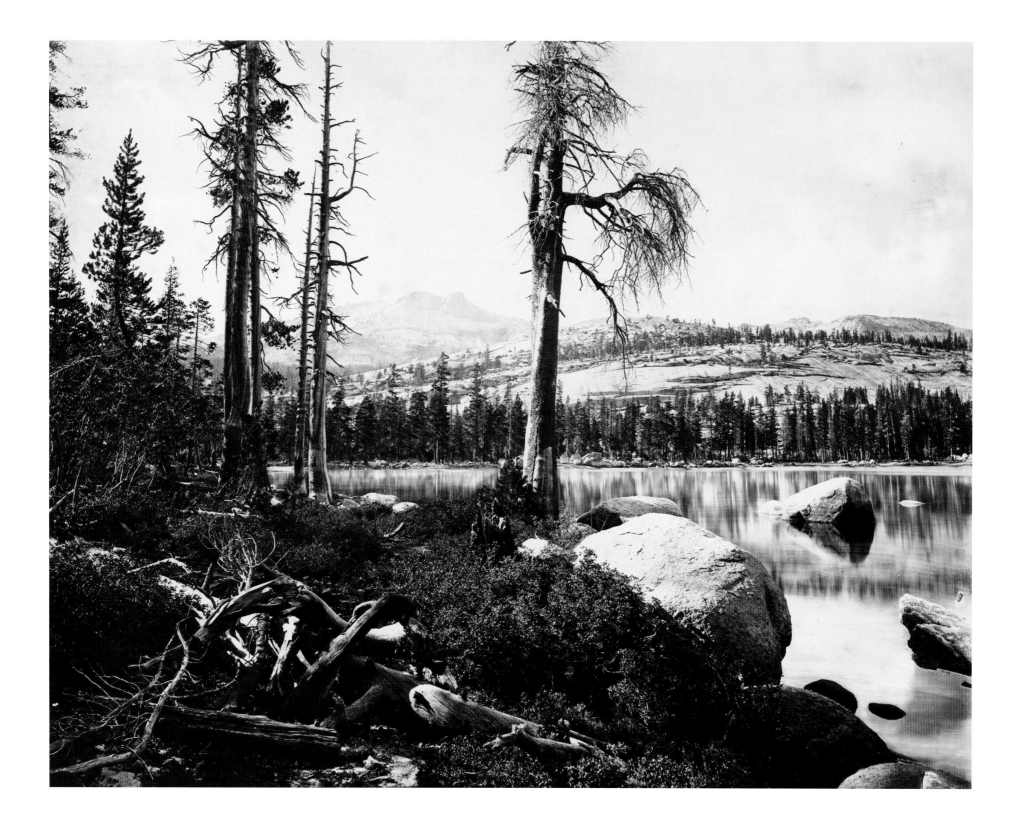

112 Eadweard Muybridge, *Mount Hoffman, Sierra Nevada Mountains. From Lake Tenaya. No. 48*, 1872.

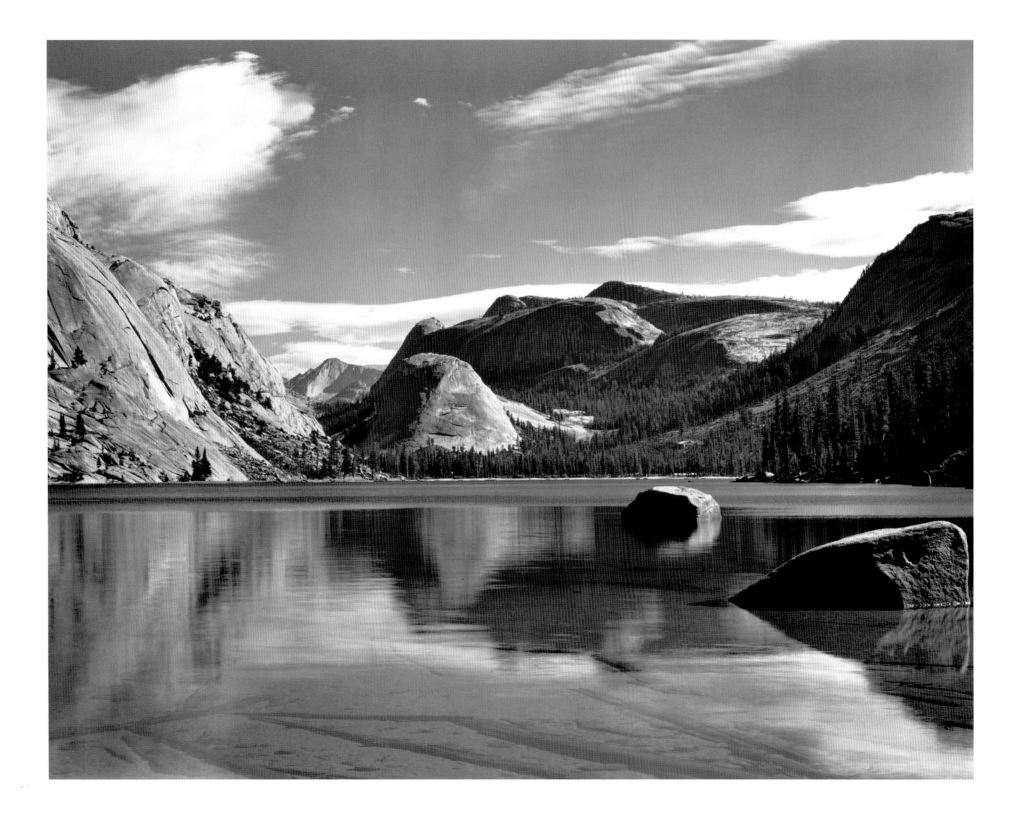

Edward Weston, *Lake Tenaya*, 1937 114

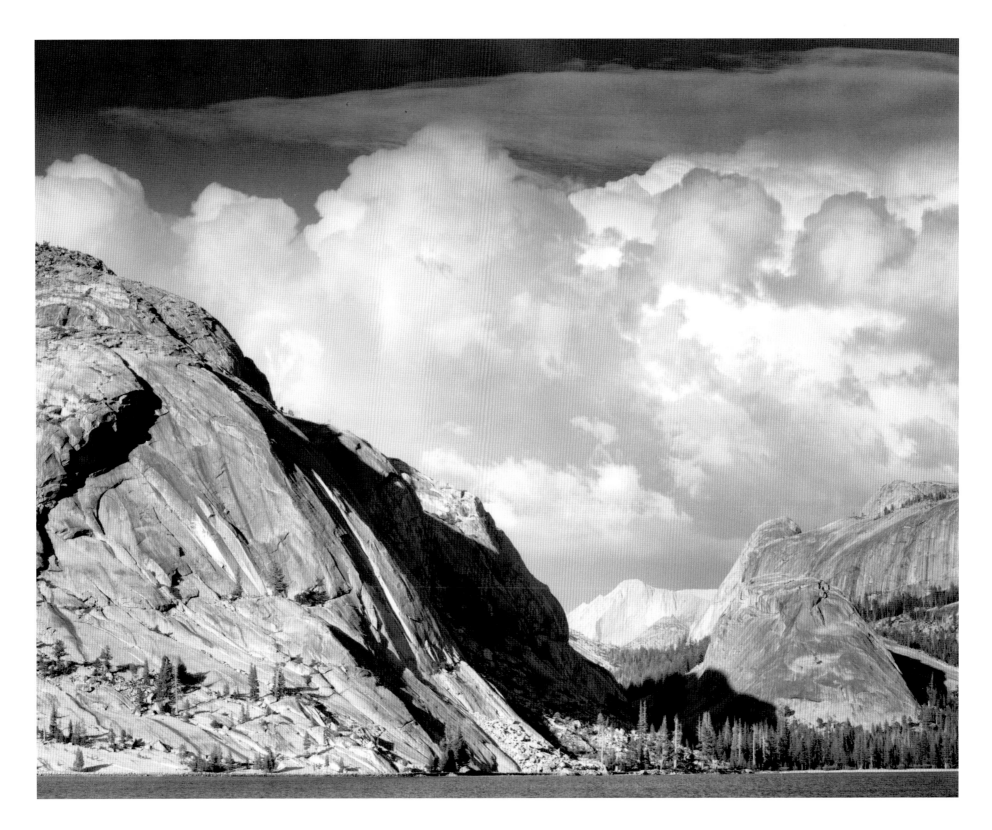

Ansel Adams, *Tenaya Lake, Mount Conness, Yosemite National Park*, c. 1942. 113

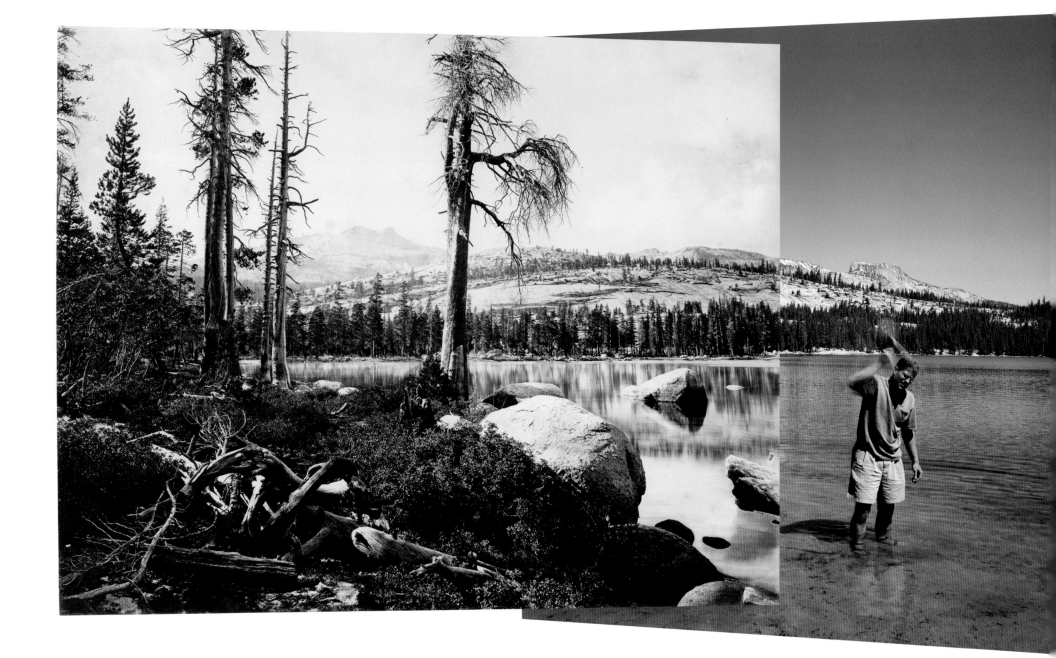

116 Mark Klett and Byron Wolfe, *Four views from four times and one shoreline, Lake Tenaya,* 2002. Left to right: Eadweard Muybridge, 1872;
Ansel Adams, c. 1942; Edward Weston, 1937. Back panels: *Swatting high-country mosquitoes,* 2002.

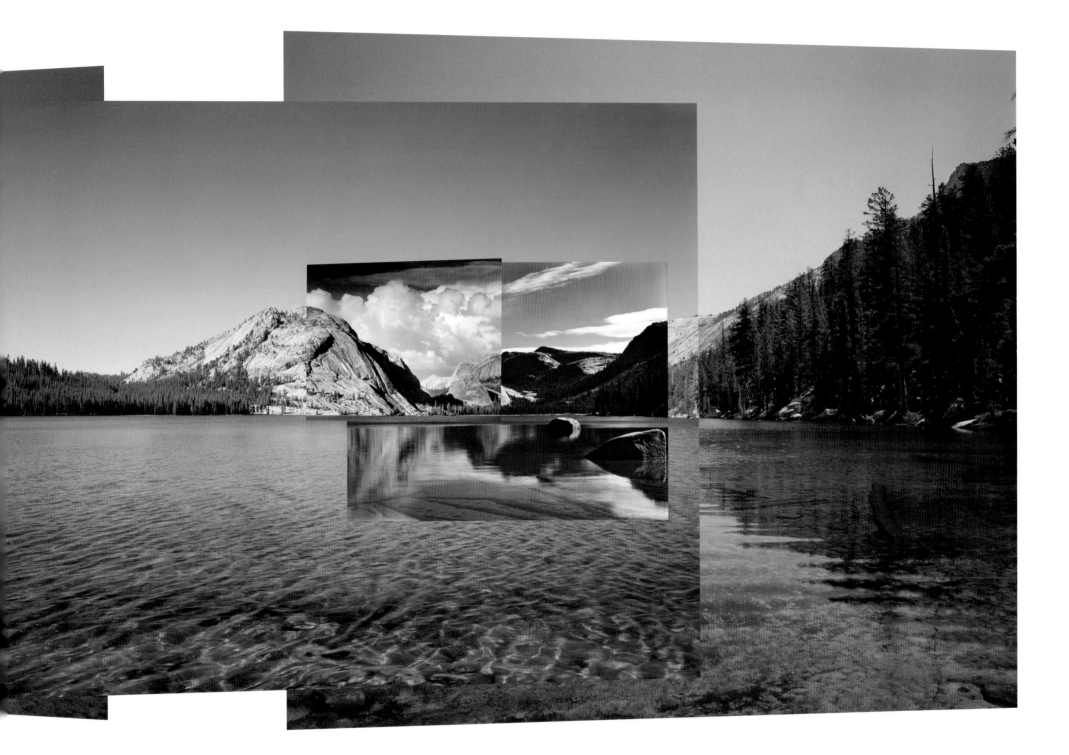

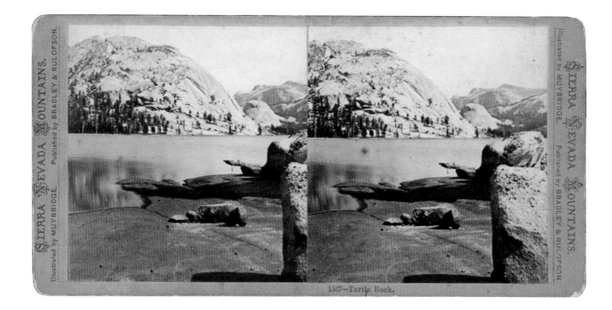

118 Eadweard Muybridge, *No. 1537 – Turtle Rock,* 1872. (Reproduction from a stereo card listed on an online auction.)

Mark Klett and Byron Wolfe, *Stereo view of the rocks and bathers on the western shore of Lake Tenaya (the two sides made at different times)*, 2003. 119

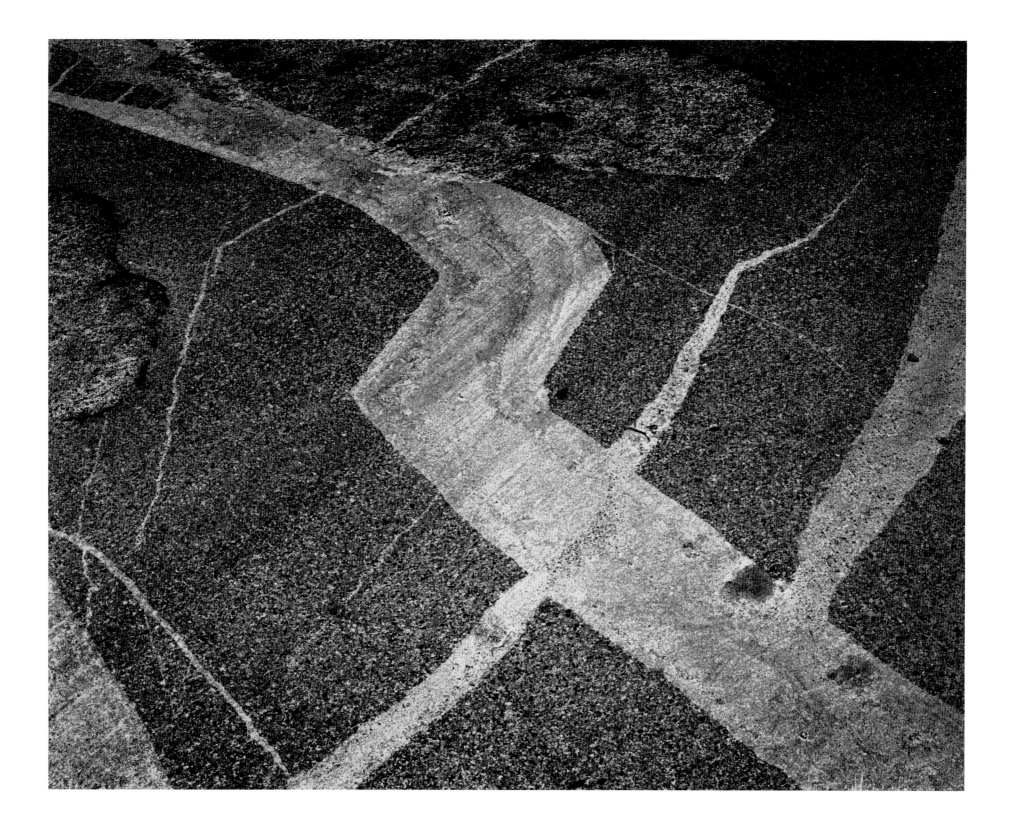

120 Ansel Adams, *Rock Pavement near Tenaya Lake, Yosemite National Park,* c. 1935.

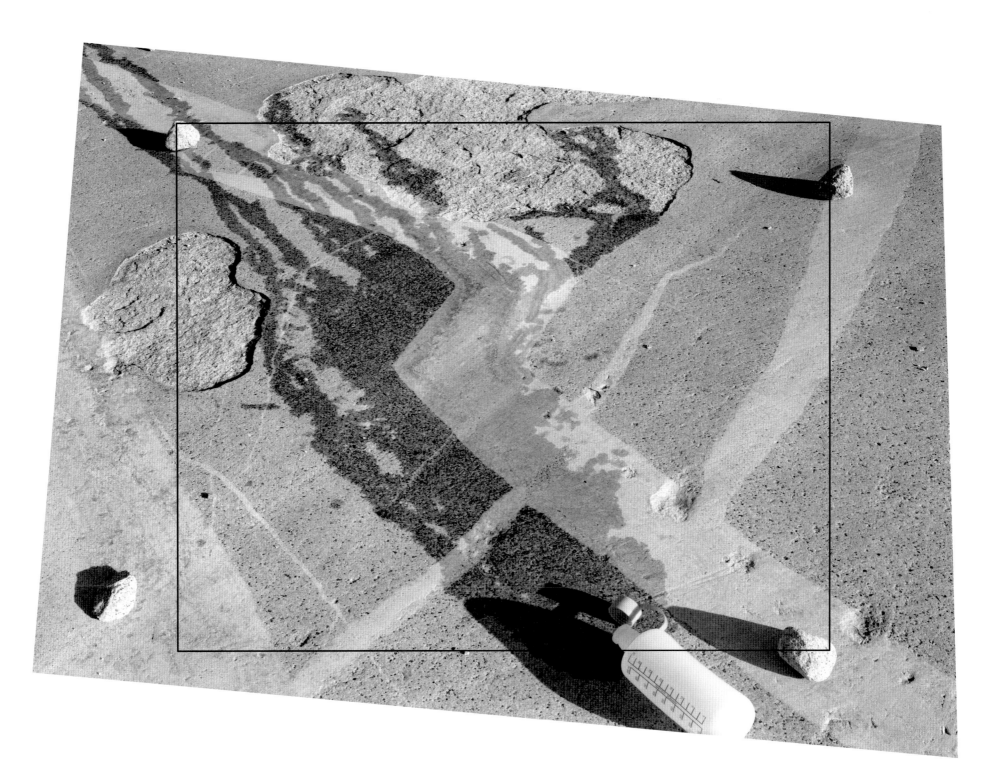

Mark Klett and Byron Wolfe, *The rock pavement photographed by Ansel Adams, moistened by a water bottle to increase contrast*, 2003. 121

122 Eadweard Muybridge, *Ancient Glacier Channel. Lake Tenaya. Sierra Nevada Mountains. No. 47*, 1872.

Mark Klett and Byron Wolfe, *Glacial deposits above Lake Tenaya*, 2001. 123

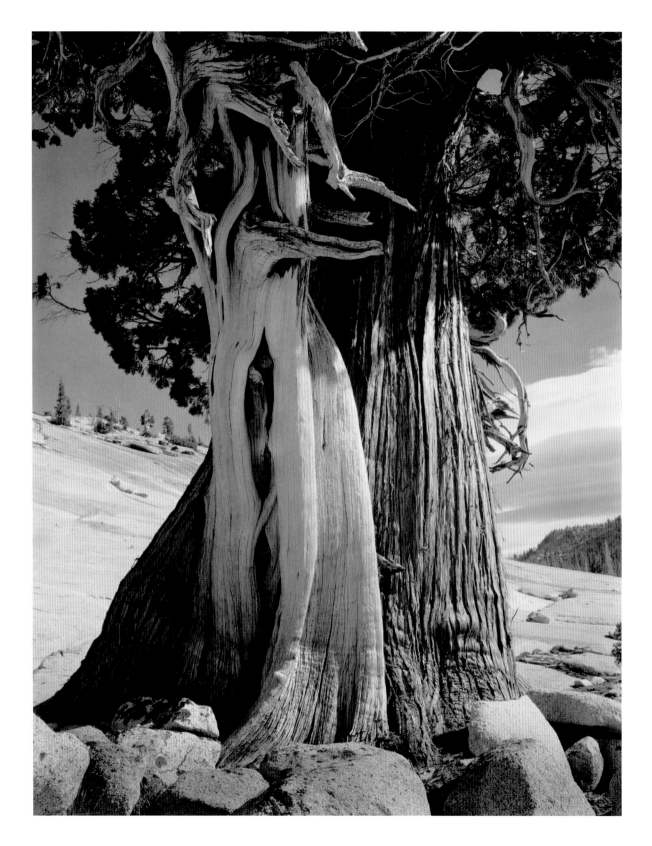

124 Edward Weston, *Juniper*, 1936.

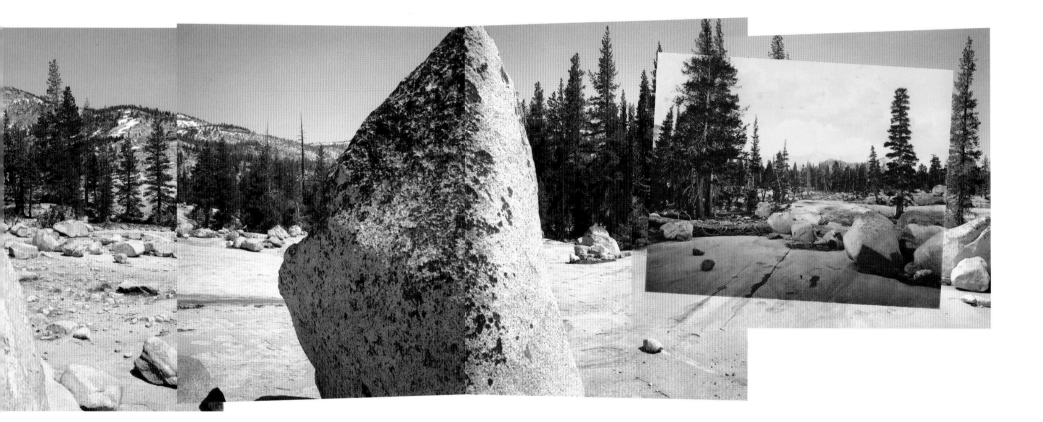

Mark Klett and Byron Wolfe, *Above Lake Tenaya, connecting views from Edward Weston to Eadweard Muybridge*, 2002. 126
Left: Edward Weston, *Juniper*, 1936. Right: Eadweard Muybridge, *Ancient Glacier Channel, at Lake Tenaya, Mammoth Plate No. 47*, 1872.

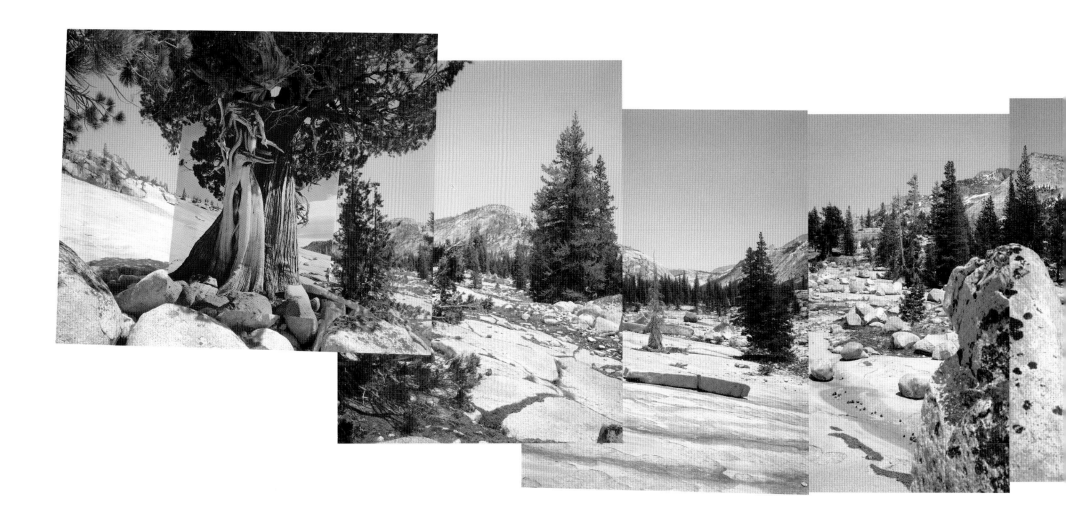

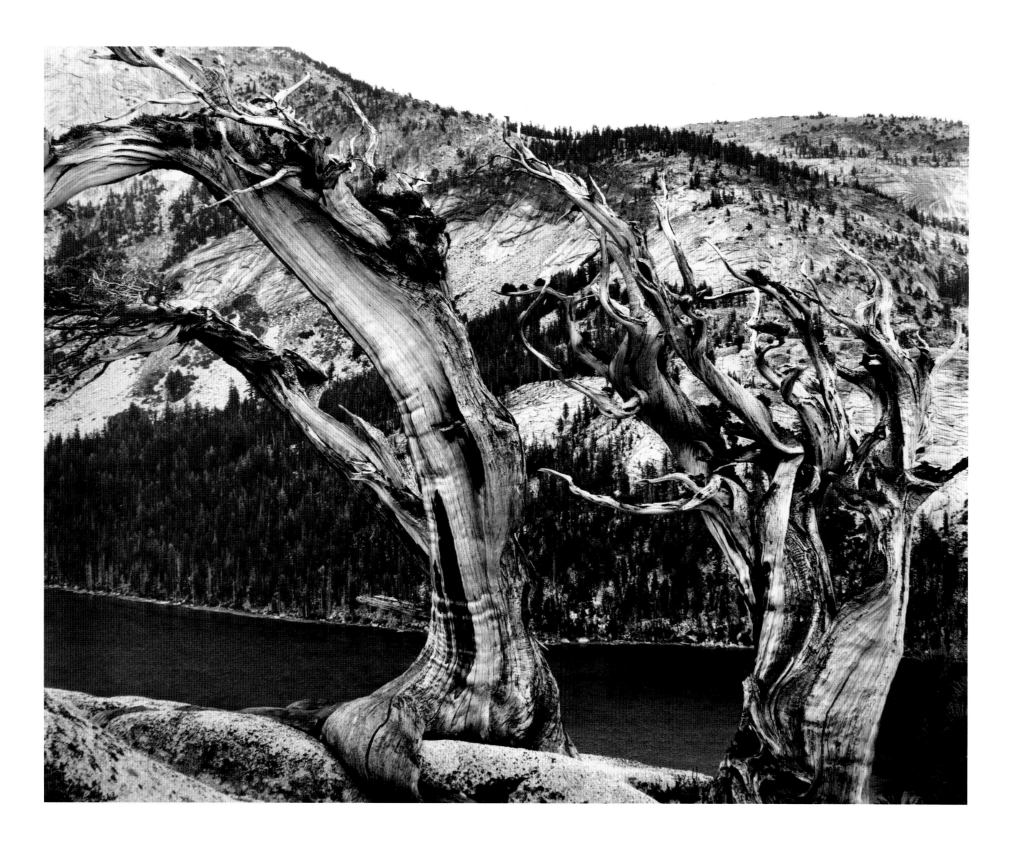

128 Edward Weston, *Junipers, Lake Tenaya, Sierra Nevada,* 1940.

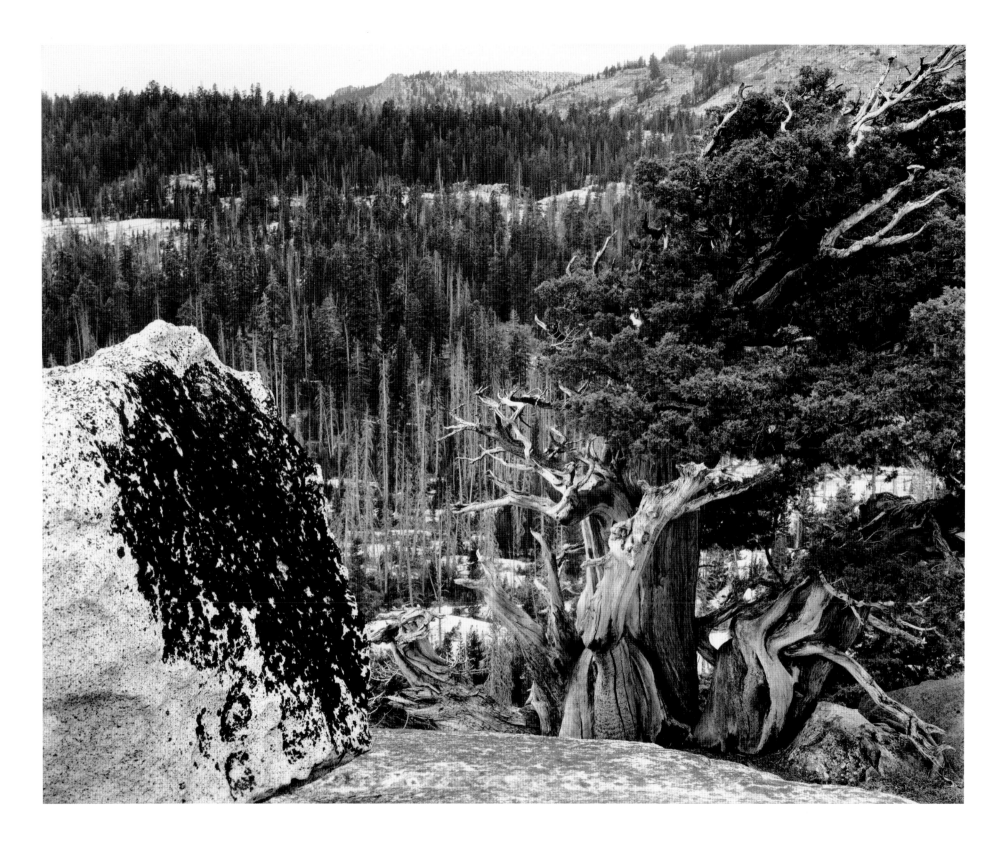

Edward Weston, *Lake Tenaya Country*, 1940. 129

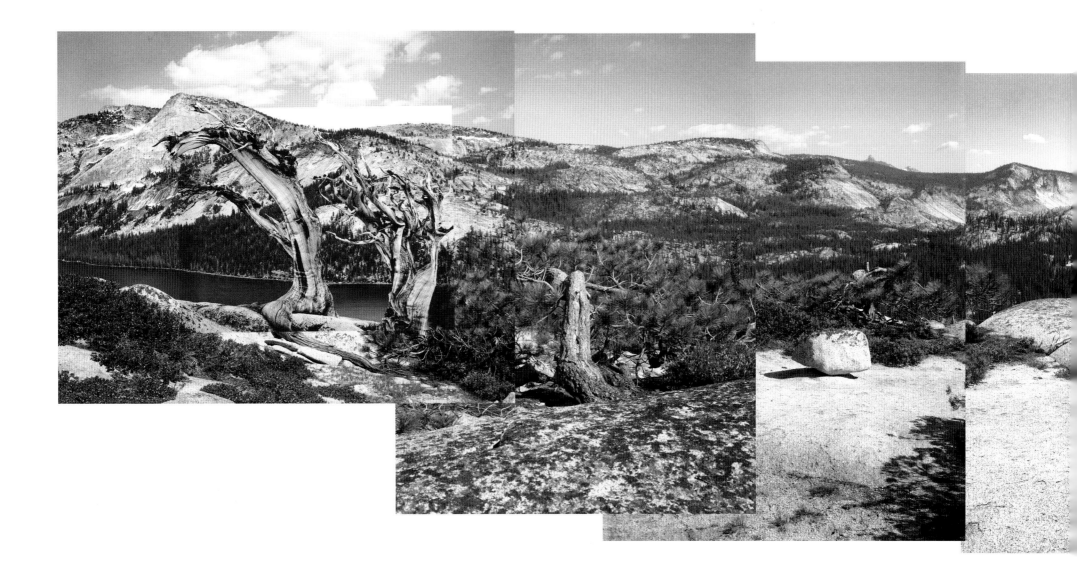

130　Mark Klett and Byron Wolfe, *Above Lake Tenaya connecting two 1940 views by Edward Weston*, 2003.

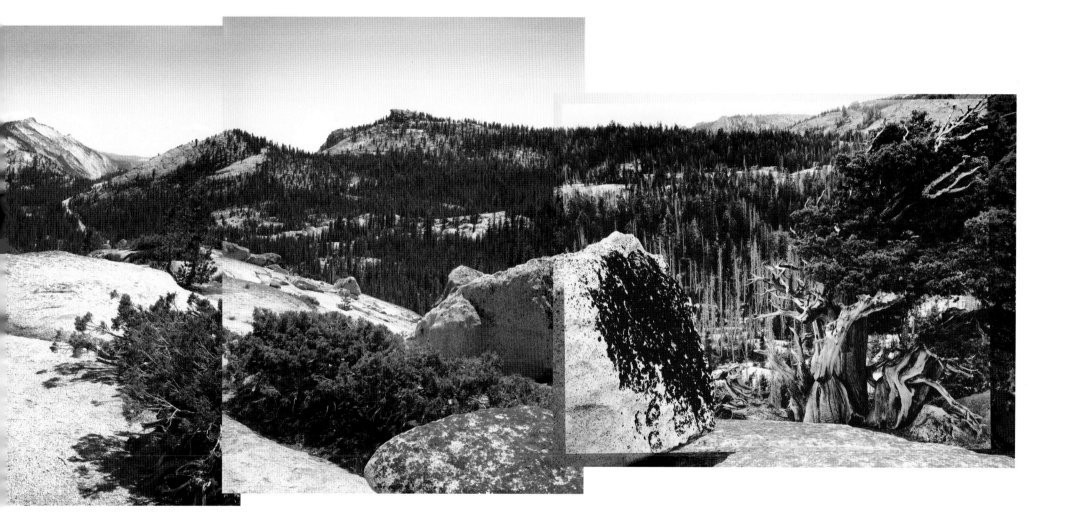

132 Mark Klett and Byron Wolfe, *Toy camera discovered at the water's edge where Muybridge, Weston, and Adams photographed Lake Tenaya*, 2002.

NOTES

GHOST RIVER

p. 11: "I once heard Martin Broken Leg," in Kathleen Norris, *Dakota: A Spiritual Geography* (Boston: Houghton-Mifflin, 1993), 170.

p. 11: Titles of Muybridge's photographs are printed on the paper mounts; all of the mammoth plate photographs mentioned in this text can be viewed at: www.oac.cdlib.org/images/ark:/13030/tf2779p2bj.

p. 16: Linguist Benjamin Whorf wrote, "I find it gratuitous to assume that a Hopi," in *Language, Thought, and Reality: Selected Writings* (Cambridge: MIT Press, 1966).

p. 17: Jorge Luis Borges: "a growing, dizzying web" in "The Garden of Forking Paths," in *Labyrinths* (Harmondsworth, England: Penguin Books, 1964), 53.

p. 30: Man Ray wrote, "Wishing to record my impressions," in *Self Portrait* (New York: McGraw-Hill, 1963), 356.

p. 31: Henri Cartier-Bresson said, "The whole world is falling to pieces," quoted in Estelle Jussim and Elizabeth Lindquist-Cock, *Landscape as Photograph* (New Haven: Yale University Press, 1985), 140.

p. 49: "In the early nineteenth century," writes Barbara Novak in *Nature and Culture: American Landscape and Painting 1825–1875* (New York: Oxford University Press, 1980), 3.

p. 49: "Now John stop and think of it for a moment," in Edward Lurie, *Louis Agassiz: A Life in Science* (Chicago: University of Chicago Press, 1960), 312.

p. 49: "Shaking the moral and intellectual world as by an earthquake," in Ronald L. Numbers, *Darwinism Comes to America* (Cambridge: Harvard University Press, 1998), 31.

p. 50: "I have had a great day in meeting Dr. Asa Gray," July 16, 1872, Muir letter in Bancroft Library, University of California, Berkeley, microfilm of the Muir archives at the University of the Pacific.

p. 51: "Were they created thus local and lonely, denizens of California only?" Gray asked in "Sequoia and Its History," address to the American Association for the Advancement of Science, Dubuque, August 1872, reprinted in Asa Gray, *Darwiniana: Essays and Reviews Pertaining to Darwinism*, edited by A. Hunter Dupree (Cambridge: Harvard University Press, 1963), 170.

p. 51: "Organic Nature—by which I mean the system," in Asa Gray, "Sequoia and Its History," in Gray, *Darwiniana*, 172.

p. 52: "Is always writing and talking ad populum," Asa Gray in Louis Menand, *The Metaphysical Club* (New York: Farrar, Straus and Giroux, 2001), 125.

p. 52: His biographer notes, "In an era of transition in the interpretation of nature," Lurie, *Agassiz: A Life in Science,* 98.

p. 52: He wrote to a colleague, "Since I saw the glaciers I am quite of a snowy humor," Lurie, *Agassiz: A Life in Science,* 98–99.

p. 54: Darwin once wrote a friend, "Lyell told me," Lurie, *Agassiz: A Life in Science,* 268–69.

p. 54: "On one of the yellow days of October 1871, when I was among the mountains of the 'Merced group,' " Muir, *Overland Review,* December 1872, 547.

p. 54: Muir wrote a friend, "The grandeur of these forces & their glorious results overpower me," Steven J. Holmes, *The Young John Muir* (Madison: University of Wisconsin Press, 1999), 224.

p. 55: Muir, "I've had a very noble time with Gray," letter to Carr, July 16, 1872, microfilm of Muir archives, Bancroft Library.

p. 55: Elizabeth Agassiz reported that her husband had said, "Here is the first man who," quoted in Linnie Marsh Wolfe, *Son of the Wilderness: The Life of John Muir* (Madison: University of Wisconsin Press, 1978), 160.

p. 55: Whitney famously referred to him as a "mere sheepherder, an ignoramus" in his 1869 *Yosemite Guidebook,* quoted in Jeffrey P. Schaffer, *The Geomorphic Evolution of the Yosemite Valley and Sierra Nevada Landscapes* (Berkeley: Wilderness Press, 1997), 36.

p. 56: King wrote his superiors, "Owing to the snow and difficulty," letter of August 13, 1872, National Archives Record Group X, frame 365.

p. 56: Muybridge described his work there as "illustrating the geology of the Sierras," in *Sacramento Bee/Record Union,* Sept. 18, 1878. He was talking about what he would present in Sacramento in a magic-lantern show including the Yosemite work.

p. 56: The catalogue issued in 1873 announced, "At no very remote period a vast area," in *Catalogue of Photographic Views*

Illustrating the Yosemite, Mammoth Trees, Geyser Springs, and other remarkable and Interesting Scenery of the Far West by Muybridge published by Bradley and Rulsofson Gallery of Portrait and Landscape Photographic Art, 1873 (original and microfilm in Bancroft Library).

p. 57: C. A. Coulson describes the God of the Gaps in several books he wrote on the subjects of theology and science, but my primary source was the geologist Anna Sojourner, who e-mailed me about the idea, and the Internet.

p. 57: He is often called a catastrophist. King, in "Catastrophism and Evolution," *The American Naturalist,* August 1877, 454, writes: "Sweeping catastrophism is an error of the past. Radical uniformitarianism, however, persists, and probably controls the faith of a majority of geologists and biologists." "Between each two successive forms of the horse there was a catastrophe which seriously altered the climate and configuration of the whole region in which these animals lived."

p. 58: He remarked, quite wrongly, that "although the peaks," King, *Systematic Geology* (Washington, D.C.: Government Printing Office, 1878, Vol. 1 of the United States Geological Exploration of the Fortieth Parallel Report), 463.

p. 58: Fox, "When Muir rejected the Whitney theory 'most devoutly,' " in Stephen Fox, *The American Conservation Movement: John Muir and His Legacy* (Boston: Little, Brown, 1981), 21.

p. 58: Muir, "Contemplating the lace-like fabric of streams outspread over the mountains," *My First Summer in the Sierra* (San Francisco: Sierra Club Books, 1988), 164.

p. 59: Darwin, "I cannot persuade myself that a beneficent and omnipotent God," quoted in John C. Greene, *The Death of Adam: Evolution and Its Impact on Western Thought* (Ames: Iowa

State University Press, 1996), 303.

p. 59: Muir, "How narrow we selfish, conceited creatures are," Michael P. Cohen, *The Pathless Way: John Muir and American Wilderness* (Madison: University of Wisconsin Press, 1984), 158.

p. 59: King, "The Quakers will have to work a great reformation," in *Mountaineering in the Sierra Nevada* (Yosemite National Park: Yosemite Association, 1997), 37.

p. 59: Muir, "It is when the deer are coming down," in *Our Yosemite National Park* (Golden, Colo.: Outbooks, 1980), 59.

p. 60: Jackson, "Half naked, dirty beyond words," in "Ahwahnee Days" in *Bits of Travel at Home* (Boston: Roberts Brothers, 1893), 107.

p. 61: Harry, "An Italian fertility doctor," in an e-mail list-serve received by the author, November 2002.

p. 61: "When naturalists first hiked through Glacier National Park," *San Francisco Chronicle,* November 29, 2002, 16.

p. 63: Byron put it another way. Mark's undergraduate degree was in geology, mine in literature, but Byron's was in evolutionary biology, a degree he hybridized himself from the available programs. In response to this essay, he wrote:

When Darwin first described evolution, he wrote primarily about the most straightforward aspect—natural selection. But there are other evolutionary forces, many of them possibly yet undescribed. Sexual selection is distinct from natural selection and is frequently invoked to explain physical characteristics (and behaviors) that don't seem to directly contribute to an individual's likelihood for survival—and in some cases would seem to place individuals at a significant disadvantage. This would include such things as elaborate plumage, ridicu-

lously large antlers, and birds with tail feathers so large that flying becomes difficult, if not impossible. For whatever reason, individuals with these features were considered "attractive" and were therefore disproportionally selected as mates. In a bizarre kind of positive feedback loop, these characteristics became highly exaggerated to the point that natural selection began to work in opposition to dampen the forces of sexual selection. All of this is to say that there are several forms of selection at work and that results of life are therefore elaborate, and contradictory, and mysterious, and elegant, and unexpected, and beautiful (or should I say attractive?). But ultimately, at its core, there is a fundamental randomness involved in this, or at least there isn't a requirement for a higher entity to explain how the world works, or even explain our very existence. And that, I think, is why most were, and are, resistant to evolutionary theory. It can appear grim and seem to suggest a meaninglessness to life, and in particular, death. To whom do you appeal if you're the individual with a fatal inherited characteristic? What recourse is there if you lose a child to an unexplained disease or infection? Religion plays a big role in giving meaning to death and explaining what happens in the afterlife. I don't know if our fear of death has changed in the last few thousand years or not, but I think it is reasonable to propose that we believe we have mastered our world in ways our ancestors did not and should expect to be able to better control our individual destiny—all the while knowing that we can bring about death in ways and in a scale once unimaginable.

In the face of this, I believe that we have to have faith and hope. And we can't expect to get meaning from life,

instead we have to give meaning to life, in whatever way we can—through art, writing, science, religion. And our lives are therefore elaborate, and contradictory, and mysterious, and elegant, and unexpected, and beautiful.

BACK AT THE LAKE WITH TWO NAMES

p. 98: Bunnell, "As I lowered my line of vision to the base," in *Discovery of the Yosemite and the Indian War of 1851 Which Led to That Event* (Yosemite National Park: Yosemite Association, 1990), 205.

p. 98: "I called him up to us," recounted Bunnell, in *Discovery of the Yosemite,* 213–14.

p. 98: Rebecca Solnit, "Usually annihilating a culture," in *Savage Dreams: A Journey into the Landscape Wars of the American West* (Berkeley: University of California Press, 1994), 220.

p. 99: Toni Morrison wrote, "It never looked as terrible as it was," in *Beloved* (New York: Penguin, 1988), 6.

p. 100: Muir in his heavily revised journal for July 27, 1869, writes, "Up and away to Lake Tenaya," *My First Summer in the Sierra,* 108.

p. 100: Muir, "When we try to pick out anything by itself," in *My First Summer in the Sierra,* 110.

Carl Anthony once wryly observed, in conversation with the author, ca. 2000.

p. 104: See Chinua Obata, *Obata's Yosemite: The Art and Letters of Chinua Obata from His Trip to the High Sierra in 1927* (Yosemite National Park: Yosemite Association, 1993).

CREDITS

The archival photographs in this book were reproduced with the kind permission of museums and libraries across the country.

Note: The Eadweard Muybridge mammoth plate albumen prints reproduced herein are from the print collection at the Bancroft Library, University of California, Berkeley. The pictures were made in 1872 and published by Bradley and Rulofson of 429 Montogomery Street, San Francisco. The Bancroft Library's prints are numbered according to the photographer's number listed in Bradley & Rulofson's 1873 *Catalogue of Photographic Views Illustrating the Yosemite, Mammoth Trees, Geyser Springs, and other Remarkable and Interesting Scenery of the Far West.* This catalogue included Muybridge's stereo photographs, which were similarly numbered. The numbering system is also used with the sole Muybridge stereo photograph reproduced in this book.

Page 2. Charles Leander Weed, American, 1824–1903. *Yosemite Valley from Mariposa Trail,* c. 1865. Mammoth albumen print from wet collodion negative, 39.7 x 51.7 cm. © The Cleveland Museum of Art, John L. Severance Fund, 2002.43.

Page 4. Carleton E. Watkins, *First View of the Yosemite Valley from the Mariposa Trail,* c. 1866. Courtesy of the Boston Public Library, Print Department.

Page 6. Eadweard Muybridge, *Valley of the Yosemite, from Moonlight Rock, No. 1,* 1872. Courtesy of the Bancroft Library, University of California, Berkeley.

Page 8. Ansel Adams, *Clearing Winter Storm, Yosemite National Park,* 1944. Collection Center for Creative Photography, University of Arizona © Trustees of the Ansel Adams Publishing Rights Trust.

Pages 24–25. Byron Wolfe and Mark Klett, *Panorama from Timothy O'Sullivan's 1872* Canyons of Lodore, *Dinosaur National Monument, Colorado,* 2000. Inset image, Timothy O'Sullivan's *Brown's Park from Entrance to Canyon of Lodore, southern Wyoming,* 1872, courtesy of the National Archives.

Page 32. Ansel Adams, *Jeffrey Pine, Sentinel Dome, Yosemite National Park, California*, c. 1940. Collection Center for Creative Photography, University of Arizona © Trustees of the Ansel Adams Publishing Rights Trust.

Page 34. Carleton E. Watkins, *Part of the Trunk of the "Grizzly Giant" with Clark-Mariposa Grove-33 feet diameter*, 1861. Courtesy the J. Paul Getty Museum, Los Angeles, © The J. Paul Getty Museum, #85.XM.11.6.

Page 36. Carleton E. Watkins. *Grizzly Giant, Mariposa Grove, 33 Ft. Diam.*, 1861. Courtesy of the Boston Public Library, Print Department.

Page 38. Eadweard Muybridge, *Helmet Dome and Little Grizzly Fall. No. 42*, 1872. Courtesy of the Bancroft Library, University of California, Berkeley.

Pages 40–41. From Eadweard Muybridge, *Helmet Dome and Little Grizzly Fall. No. 42*, 1872. Courtesy of the Bancroft Library, University of California, Berkeley. From Mark Klett and Byron Wolfe, *Sugar Loaf and Bunnell Cascade*, 2003.

Page 42. Eadweard Muybridge, *Yosemite Cliff. At Summit of Falls. No. 45*, 1872. Courtesy of the Bancroft Library, University of California, Berkeley.

Page 44. Eadweard Muybridge, *Yosemite Creek. Summit of Falls at Low Water. No. 44*, 1872. Courtesy of the Bancroft Library, University of California, Berkeley.

Page 64. Eadweard Muybridge, *Pohona, Valley of the Yosemite. No. 6*, 1872. (More commonly known as Bridalveil Falls.) Courtesy of the Bancroft Library, University of California, Berkeley.

Page 66. Eadweard Muybridge, *Tutocanula, Valley of the Yosemite. The Great Chief "El Capitan." 3500 Feet High. No. 9*, 1872. Courtesy of the Bancroft Library, University of California, Berkeley.

Page 68. Eadweard Muybridge, *Tutocanula, Valley of the Yosemite. (The Great Chief) "El Capitan." Reflected in the Merced. No. 11*, 1872. Courtesy of the Bancroft Library, University of California, Berkeley.

Page 70. Eadweard Muybridge, *The Pompons. Valley of the Yosemite. (The Jumping Frogs) "Three Brothers." 4300 Feet High. No. 12*, 1872. Courtesy of the Bancroft Library, University of California, Berkeley.

Pages 72–73. Mark Klett and Byron Wolfe. *Panorama of a ghost river, made over 100 meters and two days beginning and ending with Muybridge's mammoth plates No. 11 and No. 12*, 2001. Eadweard Muybridge, *Tutocanula, Valley of the Yosemite. (The Great Chief) "El Capitan." Reflected in the Merced. No. 11*, 1872; and *The Pompons. Valley of the Yosemite. (The Jumping Frogs) "Three Brothers." 4300 Feet High. No. 12*, 1872, both courtesy of the Bancroft Library, University of California, Berkeley.

Page 74. Ansel Adams, *Mount Gibbs, Dana Fork, Upper Tuolumne Meadows, Yosemite National Park*, c. 1946. Collection Center for Creative Photography, University of Arizona © Trustees of the Ansel Adams Publishing Rights Trust.

Page 76. *Four Views of Cathedral Rocks*. Top left: Carleton E. Watkins, 1861. Top right: Eadweard Muybridge, 1872. Bottom left: Ansel Adams, c. 1944. Bottom right: Mark Klett and Byron Wolfe, 2002. (The last view is made from Ansel Adams's camera position, using lighting consistent with versions by Eadweard Muybridge and Carleton Watkins.) Carleton E. Watkins, *River View, Cathedral Rock (midday)*, 1861, courtesy of the Boston Public Library, Print Department. Eadweard Muybridge, *Cathedral Rocks. Valley of the Yosemite, 2600 Feet High. No. 7*, 1872, courtesy of the Bancroft Library, University of California, Berkeley. Ansel Adams, *Cathedral Rocks (late afternoon)*, c. 1944, Collection Center for Creative Photography, University of Arizona © Trustees of the Ansel Adams Publishing Rights Trust.

Page 80. Eadweard Muybridge, *Pi-Wi-Ack (Shower of Stars). "Vernal Fall," 400 Feet Tall. No. 29*, 1872. Courtesy of the Bancroft Library, University of California, Berkeley.

Page 82. Eadweard Muybridge, *Cloud's Rest. Valley of the Yosemite. No. 40*; and *Glacier Channels. Valley of the Yosemite. From Panorama Rock. No. 41*, 1872. (Combined to form overlapping views.) Courtesy of the Bancroft Library, University of California, Berkeley.

Page 86. Eadweard Muybridge, *The Domes. Valley of the Yosemite. From Glacier Rock. No. 37*, 1872. Courtesy of the Bancroft Library, University of California, Berkeley.

Page 88. Ansel Adams, *Half Dome and Clouds*, 1935. Collection Center for Creative Photography, University of Arizona © Trustees of the Ansel Adams Publishing Rights Trust.

Page 89. Mark Klett and Byron Wolfe, *View from the handrail at Glacier Point overlook, connecting views from Ansel Adams to Carleton Watkins*, 2003. (Watkins's photograph shows the distorting effects of his camera's movements as he focused the scene.) Left insert: Ansel Adams, c. 1935. Rightt

insert: Carleton E. Watkins, 1861. Ansel Adams, *Half Dome and Cloud, 1935*, Collection Center for Creative Photography, University of Arizona © Trustees of the Ansel Adams Publishing Rights Trust. Carleton E. Watkins, *View looking toward the Sierra Nevada and Merced Falls, from Glacier Point*, 1861, courtesy Jeffrey Fraenkel, Fraenkel Gallery.

Pages 90–91. Mark Klett and Byron Wolfe, *Panorama from Sentinel Dome connecting three views by Carleton Watkins*, 2003. Left insert: *From the Sentinel Dome, Down the Valley, Yosemite*, 1865–66. Center insert: *Yosemite Falls from the Sentinel Dome*, 1865–66. Right insert: *The Domes, from the Sentinel Dome*, 1865–66. Watkins's pictures courtesy Jeffrey Fraenkel, Fraenkel Gallery.

Page 92. Carleton E. Watkins, *Yosemite Falls (From the Upper House), 2477 Ft.*, 1861. Denver Public Library, Western History Collection, Carleton Watkins, Z-3137.

Page 112. Eadweard Muybridge, *Mount Hoffman, Sierra Nevada Mountains. From Lake Tenaya. No. 48*, 1872. Courtesy of the Bancroft Library, University of California, Berkeley.

Page 113. Ansel Adams, *Tenaya Lake, Mount Conness, Yosemite National Park*, c. 1942. Collection Center for Creative Photography, University of Arizona © Trustees of the Ansel Adams Publishing Rights Trust.

Page 114. Edward Weston, *Lake Tenaya*, 1937. Collection Center for Creative Photography, University of Arizona © 1981 Arizona Board of Regents.

Pages 116–17. Mark Klett and Byron Wolfe, *Four views from four times and one shoreline, Lake Tenaya*, 2002. Left to right: Eadweard Muybridge, 1872; Ansel Adams, c. 1942; Edward Weston, 1937. Back panels: *Swatting high-country mosquitoes*, 2002. Eadweard Muybridge, *Mount Hoffman, Sierra Nevada Mountains. From Lake Tenaya. No. 48*, 1872, courtesy of the Bancroft Library, University of California, Berkeley. Ansel Adams, *Tenaya Lake, Mount Conness, Yosemite National Park*, c. 1942, Collection Center for Creative Photography, University of Arizona © Trustees of the Ansel

Adams Publishing Rights Trust. Edward Weston, *Lake Tenaya*, 1937, Collection Center for Creative Photography, University of Arizona © 1981 Arizona Board of Regents.

Page 120. Ansel Adams, *Rock Pavement near Tenaya Lake, Yosemite National Park*, c. 1935. Collection Center for Creative Photography, University of Arizona © Trustees of the Ansel Adams Publishing Rights Trust.

Page 122. Eadweard Muybridge, *Ancient Glacier Channel. Lake Tenaya. Sierra Nevada Mountains. No. 47*, 1872. Courtesy of the Bancroft Library, University of California, Berkeley.

Page 124. Edward Weston, *Juniper*, 1936. Collection Center for Creative Photography, University of Arizona © 1981 Arizona Board of Regents.

Pages 125–26. Mark Klett and Byron Wolfe, *Above Lake Tenaya, connecting views from Edward Weston to Eadweard Muybridge*, 2002. Left: Edward Weston, *Juniper*, 1936. Right: Eadweard Muybridge, *Ancient Glacier Channel, at Lake Tenaya, Mammoth Plate No. 47*, 1872. Weston's picture, Collection Center for Creative Photography, University of Arizona © 1981 Arizona Board of Regents. Muybridge's picture courtesy of the Bancroft Library, University of California, Berkeley.

Page 128. Edward Weston, *Junipers, Lake Tenaya, Sierra Nevada*, 1940. Collection Center for Creative Photography, University of Arizona © 1981 Arizona Board of Regents.

Page 129. Edward Weston, *Lake Tenaya Country*, 1940. Collection Center for Creative Photography, University of Arizona © 1981 Arizona Board of Regents.

Pages 130–31. Mark Klett and Byron Wolfe, *Above Lake Tenaya connecting two 1940 views by Edward Weston*, 2003. Edward Weston, *Junipers, Lake Tenaya, Sierra Nevada*, 1940; and *Lake Tenaya Country*, 1940, both Collection Center for Creative Photography, University of Arizona © 1981 Arizona Board of Regents.

ABOUT THE AUTHORS

MARK KLETT has been photographing the western landscape for more than twenty-five years. His books include *Third Views, Second Sights: A Rephotographic Survey of the American West*. He has received three National Endowment for the Arts fellowships, a Guggenheim fellowship, a Japan-U.S. Friendship Commission fellowship, and the Buhl Foundation Award. His work has been presented in numerous national and international exhibitions. He is Regents Professor of Art at Arizona State University in Tempe.

REBECCA SOLNIT is the prize-winning author of nine books, including *Hope in the Dark* and *River of Shadows: Eadweard Muybridge and the Technological Wild West*, which won the National Book Critics Circle Award. She has received the Lannan Foundation Literary Award in nonfiction and a Guggenheim Fellowship for her work on Eadweard Muybridge and his legacy. She lives in San Francisco.

BYRON WOLFE is a widely exhibited photographer. He is a contributing photographer to *Third Views, Second Sights: A Rephotographic Survey of the American West*. A recipient of the Santa Fe Prize for Photography, he is associate professor of photography and digital imaging at California State University in Chico.